Harold Calma

S3
AL

530
ALTA

D0687010

Pottery in Alberta The Long Tradition

Pottery in Alberta
The Long Tradition

Marylu Antonelli and Jack Forbes

Hal
November 5 1980
on the occasion of the opening
of MEDALTA at Beaver House Gallery
Edmonton Alberta —
Jack Forbes

The University of Alberta Press 1978

First published by
The University of Alberta Press
Edmonton Alberta Canada
1978

Copyright © 1978 The University of Alberta Press

Canadian Cataloguing in Publication Data

 Antonelli, Marylu, 1940–
 Pottery in Alberta

 ISBN 0-88864-023-4
 1. Pottery—Alberta. I. Forbes, Jack, 1941–
 II. Title.
NK 4030.A5A57 738′.097123 C78–002001–4

Book design by Peter Bartl and Christopher Ozubko
Color photographs by Harry Savage

All rights reserved
No part of this publication may be produced,
stored in retrieval system, or transmitted in
any form, or by any means, electronic, mechanical,
photocopying, recording or otherwise without
the prior permission of the copyright owner.

Printed by Hignell Printing Limited
Winnipeg Manitoba Canada

Contents

Preface

This book was written to grasp something that almost slipped away unnoticed. In Medicine Hat in 1975, the derelict hulk of an old pottery, the Medalta, stood a refuge for homeless pigeons. The more recent buildings on the site served as temporary warehouse space, neglected; inside, the original machinery—a saggar press, pug mills, filter press, wet pan, clay cars—and stacks of filter cakes, long ago abandoned, lay vandalized. Four of the original six round downdraft kilns, some of them full of cups, saucers, and saggars from their last firing, stood idle, their crowns crumbling. The creek bed beside the buildings was filled in with discarded broken moulds.

Down the road, flanked by Plainsman Clay and Hycroft China, a few more neglected round downdraft kilns, grass and wildflowers sprouting from their crowns, remained the sole survivors of the fire which destroyed the Alberta Clay Products Company in 1961. Some of them date back to 1910. Before long, someone would find a use for the space they occupied and they would be shoveled away like the rest of the debris from the fire.

If you walk down the streets of Medicine Hat, just about every second person you meet will tell you he or she worked in the clay products industry or has a relative who did. Jog their memories with a few questions and they'll find they have a host of stories to tell about their life and work in the clay products factories. They'll also tell you they never considered their stories or their work that important.

8

The fact is, the clay products industry was a logical outgrowth of the clay deposits and natural gas supplies in southeastern Alberta. It sprang up in the early years of this century and thrived in various forms—potteries, brick and sewerpipe factories—through the present, providing employment to large numbers of Hatters and household crockery and building supplies to all of Canada. Alberta Clay Products and Medalta were the early giants of that industry.

Today the pottery industry barely survives in Alberta, but potters from all over Canada and from outside the country have chosen Alberta as a place in which to live and do their work. As it once was a centre for industrial pottery, Alberta is now a centre for artistic and production pottery. There is a connection. This book was written to demonstrate that connection and to show that there is a tradition of working in clay in this province —although Alberta potters may look elsewhere for influences, they can identify a heritage here. It was also written to document an industrial heritage which nearly slipped by unnoticed because it was so much a part of the everyday environment of the people who lived their lives in it.

Because the information we needed was not yet to be found in libraries or archives, we are greatly indebted to all those who took time to tell us their stories and to open doors for us:

Jack Barrie and Tom Court for recognizing there was a story and preserving records long before we started our research; Jim Marshall, John Porter, Jack Sissons and Malcolm Sissons for opening doors; and for telling their stories: Frank Anhelcher, Gordon Armstrong, Wally Fode, John Herter, Emil Janke, Ken Kinvig, Don Lefever, Luke Lindoe, Malcolm MacArthur, Roy Ogilvie, Ed Philipson, Jesse Reuber, Matilda Schlenker, Gertrude Thacker, Ralph Thrall, Jr., Harry Veiner, Hilda Weir, Bert Wyatt, Jesse (Bill) Wyatt, and Bill Hrehorchuk, who passed away before this book was completed: Bill Yuill, Harry Yuill, and Fred McQueen for providing photographs.

The research and writing of this book were supported by the University of Alberta Faculty of Extension. Publication was financed by the Faculty of Extension assisted by a grant from Alberta Culture, the Hon. Horst Schmid, Minister.

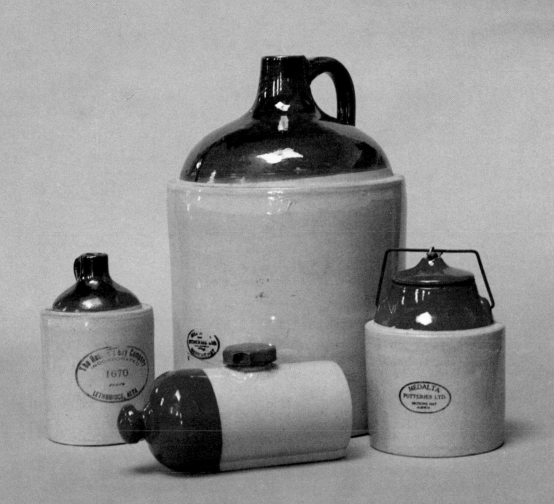

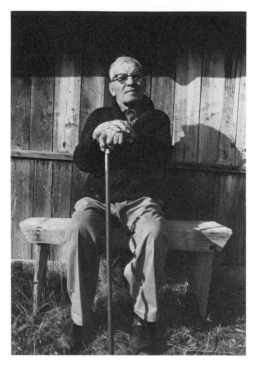

Bill Hrehorchuck in 1975.

"Fellow came in here and take a look at it. . . . looked at how big it is, how high. . . . says, 'Did you have a machine to do this?' I says, 'Sure is, you can't do it without machine.' I says, 'There it is.'" Here, Bill offered his two hands, palms up, for emphasis. "Ten fingers!"

"He says, 'I hardly believe it.'"

"I says, 'Look here. I did that. If you hardly believe it I haven't got time to talk to you no more. You better skiddoo. Because you don't understand.'" **Bill Hrehorchuk:**

Chapter 1

A new century and Medicine Hat booms as the newly incorporated city capitalizes on its clay deposits and natural gas.
Alberta Clay Products (ACP) comes to town.

When Bill Hrehorchuk arrived in Medicine Hat in 1912 he wasn't planning to stay, even though it was the greatest year so far in the prairie city's 29-year history. In fact, nobody doubted that Medicine Hat would become the "Pittsburgh of Western Canada." Sitting on top of a natural gas field that some predicted would supply the cheapest fuel in the world for all time to come, Medicine Hat was attracting industries from all over North America and immigrants from around the world to work them.

Bill came from Austria; the Alberta Clay Products Company from Iowa. For, not only was Medicine Hat rich in natural gas, but the banks and valleys of the surrounding area from the Crow's Nest Pass to the Cypress Hills were covered with clay. In Dunmore, just nine miles east of Medicine Hat, lay a deposit of the finest fire-brick clay yet uncovered in Western Canada. For cheap fuel and nearness to the raw materials required for brick, tile, and sewerpipe, the Iowa company had selected the booming southern Alberta town in 1908 as the location for its plant.

By the time Bill came to town, nineteen years old, unskilled, but not afraid of work, the Alberta Clay Products Company had a brick plant second in size and capacity only to one other in North America and was providing work for 325 men. Bill never left. Although he'd never worked in a mine before, the young Austrian took the dangerous job of blasting clay out of the Company's Dunmore pit. In return, the Company set him up in a small, spartan house at the foot of the huge clay bank, from which in a "damn good year" he extracted 200 tons a day.

Rotating loading terminal at the Dunmore pits. The dump cars were pulled by a horse along the track to this terminal, where the clay was dumped down the chute into the CPR railcar below.

When he died in that same house in 1976, "Claypit Bill" Hrehorchuk was probably, at age 83, one of the oldest workers in clay in Canada.

"That's quite a few Fridays, too, you know, since I came to work. No one can tell me about the work," Bill would reminisce with the odd visitor to his home beside the abandoned claypits.

It's likely he never made anything out of clay. That wasn't his business. But, he knew clay, had shovelled it out with his bare hands and had earned the respect of the men who made their fortunes from clay.

As Bill would tell it, it wasn't a job he particularly wanted at the start. "The guy who worked the claypit for a year or two before me went back to old country and he says, 'I leave it to you and I gonna learn you to blast.' I says that's the only thing I don't like about the job. 'Nobody ask you,' he says. 'You take the job and you learn to blast.'"

Years later a government mine inspector visited Bill's pit. "He's a mine inspector and he says he didn't know how you blast a big bank like that! I says, 'For Cripe's sake, I was figure it in mine head. If you are that dumb, let it go.' He says, 'That's really dangerous. You got to know what second it goes off.' I says, 'I know that.'"

When he started, Bill was the youngest hand at the pit. "When we go in the morning, the guys say, 'You got to take a lunch with you.' I say, 'You don't come in to dinner?' They say, 'Yes, but you youngest guy here. Work is hard. You get hungry.' I don't take my lunch either."

Bill had a contract to supply Alberta Clay Products with four to five carloads of clay a day at fifteen dollars a carload (45 to 50 tons). He had a crew of eight or nine men working for him. Nearby, a second Company-owned pit yielded the same quantity of clay under the supervision of another man on a separate contract. "He didn't bother me and I didn't bother him," Bill recalled.

The clay was hauled from the open pits in small cars which ran on tracks to the end of a ramp. From there it was dumped over into the CPR box cars waiting below. It took eight or nine carloads a day to feed the Company's 14 round kilns, which turned out 80,000 bricks and 24,000 six-inch sewer pipes a day to supply Western Canada's construction boom.

Medicine Hat's boom had shifted into high gear in 1906, when the City itself and scores of North American industrialists recognized the potential

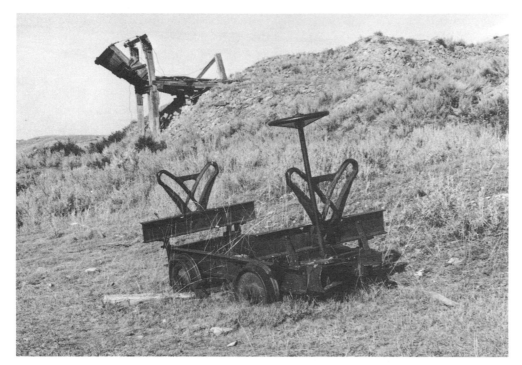

Loading terminal at Dunmore pits. The CPR tracks, since removed, ran below the terminal. The foreground shows an abandoned hauling car, minus its bucket.

of the unique combination of cheap natural gas and prime location on the railways. The potential had been there since 1883 when Medicine Hat came into being with the coming of the Canadian Pacific Railroad. That same year the CPR struck gas in the area while boring for water, but the railway made little use of the fuel except for lighting a section house. Over the next 20 years the population shot up from 400 to 5,000 as the prairie town became the hub of a rich farming and ranching district.

When the City incorporated in 1906 it decided to capitalize on its resources with an aggressive campaign to encourage industry. "Is not this fair city destined to be the manufacturing and distributing centre of the West?" the *Medicine Hat News* prompted from its editorial page that year. To entice industry, the municipality offered concessions that were hard to ignore: free sites, free water, tax concessions and, most alluring of all, gas, as the *Chicago Chronicle* reported "at the absurdly low rate of 5 cents per thousand feet." At that rate, the most extensive industrial plant in the City at the time, the Woolen Mills, was spending only 87 cents a day for operating power and light.

Drilled by W. R. Martin, 1909.

"Old Glory" – Medicine Hat District.
Depth – 1909 feet.
Capacity – 4,500,000 cubic feet per day.
Will develop 21,000 H.P.
Equivalent to 3200 tons of Coal per day.

"While the Canadian Northwest is attracting marked attention the world over these days, the particular locality which especially engages the attention of manufacturers throughout Canada and the United States is the City of Medicine Hat in the province of Alberta," the Chicago paper reported in a feature article in 1906. "Here it is that natural gas has been found in quantities, which settles the question as to the future industrial hub of the 'last west'...

"The proposition looks so good to American capital that at the present time a representative of one of Chicago's best known iron firms is engaged in making tests with the object of establishing a Canadian branch if the gas will meet the demand which will be made upon it by the furnaces...

"Indiana people have also got wise to the good thing at Medicine Hat and as pressed bricks sell at $50 a thousand in the Canadian Northwest, they have sent an expert up here to experiment with the extensive clay deposits, the object being to ascertain if the clay can not be utilized with the gas in supplying this rich market. With the Canadian Pacific Railway running east and west, the Crow's Nest line southwest, J. J. Hill's new venture

north and south through Medicine Hat, the prospects are bright for the future of this bustling city."

Alberta Clay Products was only one of several major North American companies of its kind to recognize Medicine Hat's potential just after the turn of the century as an ideal location for the manufacture of brick, tile, sewer pipe, and pottery. Leafing through the *Medicine Hat Daily News* from 1906 to 1908, one might imagine scouts from companies all over the continent bumping into each other on secret clay-testing missions. Momentum built weekly as the *News* reported the comings and goings of "capitalists from Indiana," "representatives of an Eastern sewer pipe business looking for a western branch," "a Minneapolis real estate tycoon," "a Chicago expert," "two Montreal men," "Ohio men sampling clay for sewer pipe business," "representatives from a Hamilton, Ontario, sewer pipe company," "a Mr. Colby of Mason City, Iowa, and a Mr. McNeill of Red Wing, Minnesota," . . . all sampling clay.

The editor of the *News* observed in May 1907: "With the clays, fuel and power, why should Medicine Hat not make the pressed brick, common bricks, sewer pipe, tile and cement for the whole West?" The results of all the testing were carefully noted by the *News*. The Chicago expert was reported "pleased" with his tests of Saratoga Park clay. The representatives from Hamilton were "enthusiastic." Dr. Stoner, the real estate man from Minneapolis and owner of the huge Stair Farm just five miles west of Medicine Hat, decided in 1906 to develop the clay deposits on three sections of his land and sold the rest.

Finally, in November 1908, the *News* reported that "the high quality of Medicine Hat clay has been firmly established." The Iowa group had been quietly testing clays along the Canadian Pacific and the Canadian National lines from the Crow's Nest to Fort Francis, Ontario. They found only one bed of shale clay that proved suitable for their purposes. It was in the Medicine Hat area. Warren Overpack, the Company's representative, announced to the *Medicine Hat News* that sewer pipe made from samples of the clay in Lehigh, Iowa was "equal in tensile strength and finish to any pipe now on the market."

Meanwhile, Dr. Stoner had wasted no time and announced in August 1907 that his syndicate was investing $150,000 capital to set up the Red

Cliff Brick Company on 600 acres of the old Stair Farm. A month later the Company struck gas at the strongest pressure yet in the area. Dr. Stoner came up from Minneapolis to personally oversee the building of the brickyard, described by the *News* as one of "stupendous proportions," which promised to turn Red Cliff into a company town and a flourishing suburb of Medicine Hat. The Company erected eight oblong kilns with a capacity of 60,000 brick per ten-hour day. To house a good number of the 500 men it planned to employ, Stoner's company built a bunk house and the brick cottages which still distinguish the town of Redcliff today. When the CPR spur line was laid the company was in business.

At the same time, the "Chicago expert" announced plans to operate a kiln within the month, and L. H. Pruitt, "a Texan who is chuck full of energy and is not afraid to loosen up the funds necessary to make his investment a good one," put up a pressed brick plant against a mountain of clay a mile and a half east of Medicine Hat. Medicine Hat was taking its clay seriously now. Of Pruitt the *News* noted, "He will soon have on the market an article which will make his name and the name of Medicine Hat famous." And, Jack Green sold out his share of his laundry to take charge of the Texan's brickyard, which was furnished with the most up-to-date equipment available with a capacity of 20,000 brick per day.

Brickmaking wasn't new in Medicine Hat. The town already had the character of an area rich in clay. Hatters were living in and doing business in buildings made of stock brick which the Purmal brothers had been turning out for some years. It was the large scale and diversification which marked 1907 as the year Medicine Hat became a major clay products centre in Canada. A local business roundup for that year listed five brick works, four of them new ones.

Even Rudyard Kipling was impressed. Hatters took delight for decades to come in quoting the famous author/adventurer's lyrical impressions of their frontier town, which he passed through in the fall of 1907. It was as if, by translating their worldly affairs into the language of universal drama, Kipling had bestowed upon Medicine Hat a badly needed legitimacy, especially in the eyes of the sophisticated world back east by which Westerners measured themselves culturally. Actually, Kipling reserved his most quotable prose for Redcliff. After touring the construction site

for Dr. Stoner's brickyard of stupendous proportions and lunching in the bunkhouse with the laborers, Kipling wrote:

"To the eye, the affair was no more than a novel or delicious picnic. What it actually meant was a committee to change the material of civilization for a hundred miles around. I felt as though I were assisting at the planning of Nineveh, and whatever of good that comes to the little town that was born lucky, I shall always claim a share."

As 1908 opened, nobody expected that anything but good was coming. Weekly reports in the *News* anticipated the opening of the Red Cliff plant—March 26: "Red Cliff Brick Company to start first kiln next week"; April 9: "Red Cliff opens first kiln today." Finally, in a front page story April 16, the *News* reported Red Cliff's official opening. Dr. Stoner pronounced the product of his first test kiln a "good one." Recounting the history of his enterprise, Dr. Stoner revealed for the first time that before investing in Red Cliff, his company had tested the clay in no fewer than four simultaneous blind experiments by skilled brickmakers in Ohio, Wisconsin, Minnesota, and Kansas.

Stoner imported an experienced brickmaker from Kansas to manage his plant. With an opening capacity of 40,000 brick per day, Red Cliff announced plans for immediate expansion to produce 100,000 per day, but, before Stoner could expand, he had to rebuild. That year the Medicine Hat area's new brick and tile industry was set back by the kind of disaster that seemed chronic in the industry for years to come. Within a space of four months both the Red Cliff Brick Company and the Canadian Brick Works burned down. Reporting the "disastrous fire" at Red Cliff, the *News* observed that Medicine Hat would experience "a brick famine" for several months to come. Stoner's main building and dry kilns were ruined —a total loss of $50,000.

R. R. Hoffman managed to get his Canadian Brick Works back into business that same year; but it took the Red Cliff people a full year to reestablish their operation. By 1909, Medicine Hat's brick and tile industry was solidly underway again. Hoffman's bricks were judged by an expert as "equal in color and quality of any Canadian brick seen." People from Winnipeg to Vancouver were building with Red Cliff's hollow-ware, which the *News* boasted was "equal to the best American product." In fact, the

demand for the Redcliff plant's product was so great that bricks were shuttled hot from the kilns straight into the waiting boxcars. The town's two-horse fire brigade became accustomed to answering calls to put down fires in loaded boxcars beside the plant. The Purmals had amalgamated with Pruitt, the Texan losing his name in the merger. The new Purmal Brick Company made pressed brick at the old Pruitt yard and stock brick at the Purmal yard.

Still there was clay enough and market enough for more. While the established companies worked overtime, the Stephens Brick Company of Portage scouted Medicine Hat clay, and the Alberta Clay Products Company set up two kilns to make all their own brick for what would become the biggest clay works yet.

During that first decade of the Twentieth Century, Medicine Hat went through a metamorphosis from dusty prairie town to major industrial city. The transition came about at such a rapid gait that newspaper accounts from day to day of the City's negotiations with prospective industries had a breathless, stop-the-presses pace to them. In addition to brick and tile, the city attracted a massive irrigation company, a packing industry from Chicago, and its famous Rosery Company, a "City of Glass" covering five acres to supply roses for Western Canada.

It started to look like a real city. By 1907 Medicine Hat had sidewalks and a house number and street name system. No longer did Hatters find each other by remembering that Mr. Smith's house is two blocks west of Mr. Jones' house. Smith's and Jones' houses were lit by electric power by 1911. In the course of modernization, Medicine Hat eventually gave up its charming reputation as "perhaps the only city in the world that keeps its lamps alight day and night, month after month and year after year because it is cheaper to let them burn than hire men to turn off the street lamps." The Old-West main street was no longer fitting the city's new image. Steward and Tweed's department store started the construction boom which put pressure on the local brickyards in 1906 when they began excavation for what the *News* described as "a magnificent brick building to replace their present commodious premises."

Was the name "Medicine Hat" fitting a city that would be taken seriously as an industrial centre? Suddenly, in 1910, the city became self-conscious

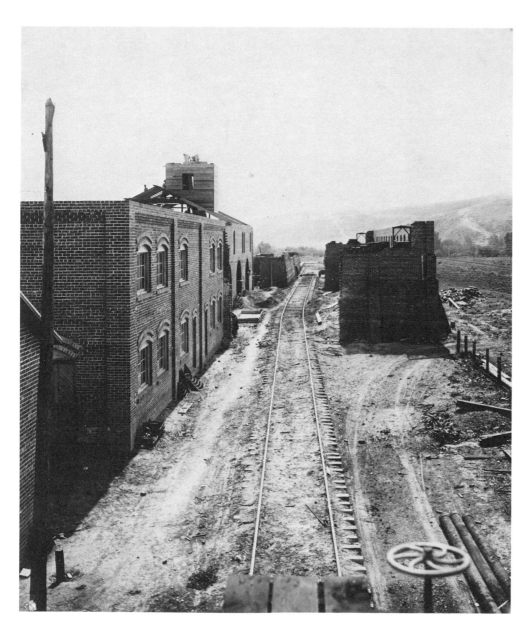

ACP yard in July, 1910.

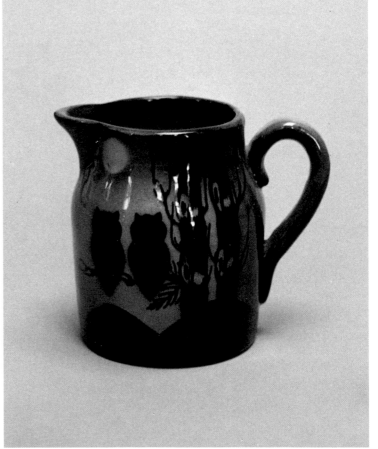

about its name. "Smacks of small townishness," said some. "Too much of the Indian influence," others worried. So frenzied was their desire to "hold everything we have and to reach out for as much more as we can get," City Council and Medicine Hat businessmen weren't about to have their ambitions quashed by overlooking the impression the City's name might have on prospective business from the cosmopolitan world outside.

Matters weren't helped any by a letter from a gentleman in England to City Council printed in the *News* in 1911:

"Gentlemen: May I most respectfully suggest that it would be an advantage to your city if another name—for instance, 'Medcenat,' were substituted for its present name. It may, perchance, be desirous of obtaining money from abroad for city improvements and it will be advantageous for your city to have a more euphonious title."

Hatters weren't swayed by the euphony of the Englishman's suggestion. The letter may have raised second doubts, but the matter had already been settled. Almost on the eve of a plebiscite to determine if "Medicine Hat" should be retired, F.F. Fatt, a man who had come to the City's rescue before on a sticky problem, decided to solicit an outside opinion. Fatt sent off an appeal to Medicine Hat's old friend Rudyard Kipling. Kipling replied sternly, reminding the City of its dignity and of the pride it should have in its heritage. The plebiscite was never held.

A year before, the City had almost lost the Alberta Clay Products Company, when a year's negotiations appeared to be falling through. It wasn't the ring of the City's name that influenced the Iowa company to seriously consider Coleridge, six miles east, over Medicine Hat. Southern Alberta towns were competing feverishly for the favors of outside industry, and no one of them had a monopoly on clay. Warren Overpack's group had sampled clays in the area throughout 1908 before it decided to locate. The Company originally selected Coleridge and purchased property there on which to erect its huge plant. While Medicine Hat was planning to become the Pittsburgh of Western Canada, six miles down the road, Coleridge, with its future clay works, dreamed of becoming "the Chicago of the Canadian West."

But, Alberta Clay Products couldn't get a railroad right-of-way for their Coleridge property, so Overpack took his building plans before a special

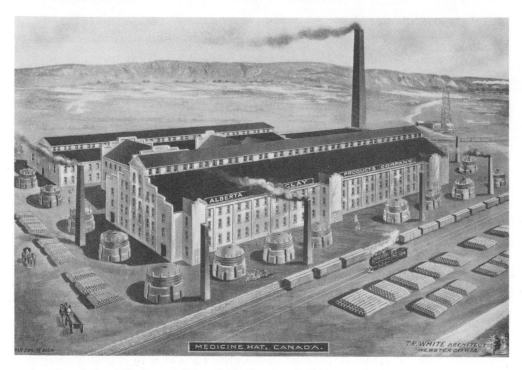

The photograph is from Alberta Clay
Products Co. stock brochure.

meeting of the Medicine Hat City Council. "This industrial proposition of
the sewer pipe company looks good anyway you look at it," the *News*
commented. And, it would relieve Western Canada from the need to
import its sewer pipe from the United States.

In January of 1909, the City burgesses ratified a bylaw granting Over-
pack's company 35 acres of land for one dollar providing only that Alberta
Clay Products build the proposed plant and operate for at least one
month. The City agreed also to sink a gas well on the land, to provide
right-of-way and construct the track, and to give the Company a 15-year
exemption from all municipal taxes except school taxes.

Several months went by as the City anxiously waited for the Company
to start building. Finally, in May, Overpack came back to Medicine Hat
with the news that the site offered by the City wasn't suitable. The land
wasn't level. The Company wanted an even better deal: either the City
level the land in question or provide an alternative site—or else. The City
hesitated. The new land proposition would have to go back to the bur-
gesses.

Overpack issued an ultimatum. The Company was ready *now* to start construction and it couldn't wait for an alternative site bylaw. He announced that Alberta Clay Products would go back to Coleridge.

Two weeks later, the Alberta Clay Products Company started excavating foundations in Medicine Hat on the site they wanted. The bylaw still had to be passed. It looked as though someone was taking a risk. By the time the bylaw was passed, six weeks after Overpack's ultimatum, the Company had raised a temporary frame building and were already making brick for their permanent buildings out of clay from the foundation trenches.

"A man not being given to parading his virtues," F. F. Fatt had secretly taken a personal risk and saved the situation for Medicine Hat, the *News* disclosed after the plebiscite. Behind the scenes, Fatt had agreed to sell seven acres of his land in the City's flats to Alberta Clay Products for one dollar per acre if the bylaw didn't pass. So important was this new industry to the City that the baseball and lacrosse field was donated for the site.

Southern Alberta's clays and natural gas and her favorable location on the railways were finally catalyzed by the vast influx of capital needed to turn them into a major industry. The opening up of the Canadian West and its consequent building boom completed the setting with a hungry market that made competition meaningless to the pioneering clay products plants that operated side-by-side, day and night. Alberta's clay promised tremendous returns on investment to the men who had money to invest, and a steady livelihood to those who, like Bill Hrehorchuk, had only their muscle, common sense, and a willingness to work.

Individual Boston

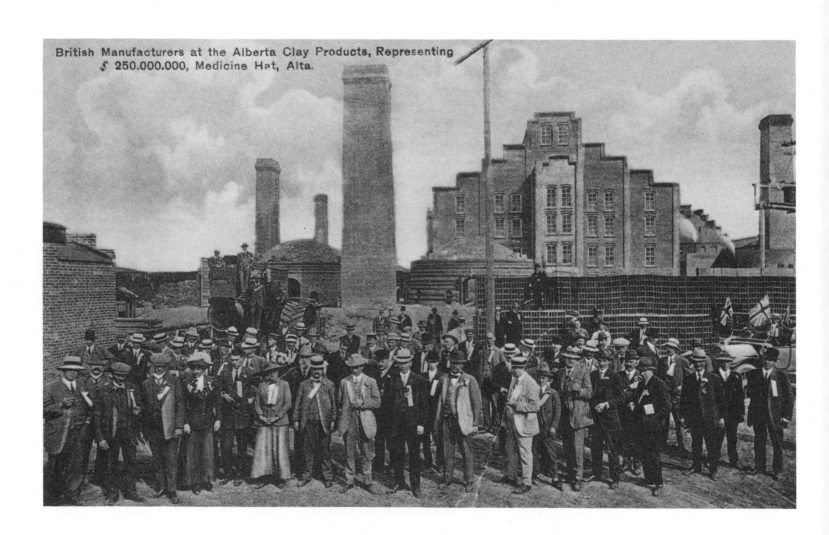

British Manufacturers at the Alberta Clay Products, Representing $ 250.000.000, Medicine Hat, Alta.

Chapter 2

Cities vie for clay industries.
Companies come and go.
First World War takes edge off
boom.
Medalta Stoneware incorporates.
Henry Clinton Yuill takes control.
Medalta products catch on.

Southeastern Alberta clays continued to yield surprises and promises as their variety became known. While scores of men kept the Alberta Clay Products plant running twenty-four-hours a day making brick to complete the gigantic complex, Overpack experimented further with the Coleridge clays. Just as his company was preparing to order fire brick from St. Louis to build its kilns, Overpack made a discovery that saved them over $25,000.

Previously, fire brick, required in certain kinds of building because of its capacity to stand up under extremely high temperatures (over 2000° Fahrenheit), had to be imported from the United States. The City of Medicine Hat and some of its first industries had paid $110 per thousand for fire brick from St. Louis during the early years of the area's building rush. "Imagine it—eleven cents a-piece," the *News* exclaimed in a front-page story reporting Overpack's discovery.

"Well, Mr. Warren Overpack, when experimenting with some of his black clay from Coleridge, the other day, made up a couple of bricks and put them into a test kiln along with the St. Louis article. The heat was turned on and after the temperature got up around the twenty-two or twenty-three hundred mark, the American bricks were reduced to the consistency of paste while the local product stood up firm and burned to a beautiful white color, as hard as flint."

The Company went into production for outside consumption in 1911 with a plant that served nearly fifty years with only minor modifications

and expansions. Ten round kilns with an inside diameter of 28 feet and four larger ones, 40 feet in diameter, surrounded the plant's main buildings on three sides and commanded aerial views of the city from that year on.

Although the Company was billed from its conception as principally a manufacturer of sewer pipe, its initial production was restricted to tile blocks and red pressed brick. Even after early clay testing experiments showed Medicine Hat clay to be superior to any other in Canada for sewer pipe, the local clays proved disappointing in actual production because they did not lend themselves to vitrification. Alberta Clay Products' early ads emphasized hollow building blocks.

Medicine Hat was proud of its new company and jealously guarded its reputation as the biggest and best in the face of competition from Calgary and Lethbridge, both of which were going into brick and tile around the same time. An editor's note in the *News* shortly after Overpack's company started production warned of "bad rumours being spread by envious Lethbridge and Calgary real estate people about the quality and output of the Alberta Clay Products." The three cities had vied for years for the singular position as Southern Alberta's main manufacturing and distribution centre, gas and railroads being the primary deciding factors. With over ten gas wells producing and more just waiting to be sunk, Medicine Hat sniggered from the sidelines each time Lethbridge drilled and struck nothing.

Calgary was a major threat with respect to railroad location. "As soon as the CPR begins sending its through traffic to the coast by way of Medicine Hat and the new cut-off on the Crow's Nest Division, we won't hear much more of Calgary," the *News* chortled in 1912. "The impartial observer must admit there will be two main centres in Alberta—Edmonton and Medicine Hat, the gateway to the South."

Edmonton had had a brick works since 1893. It was started by J. B. Little, who had made the brick for the original CPR Banff Hotel before purchasing the site on the Edmonton river flats which was to become J. B. Little and Sons, Limited. Little had clay on his site, but no gas. Instead, he used horsepower to turn his soft-mud mould machine. The horses were hitched to the ends of timbers attached to the machine and were driven in circles hour after hour. The brick were dried in the open

The workers are building the crown of the round downdraft kiln. Foundations are built for the remainder of the kilns.

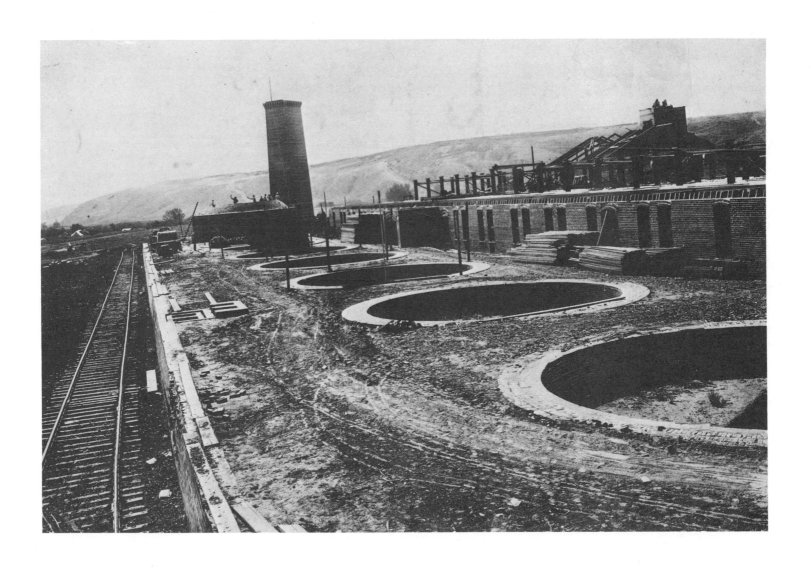

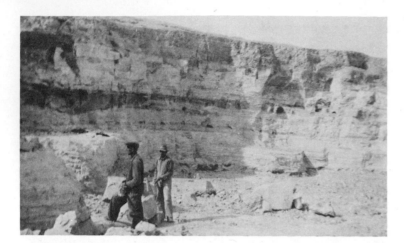

The quarry at East End, Saskatchewan.

on a large level sand area and then burned for ten days in scove kilns. Little replaced his horses eventually with a threshing engine rented from a farmer and then with his own steam engine before electric power was installed. Three generations of Littles ran the brickyard until their clay supply was exhausted around 1950. The firm then became Edmonton distributors for Medicine Hat's I-XL Industries.

In clay products, Calgary had by 1914 the Calgary Silicate Pressed Brick Company and the new Tregillus Clay Products Company. The *Calgary Souvenir Edition* of 1914 predicted a "phenomenal future" for the latter, which was praised by experts for its unique methods and valuable deposits.

Neither of these companies survived the decade. Moreover, the bad rumours about Alberta Clay Products proved unfounded. Samples of the Company's brick and hollow-ware were judged "superior" in tests conducted in New York. And, in 1912, Overpack landed the "largest individual order for building material ever in Western Canada"—500 carloads of fire-proofing for erection of the new CPR shops in Calgary.

The best news, however, came out later that same year. The Company had finally located a deposit of "perfect" sewer pipe clay. When moulded into six-inch and two-foot pipes, the clay vitrified well, glazed well, and the product was fit to carry any type of sewage. It took another year of experimenting and another clay discovery, in the Frenchman River Valley near East End, Saskatchewan, before the Company finally achieved a high

grade sewer pipe that could be manufactured economically and profitably.

Meanwhile, the City's Industrial Committee entered a carload of Alberta Clay Products wares in the 1912 International Clay Products Exhibition in Chicago. The Alberta exhibit attracted a lot of attention at the event, according to reports in the *News*, and "all brick, material and clay and labour journals photographed it."

The products attracting international attention were coming out of "the largest and most modern sewer pipe and pressed brick company in Canada." But, at the other end of the process, the raw material going into the plant was being blasted out of the hills and loaded into boxcars under the most primitive conditions. The Dunmore tract, 320 acres of clay, ninety feet thick, from which the Company made its brick, could only be tapped by blasting. For miles around, the high hills overlooking the coulee where Bill Hrehorchuk lived and worked boomed back the echoes of dynamite blasts six days a week.

"You know, this guy would come out from the union mine. He didn't know if I drill a hole from the top. I say it wouldn't work. I say, if you drill a hole in top how you gonna get the dirt out?" There was only one way. Bill blasted.

To clean the clay off once it was uncovered, Bill kept a team of horses pulling a scraper at the top of the hill. Another horse drew the loaded carts from the open pits to the ramp where the boxcars waited.

In 1975, Bill pointed to the abandoned pit on the hill rising a few yards from his front door:

"Fellow came in here and take a look at it. . . . looked at how big it is, how high. . . . says, 'Did you have a machine to do this?' I says, 'Sure is, you can't do it without machine.' I says, 'There it is.'" Here, Bill offered his two hands, palms up, for emphasis. "Ten fingers!"

"He says, 'I hardly believe it.'

"I says, 'Look here. I did that. If you hardly believe it I haven't got time to talk to you no more. You better skiddoo. Because you don't under-stand.'

"When a fellow says he hardly believe it, what you gonna talk to him next? I got no time to waste on that!"

Bill and his crew worked year round through Southeastern Alberta's

desert-hot summers and raw winters to keep the Company's kilns supplied. "Oh, yeah, 45 below we was there in the pit. You blast it one day. . . . you come in next morning and it's solid."

The men at the pits lived in Company housing down in the coulee and were paid piecework. Commenting on the $15 a carload they split for the clay they shovelled out with their hands, Bill said: "How much they paid down there you didn't expect to make a rich doctor. But, what you gonna do?"

Looking back over years of narrow escapes, Bill was less intrepid, perhaps just wiser, at 82 than he was at 19. "You take today a fellow offered me ten dollars an hour, I wouldn't take that job. That's blasting, I mean. I wouldn't touch it."

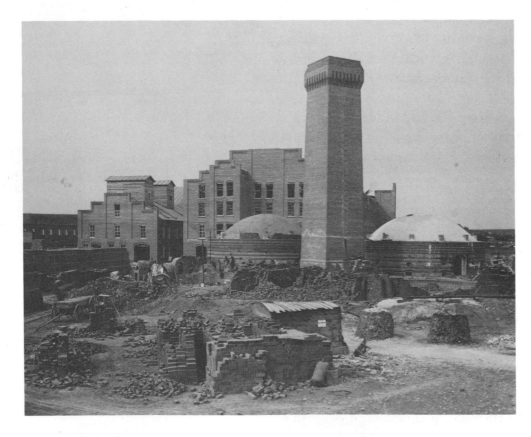

This shows two completed kilns and a complete stack.

Unlike Bill, who found a Company house waiting for him when he arrived, the men who built and staffed the Red Cliff Brick and Coal Company found nothing but two square miles of empty prairie bounded on the southeast by the high, red shale cliffs which overlook the Saskatchewan River. Those who worked in the mine, mostly European immigrants, lived in dugouts along the cut-banks facing the river. The Company provided a bunkhouse and dining hall for its laborers until their brick cottages were built. Many workers survived their first winter or two in Redcliff living in tents.

Stoner, the man from Minneapolis who came to be known as the Founder of Redcliff, set about building a town around his Company—not just a town, but a major industrial centre—one his real estate company advertised as the "Smokeless Pittsburgh of Western Canada." Stoner sank gas wells, furnished his townsite with water, and landed several more industries for the town while expanding his own. Stoner's Redcliff was going to be "the brick town of Alberta." "Three months ago a bald prairie; today, a beehive of activity," an ad for Redcliff boasted in June 1910.

An article in the *Lethbridge Herald* at that time described Stoner's Company as "probably the largest and most successful brick plant in Western Canada." The *Herald* went on to note "the uniform redness, perfect hardness and texture of the Company's product as evidenced in the buildings of the town." Meanwhile Stoner was building eight rectangular down-draft kilns for expansion into pressed brick and eight more for hollow-ware.

By 1913, Redcliff had nine new industries, including two more clay plants. One of them, Redcliff Pressed Brick Company, Ltd., managed by Herbert J. Sissons from Montreal, was to become parent company of I-XL Industries, which today has divisions in three provinces. In addition, seven more industries were committed to locate. The population swelled to nearly four thousand, but accommodations couldn't keep up. While carpenters worked day and night, tents still dotted the landscape. Many laborers rented cots for a dollar a night from a man named Dad Williams, who put up a tent bunkhouse opposite the Redcliff Hotel. Redcliff soon had a sanitation problem on its hands and a typhoid epidemic to fight.

Meanwhile, American capital, natural gas, and clay combined once again over in Medicine Hat in a totally new enterprise for Alberta. John A. McIntyre, representing the Western Porcelain Manufacturing Company of Spokane, signed an agreement with the City to start building a porcelain and pottery factory in Medicine Hat. The plant they raised in 1913 was to become over the next 40 years the source of some of Canada's most popular household crockery.

The Alberta Clay Products Company had considered stoneware when it first went into business, but, the local clays known at the time, while excellent for making varieties of brick, weren't suitable for pottery. In fact, McIntyre's company, which was named the Medicine Hat Pottery Company, at the start had to import its clays from Washington State at the prohibitive cost of $10 to $12 per ton. That may have been one factor in the Medicine Hat Pottery Company's demise less than a year after it started production. Not much is known about the product that came out of the two 30-foot beehive kilns the company built. The Medicine Hat Pottery Company was an exhibitor at the 27th Annual Exhibition of the Medicine Hat Agricultural Society in September 1913 but, by March 1914, the company was liquidating and 50 men were out of work.

They may also have been off to war. World War I took the edge off the industrial boom in the area with a labor and materials shortage. The clay products industry suffered when the Canadian Government in 1915 closed down all factories other than those engaged in war work to release men and materials. Purmal's which had changed hands a few times and was now the Gas City Brick Company, had to cease production until nearly 1920. As the local labor force was depleted, Chinese came in large numbers to replace the men who went to war. Chinese workmen helped keep the Alberta Clay Products Company going between 1914 and 1918, but the plant itself deteriorated for lack of materials to keep it in repair.

Redcliff's boom came and went in a matter of two years. The "Town of Opportunity" lost much of its population and its industry as plants shut down overnight and men either went to war or elsewhere to find work. The Pressed Brick Company called in a skeleton crew to operate its machinery only to fill the occasional order for a carload lot.

Even while the brick and tile business suffered and scores of industries vanished, two new potteries sprang up in Medicine Hat during the war years, both in 1916 and right next door to each other. The Medalta Stoneware Limited, a totally local group, had incorporated to purchase the building and equipment abandoned two years earlier by the Medicine Hat Pottery Company. Just over the edge of Medalta's three-acre site, The Gas City Pottery set up a more modest establishment in a single small building with one kiln.

The two were actually offshoots of the first pottery, which was locally owned by the time it closed its doors, and there could have been a connection between them. When it wound up in 1914, the Medicine Hat Pottery Company was in the hands of three local businessmen: John Bending, a farmer and manufacturer, John Read, rancher and keeper of the Royal Hotel in Medicine Hat, and Adison P. Day, owner of 6,600 acres of valuable clay lands at East End, Saskatchewan. Day had secured the clay lands near the end of 1913 and had arranged for a railroad connection between the tract and the City which would supply the pottery business with clay at $2.00 per ton, one-sixth the price the first pottery was paying for clay shipped from Washington. When he purchased the East End tract, Day announced that the quantity was almost inexhaustible and he predicted that the discovery could "revolutionize the clay working business in Medicine Hat."

He was right. It is not clear whether the Medicine Hat Pottery Company ever got to use the clay or why it was liquidated. But, East End clays supplied the area's prosperous stoneware business for decades to come.

John Bending was a principal shareholder and director of Medalta Stoneware when it went into production in May 1916 with a Mr. W. Clark, an Ohio man with lifelong experience in the pottery business, as superintendent. Clark had also been superintendent of the Medicine Hat Pottery Company. Eight months later, Clark incorporated with Read to set up the Gas City Pottery, Ltd. Clark managed the small new pottery which came to be known informally as Clark's Pottery.

The War over, the clay products industries finally had the men and materials to run their plants to maximum capacity and the market ready to absorb all they could produce. The Alberta Clay Products Company

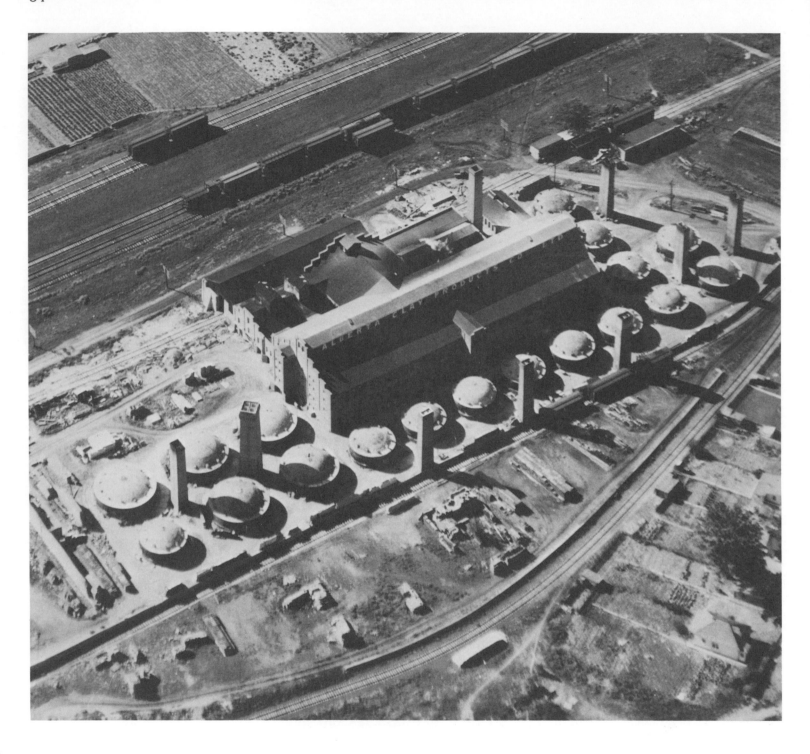

was under new management. Harry Clinton Yuill, a Nova Scotian who had come to Medicine Hat as a carpenter in 1884 purchased control of the Company in 1918 and pumped several thousands of dollars into putting the plant back into shape for the post-War building boom.

A sixth generation Canadian whose ancestors had emigrated from Scotland in 1760, Yuill left Great Village, Nova Scotia, at age 20 to go West. At Vancouver, he landed a contract to build houses for the Canadian Pacific Railway along its right-of-way. Working his way back east, Yuill stopped off in Medicine Hat, assessed the town's potential, and decided to make his future there. When he died 61 years later, Yuill's name was almost synonymous with Medicine Hat.

Starting as a building contractor, the young Nova Scotian built most of the early homes in the small Alberta prairie town. His keen sense of timing led him into real estate at the start of Medicine Hat's industrial boom and natural gas development. Before long Harry Yuill owned a thousand acres within half a mile of the city hall and the ten thousand he owned just outside the City were under cultivation. On his way to the clay products industry, Yuill had a hand in establishing a number of early Medicine Hat enterprises, including the Medicine Hat Flour Mills, the Alberta Linseed Oil Company, the Alberta Foundry, the Medicine Hat Brewery, and the Monarch Theatre Company.

Yuill was a director of the Alberta Clay Products Company almost from its start, but his involvement was strictly financial then. In 1918, however, when he acquired controlling interest, Yuill plunged into the operation end of the business as general manager. Over the next 26 years until his death at 81, he personally oversaw day-to-day every phase of production at his huge plant. "The Old Man" or "Grampa Yuill" (as Hatters and his employees called Yuill so as not to confuse him with his son J. Harlan) was a commanding figure both in the factory and out at the claypits. Moody, irascible and unpredictable, Yuill could alternately intimidate and charm those who crossed his path.

Bill Hrehorchuk was neither intimidated nor charmed by the Old Man. The millionaire and his pit foreman had a friendly respect for each other based on the intuitive intelligence and guts for hard work which they shared. "Nobody can tell him about work," Bill would say of Yuill. "He

Alberta Clay Products Co. Ltd.,—note that one stack contains 4 flues, the others all contain 2 flues. All the sewer tile (pipe) fired here was salt glazed.

was contractor before. Was 25 below, he was put shingles on houses. He used the brains, too, that guy.

"But, the only thing, if he come sour from the town, you just cut off." Bill could gauge the Old Man's moods and handled them with equanimity. "If you see his face, how he looks. . . . if you cut off on the talking, he leaves quick. He bring that sickness from town."

Yuill had the management sense to hire good people in the first place and then to trust their judgement. While keeping close to every phase of production in his plant and questioning procedures, he could delegate responsibility to people who knew more than he about their jobs and he refrained from interfering once he understood the reasons for their decisions. Behind the questions was always the desire for more profit, for Yuill was a businessman first and not always a scrupulous one. One day Bill was questioned and had to set the Old Man straight.

"Old Man Yuill come in and look down the shute. He says, 'That's all you putting in that car?' I says, 'Yah, that's all I putting in that car. She has a tonnage.'

" 'You think so?' he says.

" 'I think so,' I says, 'because I load it. A car, she 'sposed to have 45 to 50 tons.'

"He weigh some clay in his hat. He says to me, 'I wouldn't mind if you put more clay in the cars.'

"For Cripe's sake, what he talking? CPR won't take more in a car." Bill chuckled at the recollection. "Yeah, he wanted more clay for same price. He want more in his pocketbook."

Perhaps a bit knavish as a businessman, Yuill is remembered fondly by Hatters who found him generous with his pocketbook when they were in need. A true frontier millionaire, sporting the oldest hat and the biggest diamond ring in town, the Old Man always carried a lot of cash with him and gave loans freely on the spot without interest. Yuill knew just about everyone who passed him on the street, laborers and businessmen alike, by name, and they knew him as "the Banker of Medicine Hat."

In his later years, after his son J. Harlan "Hop" Yuill took over responsibility for the plant, the Old Man still kept a close watch over everything that went on at his factory. As Yuill made his daily rounds, someone

These updraft scove kilns were simply stacked with brick and fired. Notice the manner in which the bricks are piled to accommodate even-heat distribution throughout the kiln.

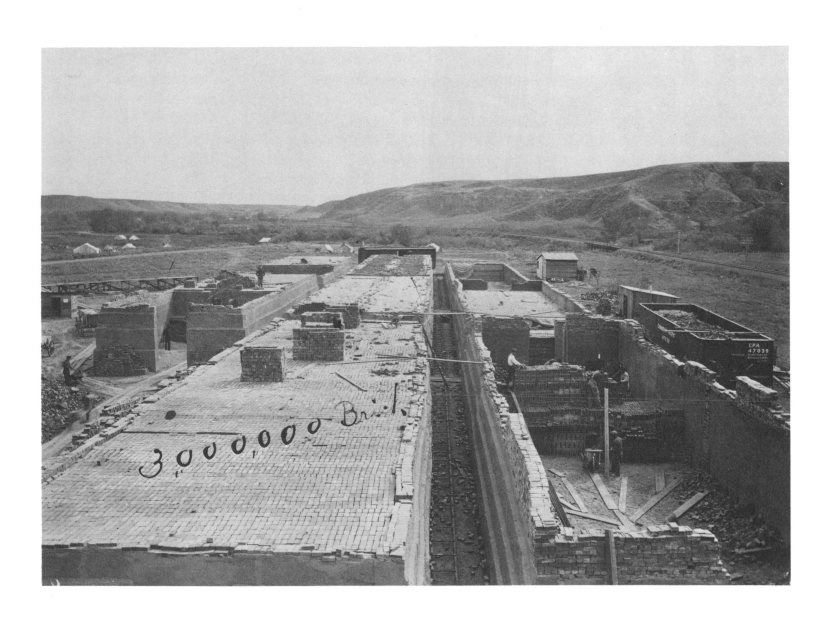

always had to keep an eye on him. A rogue to the last, unable to resist something for nothing, "Grampa Yuill" was spotted more than once during his final winters smuggling one of his own crocks out of his own plant under the great coonskin coat he always wore.

Yuill never relinquished final authority over the Alberta Clay Products Company and no one dared try to take it away. Hop, who came to the plant as timekeeper in 1920 when he left his engineering studies at the University of Alberta, had to defer to his father's sometimes arbitrary decisions even after he stepped into the manager's role. Observing the changes in management of the company over the years from his vantage point out at the claypits, Bill Hrehorchuk noted a difference between father and son.

"That guy, Hop, you know, he's different stock. Around the work it seems to me Old Man know better than Hop. This guy didn't talk much."

Employees who were there in the early Forties recall Hop's attempts to introduce modernizations into plant management. On one occasion, he commissioned a time and motion study. For three days, the time and motion experts went around the factory asking questions and carefully noting the movements of the workers. The elder Yuill followed close at their heels. On the third day, one of the consultants turned to find the Old Man peering over his shoulder.

"You work here?" the consultant asked.

"No."

"Then what are you hanging around here for?"

"Because I own the damned place!"

The study was never completed.

Back in 1918, when Yuill was just starting his new career as a clay products plant manager, a trio of businessmen, also new to the industry, acquired controlling interest in the Medalta Stoneware, practically across the road from Alberta Clay Products. Charles Pratt, W. A. Creer, and Ulysses Sherman Grant found the Medalta plant in bad repair when they came into the business. Unlike Yuill, who already had a fortune behind him to invest, they went into debt for their stock at the start. The Medalta Stoneware, Ltd., began manufacturing with no gas agreement with the city, no goods on hand, no clay nor clay deposits or leases, and they had

to borrow money for running expenses. What's more, they were entering a market already dominated by huge, long-established American potteries. At the time, Western Canadians were buying their stoneware from the Redwing Company in Minnesota and Easterners imported their crockery from the old Ohio potteries.

Pratt, Grant, and Creer set out with these handicaps to prove that Canadian-made stoneware was "equal in quality to any made in America" and could even compete successfully with the established lines. Off to a modest start with only 12 employees when it opened in 1916, Medalta Stoneware quickly expanded under its new management. By the end of the decade, they had built a third 30-foot round kiln and rooms for storage, crating, and mould-making. They had also acquired several pieces of new equipment, including two pot machines, a pug mill, a clay well and agitator, and a clay elevator.

The Company's wares caught on and gradually Medalta stoneware replaced the American product on the shelves of Western Canadian merchants. The plant itself became something of an industrial showcase in Medicine Hat. By 1920, Medalta had entertained visits by the Prince of Wales, the ex-Governor General of Canada the Duke of Devonshire, and the Governor General at the time, Lord Byng of Vimy.

Crock, 1 to 6 Gals.

Chapter 3

Bill Wyatt joins Medalta.
Women at work.
Production/delivery problems.
The product range widens.
At the mercy of the CPR.
Price wars and wages.
Extracting clay.
Exhibitions and lectures.
Depression!

In early winter of 1924, Jesse William Wyatt left Oshawa, Ontario, with his wife and five kids in a 1921 Ford touring car. They were heading west to a new home in Medicine Hat, where Wyatt had a job waiting for him as superintendent of the Medalta Potteries. An Englishman who came from a long line of practical potters, Wyatt had been approached by Pratt's brother Albert, manager of the Company's Toronto outlet, to take over supervision of the plant. The Company had just reorganized under a new name, Medalta Potteries, Limited.

In 1924, nearly three-quarters of the stoneware used in Canada was burned in Medalta's kilns. The Company was supplying all of the market west of Winnipeg and was doing a brisk trade as far east as Prince Edward Island. Medalta Stoneware's Indian head stamp had marked the first car-load of manufactured goods other than cereals to be shipped east of the lakehead. That was in 1921. Now, Pratt, Grant, and Creer were ready to expand into new lines.

White ware is what they had in mind. They observed that "nearly all the pottery used in Canada is imported, including five or six million pieces of white ware a year." For this new venture, they would require a new plant and far more capital than was available locally. They had interested a group in England called the Canadian British Corporation in putting up the money. A letter from the British group hinted at the great potential the deal held for Medicine Hat's ceramic industry: "...it would mean that a group of the leading potters in Great Britain would co-operate with

The original Medalta buildings housing clay preparation, dry pans, and elevator.

you." But, the backers were being cautious and sent one of their experts over to test the local clays, "before actual start of the construction of the new plant."

The City of Medicine Hat was soundly behind Medalta now. In a letter of reference to the Saskatchewan Board of Control, which had enquired into the standing of the Company, Medicine Hat's mayor had replied: "The writer considers Medalta Stoneware Limited one of our best industries, as it has been in continual operation since it started." To encourage the British proposition, the City entered into gas agreements with Medalta which would guarantee fuel at a minimum cost for over thirty years. This gave the Company, at last, the tremendous advantage enjoyed by other industries in the City. As Pratt pointed out about this advantage in a letter declining an invitation to purchase coal: "...in fact, we would not burn coal if we got it for nothing, as the cost of stoking the coal and removing the ashes would be greater than we are at present paying for gas."

None of Medalta's three owners was a potter. Pratt had come over from Scotland in 1886 at the age of eleven to settle in Heathcote, Ontario. There he eventually became his father's partner in a prosperous general store business. "Delicate and fighting for his life," according to a 1928 *MacLean's* article, Pratt had been drawn toward the purer air of the West, where, the story was told, one village had had to shoot a horse thief in order to start a graveyard. Settling in Medicine Hat, Pratt started the Gas City Lumber Company in 1908. This he operated for five years until the real estate boom of 1913. When corner lots in Medicine Hat were selling for $70,000 cash, Pratt gambled all his money on real estate and lost. Within two years he had recovered his solvency through a successful farm venture. With his winnings, according to *MacLean's*, he "negotiated the purchase of a factory, a defunct, dirty, prosaic, uninteresting factory which had operated six months and now rested in the hands of the receiver."

Grant, described by a former employee as a "Kentucky colonel-type man" with "many irons in the fire," was effectively an absentee owner who rarely made it to annual meetings. Pratt and Creer spent their days in the plant close to the clay, the kilns, and the machinery, Creer working as

kiln burner, and Pratt spelling him. But, there was no one on the premises who had ever seen another pottery plant. They needed a man who knew the pottery process inside out if their bigger ventures were to succeed.

Bill Wyatt was such a man. Following the example of his father and his grandfather, Wyatt started working at the age of 12 in his native Bristol as an apprentice potter. By the time he emigrated as a young man to Canada in 1912, when coal strikes shut down the potteries in England, he was skilled in designing, mould-making, kiln construction, jiggering, glaze formulation, and burning.

Wyatt had spent his first seven years in Canada making flower pots at the Davisville Pottery in Ontario before striking out on his own in the ceramic business. In a short period of time he made three or four brief, not too successful attempts at running his own business, one of them turning out kewpie dolls and another making ceramic dolls' heads which Mrs. Wyatt painted at home. Bill Wyatt is said to have made the first Eaton's "Beauty Doll." About ready to concede his shortcomings as a businessman, Wyatt ran into the eastern Pratt brother in 1924 and decided to take his chances out West.

The Ford touring car never made it to Medicine Hat. Unprepared for the chimerical late autumn climate of the Prairies, the Wyatt family found themselves snowbound in Minot, North Dakota. They sold the car and travelled the rest of the way by train. Pratt met them at the station and delivered them to the warm, furnished house the Company had prepared for them. But, the youngest Wyatt, a year-old baby, had come down with pneumonia on the difficult trip. The baby was buried in Medicine Hat shortly after the family moved into their new home.

When Bill Wyatt arrived, Pratt, Grant, and Creer had given up on the white ware idea. The local white-burning clays hadn't tested to the satisfaction of the British pottery group and Medalta lost its backing for the new plant. The owners abandoned ideas of using the clays that had failed the test and decided to concentrate on building up their stoneware lines. Working with the stoneware clays from the Company's holdings in nearby East End, Saskatchewan, Wyatt designed within the next five years over 500 new items, including pigeon nests, umbrella stands, dog bowls, cream pitchers, vases, wall plaques, and bowls in a variety of shapes and sizes.

Medalta plant from the rear showing storage yard. The 4th outdoor kiln has not yet been built. (*ca.* 1925)

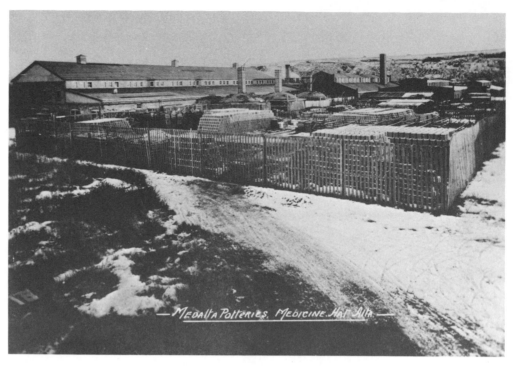

Some changes were already underway at Medalta when Wyatt stepped in. Across the road to the north, Clark's Gas City Pottery, which had been re-named the Canada Pottery, had just closed its doors. The smaller pottery, equipped with one round kiln and two jigger machines, had never been in competition with Medalta. Clark, his son Jack, and about ten men and women made small items—bowls, jugs, teapots, and kitchen dishes—out of yellow clay, while Medalta concentrated on stoneware crocks, churns, and one-gallon jugs. Then, in the early 1920's Medalta started making teapots. Clark lost most of his business; he laid off his staff and went back to Ohio, leaving his son and one female employee, Matilda Schlenker, to carry on.

Miss Schlenker, who had gone to work putting handles and spouts on teapots at Clark's when she finished high school, recalls that she was earning $6.00 for a 48-hour week at the pottery.

"It was a good job for a woman then. There was hospital work, but you had to work Sundays and evenings. The only other alternatives open to women were housework and jobs in stores."

When Medalta went into teapots, they called her over and offered her $12.00 a week.

"But, I didn't want to leave Jack. We still had work to do. So, I told them to hire the other girls who had been laid off from Clark's."

Medalta hired its first female employees then and Miss Schlenker joined them shortly after when Jack Clark finally closed down his father's pottery. To repay Tillie Schlenker's loyalty, Clark took her over to Grant's office and personally saw to it that she was hired.

The move from the small pottery to the big factory wasn't an easy adjustment for a young girl.

"At first I didn't think it was possible for a woman to work at a place like that," Miss Schlenker recalled.

In a plant geared toward men, the newcomers posed some problems. In the whole pottery there was only one toilet, the "Throne Room." It was perched at the top of a flight of steps in front of the chimney in the clay preparation area. As one former Medalta employee recalls, "It had two sides on it—no front, not even a curtain. I don't think from the day it was put in it was ever cleaned. To use it you had to sit there like the King of England with everybody looking."

The women were segregated at first at one end of the jigger room. Later, they worked in a shed which was added at the back of the building.

Before Wyatt, Medalta had made red flower pots, but these had been discontinued in favor of "fancy flower pots," moulded in stoneware and glazed in a cream color. These were popular, but customers wanted ordinary red clay flower pots and Pratt was often prodded about this market by his retailers. "We had quite a talk this morning over flower pots," wrote an Eaton's buyer. "By gosh, Mr. Pratt, you should go after this business and make a real Flower Pot."

So, with the red-burning clay dug out of its own backyard, Medalta began producing "real flower pots" once again in 1928 on a second-hand press imported from Montana. The press was secured for the Company apparently with immense effort by a W. H. Gunniss, Esq., of the Great Falls Brick and Tile Company. Gunniss arranged for the press to pass through customs duty-free at a big saving for Medalta, which, in spite of its higher than ever volume of business, was still scraping the till to make

its mortgage payments each month to the Royal Bank. Pratt, who meticulously attended to the Company's public relations by sending Christmas boxes of cigars every year to his best customers, made sure that Gunniss' favor was rewarded. Mrs. Gunniss' kitchen was outfitted with a wide sampling of Medalta ware.

Medalta relied heavily on such opportunities to procure second hand the large pieces of equipment it required. It took a whole year of inquiries and careful attention to ads in trade journals before the Company located a used magnetic separator at a price it could afford. This item had to be imported from Trenton, New Jersey. Wyatt's intimate knowledge of the Eastern potteries came in handy in the search for other equipment. When the Ontario Potteries Company liquidated in 1926, Medalta made an offer, on Wyatt's recommendation, to purchase several pieces of the insolvent company's machinery. The Trustees of the estate accepted Medalta's offer of $1,200 in exchange for:

 1 Double automatic cup making machine
 1 Combined plate-making and batting machine
 2 Batting machines
 2 Jiggers
 1 Slip pump and press filter
 1 Double blunger
 1 Vertical pug mill
 1 Horizontal pug mill
 1 Upright jolly and 1 time clock

More equipment and structures to make room for new lines were scavenged that year. The factory grew to half again its size when the management purchased a structural steel building at the edge of town from the Manitoba Bridge and Iron Works and reconstructed it on the Medalta site. From a nearby brickyard Wyatt bought a narrow gauge track system with 200 cars, which he installed for moving clay through the clay preparation area and into the jigger room.

By 1926, Medalta had overreached the capacity of its three round downdraft kilns and was running into trouble meeting orders. Saskatchewan's drinking habits had something to do with the problem. Wine was selling in that province at the rate of 1,500 gallons a day. The Saskatchewan

Liquor Control Board had become one of Medalta's biggest customers demanding 6,000 one-gallon jugs a week. Medalta couldn't keep up the pace. Finally, after putting up with several shipping delays and numerous customer complaints concerning leaky jugs, the Saskatchewan vendors bore down:

"We again have to complain regarding the quality of your jugs as there is never a day passes but we receive reports from our stores in connection with the loss sustained by them in our various bulk wines due to leaky jars. . . . Incidentally we might mention that due to the fact that you were unable to keep us supplied with jars, it was necessary for us to purchase several car-loads from the United States, and in checking over the various complaints, we invariably find that the container is a Medalta jar."

At about the same time, late fall of 1926, Pratt had to explain to another big customer, H. Morgan & Son of Montreal: "We have been hoping against hope to ship your car order of November the 4th with 2,000 one gallon jugs. The situation is that we are unable to supply any one gallon jugs till after the first of January. The reason for this is that we have undertaken to supply the Government Liquor Vendors of Alberta, Saskatchewan, and Manitoba, and they are insisting on more delivery of one gallon jugs than we anticipated. . . . We very much regret this condition, and the only remedy is MORE KILN ROOM. We cannot, however, build a kiln during the winter, and must wait till next spring before we can increase our kiln capacity."

Two weeks later, Pratt complained to his brother in Toronto: "We are in a very peculiar position regarding jugs at the present time. The facts are that our factory is losing money trying to make too many jugs. A one-gallon jug takes up as much room in the kilns as 2½ gallons of anything else. We are making 1900 one gallon jugs per day, and it is simply using up our kiln space so that we can not get sufficient other goods through the kilns. This means that the production of our factory is decreased, which is quite a serious thing for us. We were pushed so much for jugs recently that we were forced to turn down the Manitoba Liquor Commission. This is unfortunate after having catered for their business.

"We are today making a start on the excavation for a new kiln, which will cost $5,500, but we do not see anything else to do."

Three more round downdraft kilns, 34 feet in diameter, went up under Wyatt's supervision over the next three years. Still standing today, they were modelled after the first two kilns built in 1913. Bert Wyatt, who left school after Grade eight to work with his father at Medalta, had a hand in building the kilns. According to him, kiln construction at the time was simply a matter of copying. "They're standard kilns which had been built the same way for years. You look at one downdraft and you can build another. We called in some bricklayers and asked them to build the new ones just like the ones that were already there."

Eager to keep up with the demands of the stoneware market and to expand its business, Medalta often created new lines in response to requests from its distributors and its travellers. This was an expensive and risky practice. If the market for a new item was not sufficiently large, the cost of pattern-making, mould-making, and converting equipment was prohibitive. Superintendent Wyatt was Medalta's only designer and the time he put into creating new mould patterns took away from his other duties.

"We are under the impression, however, that your customer does not realize the work and cost necessary to make a special article," Pratt replied to a query from Messrs. Renwick & Cunliffe, the Company's Vancouver outlet. "We do not manufacture a four gallon jug and it would cost at least $25.00 to make a model and moulds, in fact we are not prepared to make it even at that price as our Superintendent is the only man we have at present who can make models and he cannot spare his time in making a special model for an article which has no volume of business."

Since a single mould could be used only once in a day, a large number were needed for each item—1,500 for one-gallon jugs alone. Each mould cost about 60 cents to make in 1927 and lasted less than one year before wearing out. Yet, retailers like the F. W. Woolworth Company, Ltd., purchased their one-gallon crocks from Medalta at $8.00 per 100 and three-pound butter crocks at $6.50 per 100. Items that could not be sold in volume were losing propositions.

In the mid-Twenties there seemed to be enough demand to justify going into the insulator business. Wyatt built an insulator machine and for a while the Company made brown-glazed insulators for the CPR. But, by

Medalta Potteries Limited

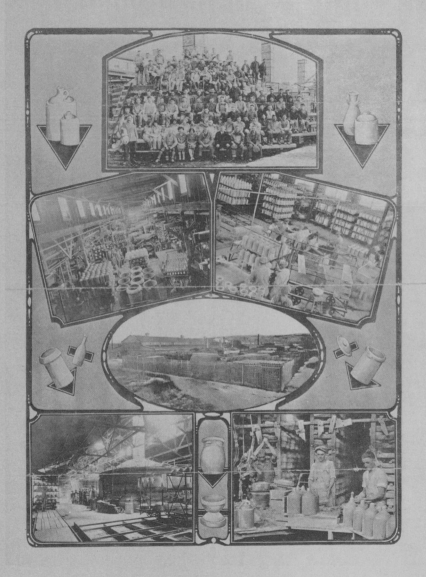

1928, Medalta had to turn down insulator orders, because the clay it was using wasn't suitable and often cracked during drying. A year later, glass replaced clay as a cheaper and more efficient manufacturing material and Medalta lost its insulator market entirely. Company correspondence from the Thirties indicates that the insulator venture had run into even more problems:

"Some years ago we made insulators, and would ask you to check up and see if you have any moulds for this article in stock. If we remember rightly, there was always a certain amount of grief in connection with the Thread on the insulator," Medalta's sales manager in Calgary wrote to the plant superintendent in 1938.

"Concerning the inquiry about insulators, our plant is absolutely not fit for the manufacture of same, we did previously manufacture insulators but this was done in such a crude and imperfect way that it resulted in a total loss," came the reply. "Insulators require special handling in manufacture, drying, and particularly entirely a different way of burning than our stone ware burn. We had a home made machine, which was scrapped years ago."

To satisfy one special request, Wyatt went so far as to import a craftsman from Scotland. Medalta did a big trade in stone ginger beer bottles, which they moulded in two sizes to meet the requirements of their two major soft drink customers, Charles Gurd & Company, Ltd., of Montreal and Douglas & King of Winnipeg. Cast in two-piece moulds, the bottles came out with side splices. Some customers complained that these seams captured deposits which were difficult to remove. One way to beat this problem was to supply hand-thrown bottles, but finding the craftsman who could perform this feat was still another problem. Throwing bottles was a skill that required about five years training and experience. Wyatt finally located a Scotsman who could throw 600 bottles a day, one-half the capacity of a jiggerman.

Because of his special talent, the Scotsman enjoyed a privilege denied all other employees. Wyatt, who neither smoked nor drank, rigidly enforced a no-smoking rule in the plant for safety reasons. Any employee caught smoking was dismissed on the spot. But, the ginger beer bottle thrower was inseparable from his corncob pipe. When Wyatt first noticed

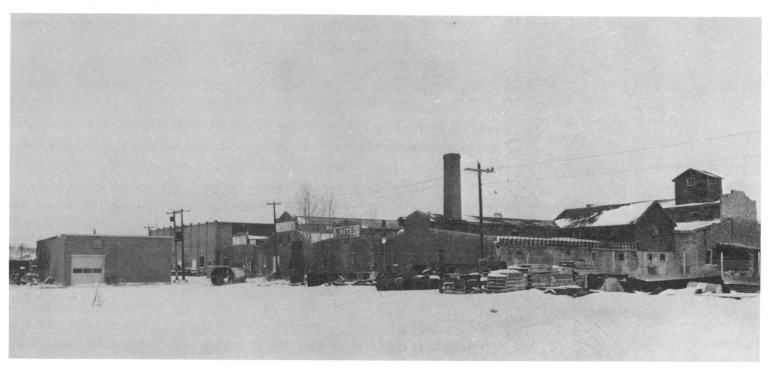

Medalta Potteries Ltd.,—shows pottery, clay elevator, and milling area (far right).

this, he issued an ultimatum: "Either your pipe goes, or you go."

"Well, then I guess I'll go home." The Scotsman picked up his tools and headed for the door.

"I remember the man always with that pipe hanging from his mouth," Bert Wyatt recalls. "It wasn't lit most of the time and it was usually upside down, spilling ashes all over the place."

In 1927, Wyatt imported another craftsman from the British Isles, Tom Hulme, an Englishman. Before that time, Medalta manufactured strictly functional undecorated stoneware items. But, a large part of the stoneware business was seasonal, depending on the requirements of home food preserving and agriculture. Wyatt decided to go into production of decorated artware—vases, wall plaques, and the like. Hulme, an experienced decorator, was brought over to set up Medalta's art department, which he supervised for 27 years. The decorated ware caught on quickly and the art department kept 30 employees busy hand spraying designs which Hulme created and cut from tin foil. Decals from the United States and Great Britain were used also to embellish the new lines.

Once Medalta had its art department established, a whole new business enterprise opened up for the Company: premiums and co-operative advertising. Manufacturers of household items such as laundry soaps, flour, and shortening started the practice in the Twenties of offering premiums to their customers. With a coupon from a sack of flour, a house-wife could send away for a useful kitchen item at half the price she would have to pay at a retail store. In the late Twenties and in the Thirties these premiums often bore the Medalta stamp.

At about the same time, Ogilvie's Flour Mills, Ltd., offered its retail customers a co-operative advertising deal, whereby Ogilvie's and the retail customer split the cost of giveaways, such as bowls and pitchers. These were stamped with the name of the retail outlet along with Ogilvie's advertising message. Two examples: "Enderby Growers Association, Enderby, B.C. Ask for Royal Household Flour"; "Ford's Grocery, Mara, B.C. Ask for Royal Household Flour." One-pint Medalta pitchers bearing similar messages and decorated with two of Hulme's most popular designs, a Dutch windmill and two owls perched in a tree, are now treasured by collectors of Canadiana.

The Medalta name didn't necessarily accompany all the ware that left the plant. The Company offered its retail customers the option of having their own names stamped on the Medalta products they carried. In fact, the Company manufactured a special line of yellow bowls for the F. W. Woolworth Co., Ltd., which it made to sell at especially cheap prices by taking a short cut in the burning process. The "Woolworth Bowls," as they were called in the plant, could be identified by their raw rims and raw collars. Normally, every glazed bowl that went into Medalta's kilns was held in place on its own stilt to protect the glaze at the base. The Wool-worth bowls were indented a half inch from the top so that they could go into the kilns in stacks of six, the collar of each resting on the rim of the one below it and only the bottom one stilted. This device enhanced the kiln capacity enough that Woolworth bowls could sell at a third the price of Medalta's regular yellow bowls.

For another unstamped Medalta Item, the Indians got credit—and a little "education" in the bargain. A letter from Pratt to H. B. Lumsden of CPR's Development Branch describes the arrangement:

"Mr. W. E. Watson came to Medicine Hat to see us, and arranged for sample shipments to be made to try out the Indian Pottery. We have shipped 719 pieces of assorted shapes of Indian Pottery to three Indian Schools at Balcarres, Punnichy, and Lebret, all of Saskatchewan.

"This is more in the nature of an experiment, the idea being to have the Indians decorate this Pottery, and which will then be sold by the Hudson Bay Co. as Indian Decorated Pottery.

"Possibly the decorations will be a little crude at first, as it will take a little time to teach the Indians how it should be decorated, but the Hudson Bay are out to give it a fair trial."

By 1927, Medalta was shipping a boxcar of crockery a day to hundreds of retail customers across Canada and was beginning to capture large institutional contracts. The Fort Qu'Appelle Sanatorium in Saskatchewan warmed its patients with Medalta hot water bottles or "pigs"; the Union Milk Company, Ltd., of Calgary sold its butter in Medalta crocks; hotels in several provinces graced their lobbies with Medalta cuspidors and jardinieres.

The Canadian Pacific Railroad, at the beginning of 1927, placed an open order with Medalta to supply its dining cars with one-gallon crocks and butter crocks for the whole year. Medalta, as in the case of the jugs for the liquor control boards, found it was overreaching its grasp and came dangerously close to losing a major contract with the Great Northern Railway in 1927 for tardiness in filling a crucial order. Great Northern had ordered coffee pots, cuspidors, bean pots, pitchers, and jardinieres from Medalta to outfit the Canadian Rockies Hotel for its opening July 24. As the date drew near, the Hotel had received only a trickle of the items it needed, many of them in the wrong colors. Correspondence between customer and supplier became increasingly threatening at one end and apologetic at the other. The Hotel finally opened with a bare minimum of the crockery it required. Medalta had just scraped by.

When it came to business, Albert Pratt, manager of the Medicine Hat Pottery Company of Toronto, didn't let family ties interfere. The Eastern Pratt brother, who earned his livelihood wholesaling Medalta wares in Ontario, was Medalta's harshest, least inhibited critic.

"We have in our Warehouse here, twenty dozen Brown Mixing Bowls, and they are about the worst looking junk that we have received from you for some time," A. Pratt complained in a letter to the Medicine Hat factory. "In the first place they are about twice the weight that they should be, and particles of clay have been dropped into each Bowl. The top of the Bowls have been sawn off in the *usual* manner. Probably this sort of bowl is in demand in Western Canada, but for the Ontario trade we require a finished Bowl."

Pratt had been complaining about the *usual* manner of finishing the Brown Bowls for some time. In an earlier letter his sarcasm was already beginning to show through.

"You have made a big improvement in your Brown Bowls, but the top edge is still very rough and ragged. Is it not possible for you to use some kind of sponge to finish instead of hacking off the clay with some straight instrument. You have made considerable improvement in rounding off the top edges of the crocks, and we think that you could apply the same thing to the bowls. At least our competitors can."

Pratt was apprehensive that his brother's factory wouldn't be able to keep pace in actual output with its perhaps premature success in securing large orders in the East. In September 1926, he wrote:

"The bowl which you have shipped us is not the bowl which Eatons ordered, and whoever packed the order knew that at the time. When we originally took the order from Eatons last Spring the first shipment for Moncton was to arrive on July 1st. This is September 1st and we have been forced to ship them the bowls which you sent. We have no doubt that there will be serious objection, as Eatons have listed the bowls (the original New Style) in their Fall Catalogue. This sort of thing puts us on very dangerous ground as it is the first occasion on which we have interested them sufficiently to list our goods in the Catalogue."

Then there were the crock covers.

"We are having no end of trouble with your covers fitting the Crocks. We think that you could watch these more closely, and thus save us a lot of gasoline in chasing about the City exchanging Covers. We are getting rather fed up with this sort of thing, as we have had constant trouble with it for the past year," Albert wrote.

"I was in Belleville yesterday, and the Belleville Pottery Co. (a Medalta retailer) have got about 200 two gallon Crocks and the same number of covers. There is not one of the Covers which will fit the Crocks. . . . For Heavens Sake tell those fellows to wake up."

While the factory was struggling to squeeze orders in hand into its three overcrowded kilns, Albert Pratt, and the Company's other agents, were pressing the Company not only to improve the goods they were already selling but also to go after a larger share of the market.

"We are not selling any of your Teapots for reasons already explained, that is, finish," Pratt complained. "For your information, we have handled about 500 dozen of English Teapots during the past four months, and there is no reason why a good portion of this should not be switched your way if you can produce the goods."

"We quite realize that our Tea Pots are not what they should be," brother Charles replied. "The main difficulty is that we are using a light colored body. The English Tea Pot is made from a red burning clay. The glaze that they use is simply a transparent glaze. Should there be a slight defect it is hardly noticed; whereas, every defect in ours will show up.

"We also realize that our covers are not right. We have been using the casting method of making covers. I have gone after Mr. Wyatt very strongly regarding better fitting covers, and he admits that the method that we use will have to be changed, and adopt the method which is used in the Old Country in making covers."

While the finished product had to stand on its own merits in competition with the American and British goods, there was often good reason, or several good reasons, behind flaws in Medalta's wares and its unpredictable delivery system which agents hundreds of miles away from the factory could not understand. Since the agents were relied upon not only to move the goods but also to act as go-betweens in keeping Medalta informed of demands for new lines, Charles Pratt often had to educate his distributors about the limiting factors in the business.

Not only did the potential market for a new item have to justify the cost of pattern and mouldmaking, but each new line presented a problem in matching a suitable clay body to glaze that would be both compatible and attractive, a process that required a lot of experimenting. Only a

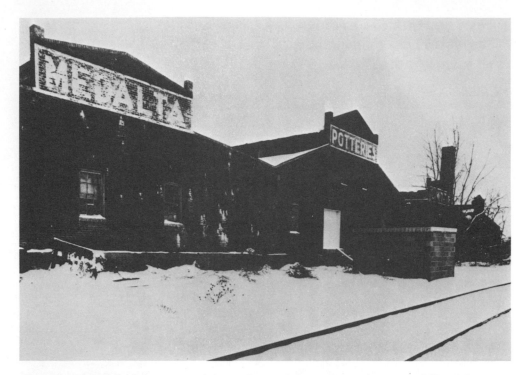

decade old, Medalta was competing against American and British companies with decades and in some cases even a century or more of experience behind them.

Technical problems within the plant were compounded by external problems over which the Company had no control. When the dust settled after Medicine Hat's whirlwind industrial boom in the early 1900's, the "future manufacturing and distributing centre in the West" found itself at the mercy of a single railroad company.

"Owing to Medicine Hat having no railway competition, but entirely a Canadian Pacific Railway point of shipment, we unfortunately have to submit to whatever ruling the C.P.R. make," Pratt explained to Renaud & Cie, Inc., a Quebec City customer which had received severely damaged goods. "So far they have accepted all the freight which we give them but do not assume responsibility for safe transportation. This we consider is entirely unfair."

Complaining about a CPR ruling which arbitrarily allowed the Dominion Glass Company of Redcliff to receive silica sand at a rate far below that

which the Railway charged Medalta for flint, Pratt told his flint dealer:

"We have pointed out to the local agent of the CPR that the sand used by the Glass Works on the 29½¢ rate from Minneapolis, is pure Silica, and that the Flint which we use is also pure Silica. We have, however, no influence with the C.P.R. as we have no competing railway at this point."

The flint dealer was the Pennsylvania Pulverizing Company. Apart from the clays it used, none of the manufacturing materials Medalta required were available locally and very few could be purchased in Canada. A delay in shipment of any of the following items on Medalta's shopping list could cause severe problems in meeting the production schedule and satisfying Canadian customers:

Stilts—East Liverpool, Ohio
Sponges—England
Pickle jar wires—Chicago
Wire cloth—Newark, Ohio
Cones—Ohio
Ground feldspar (40 tons per year)—Toronto
Red seal Zinc white—Chicago
Iron oxide, nickel oxide, manganese, caucasian and green oxide of
 chromium—New York
Barium, black under glaze—New York
Black cobalt oxide—Delora, Ontario
Gilders whiting—Winnipeg
Plaster of Paris—New Brunswick

Even when the pickle jars and churns came out of the kilns on schedule, customers sometimes chafed for months while the pickle jar fasteners, rubber rings or churn dashers made their way belatedly from far points to Medicine Hat. These were seasonal items. If Medalta couldn't supply them on time, Red Wing of Minnesota could and so could the Toronto Pottery.

In spite of a nation-wide "Made in Canada" campaign in which manu-facturers urged Canadian consumers to "Buy Canadian," Medalta was having serious problems in the mid-Twenties meeting American competi-tion. Pratt protested bitterly to the Government about the "dumping" practices of American outfits such as Red Wing, which because of their

larger production could easily undersell Medalta in its own territory. Canadian pottery products were not protected and Pratt wanted a "dump duty" imposed on the American imports.

Short of Government intervention, Medalta took drastic measures wherever necessary to keep its Canadian market. "Meet any American Price, will protect you as per your letter," Pratt wired Messrs. Renwick & Cunliffe of Vancouver upon hearing that the Vancouver agents had lost two major retail outlets to Red Wing's underpricing. "Redwing evidently intends to dump goods into Canada if it is possible for them to get away with it. They of course can manufacture cheaper than we can owing to larger production. Although we have taken the matter up with the government they seem to be very slow to act. We are also doubtful whether they are sympathetic.

"In the meantime we will stand behind any quotations you find necessary to make, and allow you five per cent on the business taken in this way."

The underpricing problem was further complicated when Medalta switched its crock sizing from American wine measure to Imperial measure in 1926. Although the Imperial measure crocks had a 25 per cent greater capacity, what first struck the eye of the Canadian customer was the fact that Red Wing's five-gallon crocks were selling for 5 per cent less than Medalta's fives. Medalta stamped its products "Imperial," but the American company did not specify its system of measurement. To many customers the only apparent difference was the price and they chose the cheaper item.

"Do not be mislead by any other make of crocks as Medalta are the only Imperial Measure Crocks on the market," the Company urged its customers in its ads. Medalta was frustrated at the slowness of the public to catch on to the difference and at the quickness of its competitors and some retail merchants to take advantage of the consumers' ignorance. A Mr. Manders, a Saskatchewan agent with whom Medalta did some business, particularly aroused Pratt's ire by promising Imperial Measure crocks from Red Wing at five per cent less than the Medalta price.

"This confirms our opinion of Mr. Manders that he is a liar and the truth is not in him," Pratt complained to a Winnipeg distributor, referring to

Manders' attempt at deception. "It definitely places Mr. Manders in the Ananais (*sic*) class."

In June 1926 Pratt and his Winnipeg representative J. B. Carter collaborated on a bitter complaint to the Canadian Manufacturing Association:

"We happen to know that a Jewish Merchant in Altona, Man., has bought a carload of Red Wing Crocks. He intends to sell them at the same price as we sell our Medalta Imperial Measure crocks, hoping that his customers will not think whether the R.W. stuff is Imperial measure or American. We got reliable information that this is his intentions, though we don't know the exact merchants' name excepting that he is a Jew, a large merchant, and located in Altona."

Carter suggested sending a letter to the electors list in the area "to give this Jew something to think about."

Whenever one of Pratt's enemies turned out to be a Jew, the man's very Jewishness seemed to be a factor in the trespass and Pratt was certain to include race in his list of grievances.

When Medalta penetrated the Eastern market in 1921, the Canadian customer benefited from the competition. Up to that time, Robinson Clay Products of Toronto, a branch of the Robinson Clay Products Company of Ohio, the largest stoneware plant in the world, controlled the stoneware trade in the East. To meet Medalta's competition, Robinson reduced its prices by 25 per cent. But the American-owned company enjoyed a 15 per cent customs advantage, which still gave it an edge over Medalta even at the reduced prices.

The biggest economic problem for Medalta, and for the Canadian pottery industry in general, was labor. Canadians could buy crockery imported from England, France, Austria, Germany, Czechoslovakia, and Japan at cheaper prices than Medalta could afford to meet, because the foreign competition tapped a cheap labor force. Even though Medalta employees were at the low end of the pay scale in the Canadian work force, wages were still a prohibitive factor for the Company. In 1926, Medalta employed 82 hands working nine hours per day. Their wages ranged from $1.25 to $5.00 per day, the average employee earning $3.25 and only one earning the top wage. The Company lobbied vigorously

against the Factories Act of 1926, which established the eight-hour day for Alberta. Pratt even managed to convince his employees that the eight-hour day would be detrimental to their interests and he submitted a petition signed by his workers protesting the Act.

"Owing to the nature of our business it is impossible to operate with more than one shift," he wrote to the Secretary of the Canadian Manufacturers Association in Alberta. "Should an 8 hour day come into effect it will reduce our out-put by that proportion, which would mean that our costs would be materially increased.... We have had an uphill fight for years in order to establish a Pottery business in Alberta. In 1923 our net profit was about 1% of our invested Capital; in 1924 we suffered a loss of over $800.00. In 1925 we made a profit of 5%.

"In discussing the matter with some of our workmen who realise our position, they acknowledge that we are unable to pay them their present rate of wages for an 8 hour day. They also state that they cannot work for less wages than they are now receiving, consequently they are very opposed to an 8 hour day and are well satisfied with present conditions."

How far Pratt and the Manufacturers' Association went to try to defeat the Act can only be surmised. A copy of a later letter from Pratt to the Secretary reads:

"Your letter of November the 25th received suggesting that I write a letter for publication in Farm Journals in Alberta to be signed by a farmer.

"I am enclosing a letter of this nature. Newspaper letters are something entirely out of my line. If the enclosed letter does not fit the situation you may tear it up or re-arrange it in any way you wish."

Forty-seven Medalta employees put their names to a petition in 1926 supporting Pratt's campaign against the Factories Act. Medalta was a major employer in Medicine Hat and, despite low wages and working conditions which would never sneak past health and safety standards established for the industry a decade or two later, workers were grateful to have jobs at the pottery. Whole families—fathers and sons, brothers and cousins—looked to Medalta for their livelihood. Five Hehrs, two Hoggs, and three Sailers, along with a number of other old Medicine Hat family names which are still represented in the City today, appeared on the petition.

Wyatt was strictly against unions, having seen the crippling effects of their power on his home country. "In those days everybody wanted work and everybody worked," Wyatt's daughter, Gertrude Thacker, recalls. "Dad never believed in unions and he never let a union into Medalta."

Tillie Schlenker, who worked for Medalta on and off for over twenty years, counts herself fortunate to have had her job at the pottery. "They were nice people to work for. They didn't force us. They just wanted our best," she says.

"Lots of people were looking for jobs. I remember one time they were going to go on strike to ask for higher wages. I remember just walking by and hearing this man who got up on one of the benches. He said, 'If you men walk out of this job there's ten of them out there waiting for each of your jobs. You can do what you like.' None of them walked out.

"I can't say I was sorry I worked there. But, afterwards I realized it affected my health. But, I don't know where I would have worked otherwise.

"It was very dusty there. When the kilns were burning the place was just smoking inside and there were all the fumes from the clay. There was a time . . . I didn't even tell my mother about it; she would have said to quit . . . but, at that time you didn't have a choice of jobs. You had to hang on to it. I thought, 'Well, I can't quit. I've got to keep working.' . . . There were periods . . . I think it might have been the dust . . . it was just choking me.

"Now, I think I wouldn't do it again. But, all in all I was glad to have the job and liked it. I didn't want to go anywhere else. So, I never said anything to anyone about it."

Don Lefever, who worked in Medalta's glazing area in 1926 as a teenager, recalled the unwholesome working conditions in the factory: "The ware was glazed in a vinegar barrel with its top half cut off. We worked with our bare hands for five hours at a time dipping the ware into the glaze." This was at a time when glazes had a high lead content.

Lefever worked his way up from $1.25 to $1.75 a day during the year he was with Medalta, but recalls that married men doing the same type of work were earning $3.00 a day. Wyatt, a staunch family man himself, made it a policy to pay more to married men, and despite his own Puritanical convictions against drink, he could never bring himself to fire a

married employee whose drinking habits interfered with his work. Mrs. Thacker recalls the great lengths to which her father went to avoid letting go a night watchman at Medalta who drank on the job.

"He used to go back to the pottery at night after dinner just to check up on the man . . . to see that he was alright and doing his job. We used to go back with him when we were kids to play in the clay. Dad was against drink, but he had compassion for family and wouldn't fire the man because he had a family. But, he had no compassion for weakness. Even today, at 89, he says, 'I never did anything wrong in my life.'"

The jiggermen, who were the most skilled workers in the factory, worked piece-work. Lined up along one wall opposite the glazing area, they worked side-by-side at their jigger machines, often challenging each other to competitions. Each jiggerman was responsible for hiring and paying his own crew of mould runners, unskilled workers who kept pace with the jiggers, supplying them with empty moulds and carrying away the full ones. Bert Wyatt turned out 1,200 ginger beer bottles a day at his machine. Four other jiggers were kept busy spinning out one-gallon wine jugs for the liquor trade, at the rate of 1,000 per day each. The Company maintained a quality control of sorts by making it a policy to pay its jiggers only for the good ware they turned out.

Meanwhile, in East End, Saskatchewan, Medalta's counterparts to Bill Hrehorchuk—A. J. Vogt, and Earl Noble—contracted to supply the factory with the 15 to 16 tons of clay a day it required to operate. For $1.05 per ton in 1926, Vogt tested, drilled, blasted, and hauled clay from a number of pits on the clay lands held by Medalta. Weekly correspondence between the East End men and Pratt over the seasons gives some idea of the multiplicity of problems and hard work involved in extracting the clay.

One March, Noble wrote:

"In regard to clay on south side of pit that was stripped last fall on Jacobs Hill there is a three and half foot vein of clay in that strip. As near as I can tell this strip will be 40 ft. East and West and 30 ft. North and South. I can not tell for shure as I haven't taken the dirt off yet as I wanted to get as much clay hauled in as I could before the ice goes out of the river as the water nearly always floods the flat west of the new bridge and we might not be able to haul for some time. The weather has been warm here

for the last three weeks. Last week the roads wer so bad I had to stop for a few days till they dried up, but the frost is all out now and the roads are starting to dry up. . . . I will haul one more car of clay and then take the dirt off of this south strip as it is hard to keep from getting some dirt in the clay and give you trouble up there."

From Vogt, in June:

"Would you please send us some dynamite as we can not do anything without. It is to high a vein and twisted. It is awful. Would be pleased if you would send some as soon as possible. 40 per ct. is good enough. The 60 per ct. has more pep but 40 per ct. will be lots good. Sorry I have to ask you for dynamite in summer but it is impossible to get along without. The wet weather has delayed us with sand. Done our best. Had to haul it down."

While the open pits in some hills were being exhausted, Vogt and Noble tested continually for suitable clays in others by drilling. This was a difficult process because hard rock was often struck before clay.

"We are sending a small hand auger which has been made for us by an experienced man who claims that this way is by far the cheapest method of drilling," Pratt wrote Vogt. "When you get down to the clay we want you to carefully measure the length of the pipe so as to determine the exact thickness of seam of each kind of clay, and would also suggest that you put in a paper bag samples of every six inches when you are down at the clay, marking what it is. By this method we will know exactly what to expect."

Vogt's reply, ten days later:

"Just a line to let you know that I tried the auger and I started four holes, one 13 ft. struck a rock, next 9 ft. deep and struck another rock, one 7 ft. other 5 ft., struck rock every time so I dont know what to do. Auger would work good if it was not for the rock. Took a stick of dynamite up. Thought could blow rock to side but was no success. Blew right out top. Thats all, so I am sure puzzled. The other rig I got did not work either. Would be glad if you would advise me what to do. Will try any thing if you will let me know what is best to do . . ."

From Ravenscrag, Saskatchewan, H. L. Siemens shipped clays to Medalta also. Apart from problems extracting the clay, he complained of difficulty getting cooperation from the CPR.

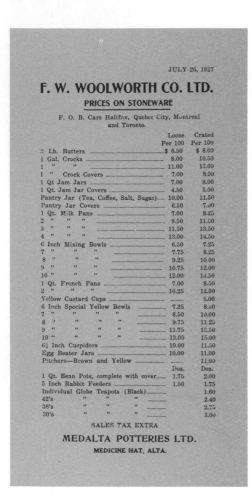

JULY 26, 1927

F. W. WOOLWORTH CO. LTD.
PRICES ON STONEWARE

F. O. B. Cars Halifax, Quebec City, Montreal
and Toronto.

	Loose Per 100	Crated Per 100
3 Lb. Butters	$ 6.50	$ 8.00
½ Gal. Crocks	8.00	10.50
1 " "	11.00	13.00
1 " Crock Covers	7.00	8.00
1 Qt Jam Jars	7.00	8.00
1 Qt. Jam Jar Covers	4.50	5.00
Pantry Jar (Tea, Coffee, Salt, Sugar)	10.00	11.50
Pantry Jar Covers	6.50	7.00
1 Qt. Milk Pans	7.00	8.25
2 " " "	9.50	11.50
3 " " "	11.50	13.50
4 " " "	13.00	14.50
6 Inch Mixing Bowls	6.50	7.25
7 " " "	7.75	8.25
8 " " "	9.25	10.00
9 " " "	10.75	12.00
10 " " "	12.00	13.50
1 Qt. French Pans	7.00	8.50
2 " " "	10.25	12.00
Yellow Custard Cups		5.00
6 Inch Special Yellow Bowls	7.25	8.00
7 " " " "	8.50	10.00
8 " " " "	9.75	11.25
9 " " " "	11.75	13.50
10 " " " "	13.00	15.00
6½ Inch Cuspidors	10.00	11.50
Egg Beater Jars	10.00	11.00
Pitchers—Brown and Yellow		11.00
	Doz.	Doz.
1 Qt. Bean Pots, complete with cover	1.75	2.00
5 Inch Rabbit Feeders	1.50	1.75
Individual Globe Teapots (Black)		1.60
42's " " "		2.40
36's " " "		2.75
30's " " "		3.00

SALES TAX EXTRA

MEDALTA POTTERIES LTD.
MEDICINE HAT, ALTA.

"Would you put in a complaint with the C.P.R. ABOUT THE LOADING PLATFORM AS THEY HAVE MOVED IT TO FARE FROME THE TRACK. WE GOT CARRY THE CLAY IN THE CAR INSTEAD OF DRIVEING ALONGSIDE THE CAR LIKE WE USED TO DO. IT MAKES LOADING ALMOST IMPOSSIBLE..."

Medalta was using three main types of clay from its Saskatchewan holdings. Noble hauled "chocolate clay," a dark, plastic clay which burned a lighter color than stoneware clay, out of Chocolate Drop Hill at East End. A pit near Willows, Saskatchewan, yielded a white burning plastic clay known as Saskatchewan Ball Clay. Noble discovered some of this type of clay also at East End. The stoneware clays were taken from East End and Ravenscrag.

Medalta had far more clay than it could use and did some business supplying clay to other companies. Carloads of the chocolate clay went to the Redcliff Brick and Coal Company. The art department of the Vancouver City School system ordered its clays from Medalta. A number of requests for samples of the ball clays came Medalta's way from potteries in the United States which had been shipping their ball clay from Great Britain. They were referred to Medalta by W. G. Worcester, Professor of Ceramic Engineering at the University of Saskatchewan.

Medalta was known by the late Twenties all over North America. *MacLean's* described the factory in 1928 as "the scene of one of Canada's unique industries, where, as they were in the Memphite period in Egypt 5,000 years ago, men are busy making pottery." The article went on:

"Charles Pratt will explain that the 'goods' made here, are guaranteed for 3,000 years; if they wear out before that time, even at the end of the twenty-ninth hundred year, you may bring back the bowl, tea-pot, pitcher, vinegar-jar, hot-water 'pig,' ginger-beer bottle, or what not, and get a new one, or money cheerfully refunded." Pratt himself was nicknamed in the article, "Canada's Wedgewood."

Along with its reputation as a leader in the pottery industry came public relations responsibilities that went beyond sending Christmas cigars to favorite customers. Medalta ware was exhibited all over Canada as a major product of Albertan and of Canadian industrial enterprise. Professor Worcester kept a Medalta exhibit in the display room in the Univer-

sity's Department of Engineering. "We installed the pieces which you shipped and feel that they are not only a credit to you but to Saskatchewan clays," he wrote to Pratt in 1926.

That same year, Worcester served as go-between in enlisting displays of Canadian clay products for the opening of the new Hudson's Bay Company in Winnipeg. He contacted Pratt to submit a sampling of Medalta wares, noting "your line of products is very wide and would occupy possibly a considerable space to properly display the same." The Women's Institutes of Alberta more than once requested crates of Medalta products for their displays at the Canadian National Exhibitions in Toronto. The Development Branch of the Canadian Pacific Railway Company's Department of Colonization and Development kept samples of Medalta pottery in its show window in Winnipeg. Pratt became sought after for his political opinions on issues relevant to industry and was asked to fill agendas of a variety of organizations as guest speaker. The Edmonton Women's Institute in 1927 wanted to hear about "The Romance of the Pottery Clays."

On such occasions Pratt could wax eloquently about clay:

"The story of civilization can best be told by following the trail of clay as it is visible in the utilities of the race. Gold and silver are called precious metals; that is because of their scarcity, because they are hard to obtain from nature. Yet, as between these and the meek and lowly clay there can be no comparison. Clay is by far the most precious, if its uses are considered. We could more readily dispense with all the gold and silver in the world than we could with clay. Man cannot get on without clay. Nature has fitted this world as man's abode. She has placed at his command the materials necessary for progress. In nothing has she been so lavish as in the making of the clays, and in nothing has she directed man to a more universal adoption of the materials."

Pratt's approach to clays was more practical than romantic. Although he corresponded with the Professor of Ceramic Engineering at Saskatoon, his self-reliant Prairie business sense made for a distrust of technology in favor of a traditional practical, trial-and-error method of running his plant.

A hint of Pratt's prejudice against the technological approach appeared

in a reply to a letter from his brother in Toronto:

"Your letter of October the 8th arrived when I was away on a shooting trip, hence the reason for the delay in answering your letter.

"You state that you expect to meet the Professor of Ceramics of the Toronto University, and that you would suggest to ship one or two hundred pounds of washed clay, and also suggest that he might be able to supply us with considerable glazes.

"Our experience in the past with so-called Professors of Ceramics have been very unsatisfactory. We have had considerable correspondence with so-called Professors, and also glaze recipes, but somehow they did not pan out."

Medalta was doing quite well for itself at the time. Its business was stoneware and the Company was prospering on the methods it had refined over the thirteen years it had been concentrating on stoneware. But a major shakeup in 1929 brought about the need for a total re-evaluation of where Medalta was going and how it was going to get there.

The Depression, of course, towed industries under indiscriminately. At the same time, however, Medalta was singled out for another blow. The glass industry captured the container market. Dominion Glass of Redcliff installed a machine which, according to Bert Wyatt, turned out jugs at half the price of stoneware. Soft drink manufacturers and liquor control boards dropped stoneware in favor of glass and Medalta lost the business that a few years earlier had demanded a doubling of its kiln space. In fact, as late as December 1928, Pratt wrote to Grant that the Company was "deluged" with orders for one-gallon jugs, so much so that he had managed to get rid of 13,000 seconds that they had accumulated over the past two years.

"....sold 9,000 to Saskatchewan at 7¢ and the balance were slipped into the Alberta cars and mixed up with firsts and we got 15¢ apiece. We thought that if we put them in as seconds and charged a second price for them they would kick so let them go through as firsts. So far we have not had any kicks and they are still shouting for more jugs."

It would seem that Medalta should have been forewarned about the impending "glass disaster," which apparently hit Great Britain even earlier. In February of 1928, Pratt received a job application from a William

Richardson of W. A. Gray and Sons, Ltd., in Great Britain. Richardson explained that he had 30 years experience in the pottery business and was now sole partner in the Midlothian Potteries, Musselburgh. At age 45 he was out of a job.

"The Stoneware trade in this country is now so bad that my firm is seriously considering about giving up business. We find glass jam jars for instance so much cheaper than we can produce stone jars that our largest line is fast disappearing."

Gordon Armstrong, whose father Walter Armstrong was Medalta's sales manager at the time, looks back on the crisis with this comment: "At any rate, I believe in the end it was the distance from market and the loss of the jug business which made the business go downhill. Medalta's biggest market was in Toronto and Ontario, with Montreal a medium to poor second. Stoneware is heavy (five pounds per gallon); therefore shipping costs were a factor."

An extraordinary meeting of shareholders was called at 2:00 p.m., March 15, 1929. Present were Pratt, Wyatt, and Walter Armstrong, who was also Medalta's bookkeeper. They agreed to sell all assets of Medalta Potteries, Ltd., to Reginald C. Carlisle and O. Clair Arnott of Calgary for $250,000.

At 2:30 p.m. the same day, a second extraordinary meeting was held. It was agreed that Medalta Potteries, Ltd., be "wound up" and that Charles Pratt be appointed liquidator for the purpose of winding up.

Individual
Chicago

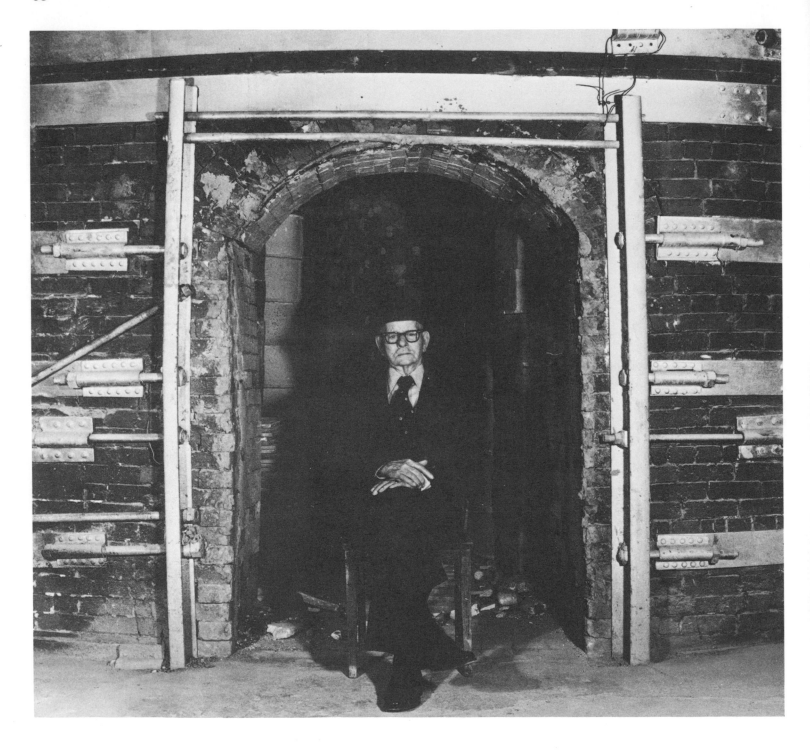

Chapter 4

Medalta changes hands.
The Wyatts set up on their own.
Depression hits ACP and Medalta.
Karl Baumler arrives.
Lamp bases and flower pots.
Hop Yuill and the Medicine Hat
Potteries.

"It wasn't hard to keep employees; you just owed them money. They weren't hard to get; they couldn't work anywhere else."

That's the way it was in the Depression years. And, according to Bert Wyatt, that's how the Alberta Potteries in Redcliff managed to survive through the rough years of the early Thirties. "We were getting paid every two weeks; sometimes I'd get fifty cents for two weeks work."

And, lots of stock. Nearly everyone in Redcliff owned a piece of Bill Wyatt's new pottery. Anybody who bought a share got a job, and when the money got down to where he couldn't pay wages, Wyatt started paying out stock.

When Medalta changed hands, Bill Wyatt and his two sons, Bert and William, had struck out on their own. A number of factors combined during Medalta's changeover to new management to prompt Wyatt's decision. Pratt had sought help at the Mayo Clinic in 1928 with a complaint for which "they were unable to do anything," and it is said that he was also experiencing other problems in his personal life. He took the opportunity to sell out and moved to Florida, quite suddenly, without his family. Creer retired to California to grow oranges. Wyatt and Armstrong had become shareholders, receiving stock bonuses in place of increases, as Pratt explained to Grant, "to have these men interested in the plant." After the shakeup, Armstrong ended up general manager in Pratt's place.

"Although he was a shareholder and had worked hard to make Medalta the big business it was by 1929, Dad didn't make a dime on the deal," Bert

Bill Wyatt (Jessie William) posed in doorway of the kiln he constructed at Redcliff in the early 30's.

Wyatt explained. "My father figured he got a raw deal. Armstrong was going to be general manager and Dad never got along with him."

"Dad's reasons for leaving the Medalta were not monetary. A German chap by the name of Karl Baumler was hired by management to supposedly relieve Dad's work load. He was less knowledgeable than Dad, but management listened to him instead of Dad. Dad couldn't take the frustration of not being able to do things as he knew they should be done. In his years at Medalta he had proven what could be done," William Wyatt added.

Gordon Armstrong offers this version:

"In the late Twenties my father became disenchanted with the results produced by Jesse Wyatt as superintendent and he started to look around for a qualified ceramic engineer. In the early 1930's he hired Karl Baumler from Bavaria in Germany."

Wyatt's daughter suggests a simpler reason for the break:

"Dad was too English to work with a German."

"We thought if Medalta were doing so good, we could, too." On that note of optimism, in the face of a depression that was levelling small businesses all around them, Jesse, Bert, and young Bill Wyatt formed their own company. Redcliff was pock-marked with abandoned factories left over from the collapse of its industrial boom 15 years earlier. With its citizens out of work, the Town of Redcliff was pleased to provide one of these buildings, an old shoe factory, for the premises of the new pottery which promised to put some of them to work.

The Wyatts managed to clean up the building and lay a foundation for a kiln before the enterprise fell through because of problems with the financial backing they had counted upon. Within six months Wyatt and sons had formed another company and were selling stock in the Alberta Potteries, Ltd. to local ranchers. At its peak the Town of Redcliff boasted Canada's first auto factory. The Wyatts purchased the old auto factory from the Town for one dollar and set to work converting it into a pottery.

They started with one round downdraft kiln modeled after the ones they had built at Medalta. "We took the steel bands from the kiln abandoned by Clark's pottery out back of Medalta," Bert recalls. "I drove our 1924 Chev over to Medalta to buy fireclay to make mortar for the kiln. I must have

The Alberta Clay Products' storage yard in the 1930's.

built about a third of that first kiln myself. The bricklayer we hired was a union man, but I managed to lay a few whenever he wasn't looking.

"We got about $2,000 worth of used equipment from Medalta—pumps, presses, jiggers and a blunger—which Dad sold to our company for $50,000 in shares. The glass plant was the only source of hydro power in town. So, we got a car motor and set it up in the plant and put in a line shaft about 70 feet long for the jiggers to run off. We'd go in in the morning, crank it up and we had hydro. Sometimes it would all be frozen."

Alberta Potteries, Ltd., employed about 15 hands at most, men who were eager for work, even when Wyatt couldn't make the payroll. Eventually Medalta's mould-maker, Ed Hollinghead, who had worked closely with Wyatt, joined the new undertaking along with a young handyman, Shorty Matuska, who had started working at Medalta under Wyatt. Martin Perry, who had been a traveller with Medalta, played a key role in managing the new business. Remembered as a "very persuasive man with a magnetic personality," Perry sold stock, went after orders, and kept the company's books.

The little Redcliff pottery started out making mixing bowls, cream jugs, custard cups, teapots, and decorated knick-knacks in competition with Medalta. The enterprise was too small to take business away from the big pottery in Medicine Hat, but the market for these items was large enough to accommodate the new pottery for a while. A second kiln, like the first, was added and by 1935 the Redcliff pottery was making small crocks. They made some attempts to divert some of Medalta's business in this line, but even though Medalta was suffering seriously from the Depression and a dwindling stoneware market, it was able to hang on to its customers in the face of underselling by the smaller pottery.

"We acknowledge receipt of yours of the 12th instant and note your remarks regarding a salesman selling crockery at approximately one-third less than our prices," Armstrong replied to Marshall Wells Company, Ltd., of Saskatoon in mid-1935. "Might say for your information that there is a small factory here at Redcliff, Alberta, who are putting out a few lines of crocks from one to eight gallon but no larger ones and a few bowls and they have been cutting the price to try and get a little business, but we do not think that this will last very long."

During the Depression years, if Alberta Potteries couldn't always pay its employees, there were times when customers couldn't pay for their purchases. "As you know our times in Redcliff were pretty tough during those Depression years," the younger Bill Wyatt recalls. "People were lucky to have food, so had no money for extras. The farmers who needed the crocks traded us eggs, butter and fowl for them."

In the beginning, the Wyatts purchased their clay from the Alberta Clay Products Company. "In the morning Dad would drive us over to Alberta Clay Products to load clay by hand into a transport truck. Later it was brought in from East End in carload lots," Bert remembers.

For the senior Wyatt, running the pottery was a 24-hour a day responsibility. Skilled labor was hard to come by and many of the help he employed required constant supervision.

"We had a man who couldn't speak English unloading clay from the boxcars when they came in from East End," Mrs. Thacker says. "The train would stop outside the plant and then the boxcars would be shoved into the clay room. This fellow would invariably jump into the car before

it got inside and he'd get knocked on the head. Dad would run out and find him lying on the ground unconscious.

"He'd get so mad sometimes. Just like at Medalta, we had a night watchman at Redcliff who tippled a little bit. Dad always had an idea which night the guy was going to get into the bottle. He'd go back at night to watch him and then he would forget the kilns."

The employees didn't always forego their paychecks cheerfully, least of all Bert Wyatt, who had a small family to keep. "The two Kitchen boys and I hadn't got paid in two months once. So, we decided to go on strike. We went to see if Dad would join us.

"He said, 'You can't do that! At least, I can't. I run the place.'

"But, we noticed Perry was getting paid. So, we sat in his office.

"'What are you doing?'

"'We're on strike.'

"'O.K. Go ahead.'

"We stayed home and two days later someone came to the house with my pay. All the others had to wait a few more weeks for theirs."

That concession didn't hold Bert Wyatt to his father's pottery for long. He picked up his family and went East, selling 15 shares of what he considered worthless stock to a local lawyer. Shortly later, sometime in 1935, Jesse Wyatt wrote his son: "Things are going well; why not come back?"

About that time, Alberta Potteries started experimenting with decorated dinnerware, using a small safe as a test kiln. They never went into production with that line. Serious problems were cropping up between Wyatt and Perry. According to Bert:

"When I came back, Dad and Perry were at each other's throats. As salesman and business manager, Perry was trying to have his say about the lines we produced. And, Dad didn't agree. I never got along with Perry. After I'd been back for five months, Perry came in one day and said, 'Bert, will you operate this plant, take your father's place?' I almost hit him. I quit on the spot and went back East for good."

"Everything came to a head all at once," Wyatt's daughter claims. "Dad was too trusting; he always believed everyone was as honest as he. He was a good ceramist, but a poor businessman. Perry kept saying that people weren't paying for their orders and Dad didn't have any money to

carry on."

Wyatt finally declared bankruptcy and pulled out to return to Ontario, where he took a job with Smith and Stone Potteries. His son Bill stayed one more year with the Redcliff plant before he, too, went East. Perry and Shorty Matuska carried on for a while longer. By 1938 the plant was out of business.

The Wyatt men carried on the family tradition in the Eastern Canadian ceramic industry, the younger Wyatts working in potteries in Ontario and their father doing ceramic research for industries on Government contracts during World War II. Bert and Bill later started small potteries separately in Ontario with their own sons. In 1975, both were heads of small successful artware enterprises of long standing. Upon his retirement, Jesse William Wyatt returned to settle in Medicine Hat.

Shorty Matuska, Martin Perry, and the Alberta Potteries were to surface again in the local industry long after the Depression had passed.

The Depression bit into the business of the Alberta Clay Products Company, which had picked up after the war to capitalize on a building boom in the early 20's. Yuill's factory had spun along through the 20's at maximum production, employing its hands at top wages. With the momentum of twenty successful years of experience and with the cushion of Yuill wealth behind it, Alberta Clay Products rolled well with the Depression and managed to retain most of its key men, even though there were months when the payroll exceeded the sales receipts. During those years, the dearth of sales didn't put a stop to production. The Company kept its kilns going, albeit at a reduced pace, and filled its storage yards with a large product inventory for when the market picked up again.

In fact you could say that the Alberta Clay Products kiln capacity actually increased during the Depression. There were 18 round kilns by then and they became a haven for the transients of the day. For, after the wares had burned for eight to ten days and cooled down for three, a kiln would be unloaded and left to sit empty, at a cozy temperature, overnight before it was reloaded. Alberta Clay Products of Medicine Hat became known all over Canada as a warm place to spend the night.

"We had as many as 40 hoboes a night in a kiln," Ken Kinvig, an assistant kiln-burner at the time, recalls. "The management went along with it

as long as they didn't interfere with the workers in the morning.

"We had one fellow, an old age pensioner with one leg and a pair of crutches. He rode the rails. Once a month he'd come through from the East on his way to Calgary to pick up his pension check. He'd hop off the train as it came by our yard and spend the night.

"There was a sheepherder who spent a whole winter here, just moving from one kiln to another. There were women, too. One man used to come through with his wife. The setup was convenient for the police, too. Whenever they were looking for someone, they'd come down here first. I remember a few hair-raising chases over the boxcars outside the plant."

After changing hands, Medalta limped into the Depression years with a reduced market and a greatly reduced payroll. With a plant built exclusively for stoneware, Medalta was faced with a major retooling job to keep up with a changing Canada. Responsibility for engineering that change fell to the new general manager, W. G. Armstrong, and the new superintendent he hired from Europe, Karl Baumler.

Of Baumler, Gordon Armstrong writes: "When he arrived he hardly knew a word of English but he worked hard at the language and did a first class job in learning it. Academically, Mr. Baumler was brilliant and from that date the pottery business began slowly and surely to change from just stoneware to lighter and more colorful lines of lamp bases, vases, etc."

The change came about far too slowly for the liking of the new president and board of directors. In 1935, Armstrong was caught in the middle between the eastern market, which still demanded its Medalta crocks on schedule with seasonal needs, and the directors in Calgary, who wanted to cut losses by closing down when sales weren't meeting production costs. Armstrong's dilemma was that he had to keep his crock customers supplied or lose the Company's good will, but, as he tried to explain to Medalta's secretary-treasurer R. G. Smith, "As you know, it takes a lot of these to make a little money."

"Business has been very quiet in Western Canada the last three months and practically the only real business we have is coming from the East. Even Manitoba and B.C. have fallen down greatly this year, and if the West keeps the way it is at the present time there will have to be some changes made in goods being manufactured. We will have to concentrate

on artware and lamps and give up a lot of the stoneware lines, but as you know, this plant was built for stoneware and it is hard to get changed around in a short time," he wrote to Smith in August 1935.

Armstrong was keeping neither the directors nor the Toronto Pratt happy and both were bearing down on him with surly letters. Medalta was in trouble with the Royal Bank which held the mortgage. Smith wanted the plant's inventory reduced, just as the Fall stoneware season started.

"You have from thirty to forty still working, whereas the plant should have been closed down except for actual orders on hand. No doubt you will have an answer for this, but you can see that something is about to happen that is not making our relationship with the Bank any too pleasant, and of course, it comes back to us here for 'The reasons why,'" Smith wrote on September 11.

"It is the intention of the Directors in Calgary to meet in my office at least once or twice a week in the future and to give more serious consideration to the Potteries."

Armstrong replied: "At this season of the year it is practically all crocks which we are shipping . . . All the crocks on hand are sold and we are only manufacturing those sizes to complete the orders here. When these orders are finished we will immediately close up again. . . . It is very difficult to explain all this to you, but you being a man who has been in business knows that it is impossible for us to ship a car to Quebec City short crocks and other items of that kind—the goods that really go to make up the weight in the car and it is impossible for us to hold them any great length of time as this is just our season and to get ahead any we have to be shipping right now."

To underscore his point, Armstrong quoted a passage from a letter he had just received from Pratt in Toronto:

"The fall stoneware business always comes in a rush. The season is short, and unless the goods are on the spot at the proper time they remain unsold or the other fellow gets the business. To give you an instance of this, we had to buy 1,000 ½ gallon jugs from the Robinson Clay Products and are going to have that many over in our stock when your car comes in owing to delayed shipment.

"In our opinion, at this time of the year you should have packers on the

job twenty-four hours a day, Sundays and holidays included. Get the goods out and you will get more business."

"This is the reason that we are manufacturing these few lines of crocks so as not to let our business depreciate," Armstrong explained to Smith. "It is the intention of the writer to cut off the over-draft at the bank just as soon as possible and every effort will be made along that line but at the same time we want to consider the business."

The Calgary group apparently lost confidence in Armstrong. In 1936 they decided to run the pottery themselves from Calgary. For the next few years, Medalta's head office was located at 620 - Third Street West, Calgary, under the direction of Mr. E. A. Stone, the bookkeeper hired a few years earlier by Armstrong.

In 1935 there were only two manufacturers of lamp bases in Canada, Smith Potteries of Oshawa, and Medalta. Smith could be discounted, because his was a small operation with high overhead. Medalta, which was just entering the market dominated up to then by American lamp base manufacturers, was in great danger of being discounted. Medalta enjoyed the advantage of a dumping duty imposed by the Department of National Revenue on the American product, but was slow to develop its new line to the satisfaction of the major Canadian lamp manufacturers in Toronto. In addition to problems of designing an appealing line of shapes and sizes and of matching clay bodies to glazes to compete with the American colors, the stoneware plant in Medicine Hat simply didn't have the space to accommodate its new business. The Toronto lamp manufacturers were more interested in selling lamps than in "buying Canadian."

"Mr. Carnegie of the Department of National Revenue was in our office on Tuesday last," Albert Pratt wrote from Toronto in February 1935. "Apparently the Department has received a request from the Lamp manufacturers to withdraw the "Dumping Duty" on Lamp Bases. The attitude of the Lamp manufacturers is that we are not producing in Canada, Lamp Bases which are competitive in style, price and colour to other countries. For instance, you are not manufacturing any white bases and Smith of Oshawa is manufacturing very few."

This could mean failure for Medalta's new venture before it could even get off the ground. Medalta was quoting fifty-five cents on a lamp base

similar in size and quality to one the Americans were selling for only a quarter. What's more, Medalta was having to turn away business because of its limited plant capacity.

"You have done yourselves considerable damage by writing to Brooks (a Toronto lamp manufacturer) and telling him that you could not manufacture certain Lamp Bases, samples which he submitted, due to the fact that you had a limited space for moulds, etc. etc. Carnegie saw that letter, in fact, he may have taken it back to Ottawa with him. To offset that letter I told Carnegie that you were in the act of building a new plant which would produce practically all the Lamp Bases that are required in Canada," Pratt admonished.

"Carnegie asked me to have you write a letter to the department telling them what your production on Lamp Bases was last year and advising them of this new Plant which you are now building. You will have to be very careful in writing that letter as it is going to have a tremendous influence on the steps which they propose to take. The present "Dumping Duty" is 33 1/3% and if that is removed you can figure out where the business is going to go. . . . Brooks has pointed out that there is a tremendous quantity of White Lamps being sold now and also ridicules the various colours you are producing such as Orange, Blue and some of your Browns."

Medalta at the time was employing 26 people to work on lamp bases alone and was completing a new building to expand its lamp base production. Armstrong wired Ottawa that Medalta was "in a position to supply any lamp base for Canada in both price and quality." As to Brooks' ridicule, Armstrong was defensive, suggesting that Brooks was a chronic complainer and that the Vancouver manufacturers didn't seem to have any complaints about Medalta's bases.

Pratt persisted. "I wired you yesterday to the effect that if you can possibly get away that it would pay to come through to the East as quickly as possible with regard to Lamp Bases. We have not made any headway on these new Bases, and while we ourselves thought that they were quite attractive, we have had very adverse criticism. . . . In some instances they tell us it is practically hopeless to fit a shade to them. . . . We must say that we have been greatly disappointed in the response which we have

ACP storage yard *ca.* 1930.

received with these new bases and we are concerned from your angle in case you are on the wrong track."

Medalta concentrated on capturing its share of the lamp base market that year and landed large orders from the Canadian Sales Association and the National Picture Frame Company. But, in trying to please the lamp trade, the factory displeased its staple customers, much to Pratt's consternation.

"Apparently we have gone out of the stoneware business as we are not getting delivery of any," Pratt commented acidly in a November 1935 Memo to Medicine Hat. "Please note that we are going to have our regular shipments of stoneware and other lines regardless of whether Lamp Bases come in the car or not. These cars are not made up for the entire convenience of the Lamp Base manufacturers for lamps on which we make little or nothing. . . . We are more interested in our staple lines which will show us some profit than we are in Lamp Bases. Is there any reason why you did not ship us half gallon Jugs in this car?"

And, three days later: "As you have not been filling orders for half gallon Jugs, we are turning our orders over to Robinson Clay Company who seem to have quite a supply. In connection with half gallon Jugs, for some time you have been shipping Jugs which do not hold imperial measure. We have mentioned this to you on previous occasions but you have made no comment on it. Can we be assured that your half gallon Jugs, from now on, will hold a full half gallon?"

Despite Medalta's efforts, the dumping duty came off on lamp bases January 1, 1936. Meanwhile, the factory had been converted and production streamlined to the point where Medalta was in a position to cope with American competition. For the next few years, the company maintained a healthy business in lamp bases, even though their quality never became a distinguishing feature.

Medalta continued producing its stoneware staples including teapots, bowls, rabbit feeders, decorated pitchers, and artware. Medalta vases, which came in 37 different shapes and sizes, were becoming a popular item, but too often they turned leaky six or eight months out of the factory, giving rise to more criticism from Pratt. Noting the popularity of Medalta's display at the 1934 Canadian National Exhibition, Pratt urged

Armstrong to tighten up on the functional quality of his wares to maintain consumer enthusiasm:

"Re: Canadian National Exhibition 1935: We are enthusiastic to go ahead again this year if you can supply us with the proper goods and carry some of the burden. My opinion is that there was not another stand at the Exhibition where as much interest was shown. People would scarcely believe that the goods were 'Made in Canada.' We have not been pushing artware as we would have done had there been no complaints afterwards. You can scarcely blame us for lying low until you have something which is perfect."

Flower pots remained a Medalta staple and from the absence of any reference to them in company correspondence it seems these items offered no cause for complaint. By the end of 1935, Karl Baumler had convinced the Calgary directors to invest $2,152 in replacing the old second hand machine from Great Falls with a new pot machine from Germany. "With a Paul Schuster machine we could in 125 days turn out the same amount as we do with the machine that we have here in 250 days," he argued. In addition, Baumler reasoned that the Company could save $4,575 a year on the production of two-gallon crocks alone, if they were made on the pot machine instead of by moulds. The production speed offered by the new machine made it possible for the factory to reduce its stock at hand, freeing factory space for the manufacture of its artware and lamp base lines.

The old machine was forgotten until two years later, when a strange thing happened to it. The plant superintendent in Medicine Hat received December 9, 1937, a cryptic order from A. D. Cumming, President and Managing Director, in Calgary: "It runs in my mind that some of the dies for the old Flower Pot Machine have not yet been converted to the new machine. It might be well to investigate this. Get them converted and dried out and then wreck the old Flower Pot Machine. Smash it up and throw it out in the back. Be sure it is of no use to anyone else."

Who else could that be?

Medalta had survived by 1937 a depression, a collapse of a large portion of its bread-and-butter market, and a drastic upheaval in management. Survival was all the company could claim at the time. The plant still had

not developed a single new line which could carry it with the success it had enjoyed in the Twenties with stoneware containers. Juggling a diversity of lines, none of them great sellers, was not a profitable way of doing business. Medalta was treading water and it wouldn't have taken much to push it under. The Company was riding on the name it had established in the Twenties. Canadians knew "Medalta" and were convinced they should "Buy Canadian." Also, up till then, Medalta had no significant Canadian competition.

Besides its local travellers, who sold Medalta products to retail shops and hardware stores in the prairie provinces, the pottery in Medicine Hat had aggressive, long established agent companies in the Eastern and Western trade centres with personal interest in Medalta. Ben Cunliffe, of the Columbia Orient Export & Import Company, Ltd., Vancouver, and Albert Pratt of the Medicine Hat Potteries Company, Toronto, pushed Medalta products and kept the company abreast of market demands, suggesting new lines and sending samples of foreign products to be copied. Pratt and Cunliffe, wholesalers in business for themselves, rode hard on Medalta but only turned to the competition for merchandise out of exasperation with Medalta's inability to provide the goods required when they were required.

As for labor, the Depression worked for Medalta. The Company had no local competition and could shut down in slack times during the lean years with confidence that it could call back its experienced employees whenever they were needed. There was no where else for them to go.

Until 1937, that is.

At about the same time the old flower pot machine met its violent demise so that nobody else could use it, somebody else, who became known as "the opposition," found a use for Medalta's experienced pottery personnel.

"Arrived here noon Monday and Karl left the same evening. He claims he is going to look into the Yuill proposition and then decide on what he is going to do. Cannot find that Armstrong is yet definitely employed by the new plant but general impression points that way," someone from the plant office in Medicine Hat wrote to A. D. Cumming December 1, 1937.

"I got it from one very reliable man in the plant that practically every

employee has an application in for employment in the Yuill factory, so believe that we can reconcile ourselves to the fact that as soon as they are ready any employees they want from us will go to them."

Dec. 1: "Re Fred Hehr, Sr., jiggerman. He makes all our big ware and should be retained if at all possible. He is working on the Yuill building, so he must have been promised a job in the future with the pottery."

Dec. 3: "We notice in the letter from the plant today, that Fred Hehr Senior, is working in the Yuill plant. Does this mean that he has left our employe?"

Dec. 4: "F. Hehr, Sr. has quit our employ. We may have difficulty keeping O. Hehr and Thompson."

Dec. 6: "O. Hehr wants 50¢ per hour or he will quit. He's the best jiggerman left."

Dec. 7: "With reference to your letter of December 6th, regarding O. Hehr wanting 50¢ an hour, this is O.K. providing this man is going to stay with us. . . . you tell him I will be down there the end of next week and at that time will go further into the wages of several of the men.

"One thing, however, I want understood, is that these men are going to stay with the firm and not hop out just when we need them the worst."

Across the street and down the road a way, Hop Yuill was getting ready to open the Medicine Hat Potteries Company.

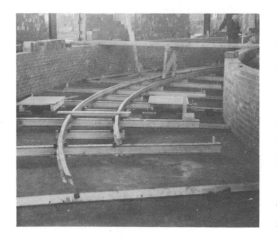

Construction of the circular tunnel kiln at Medicine Hat Potteries in February, 1938.

"I think far and above board, the most knowledgeable mind that ever came out of Medicine Hat was Hop Yuill. He had a feel for clay," says Malcolm MacArthur, who became cost accountant for the new pottery. "He used to watch that old Medalta down the street kind of wallowing and as a hobby almost, he built the Medicine Hat Potteries out of surplus profits from the Alberta Clay Products."

For his new pottery, Yuill borrowed the design of one of the biggest and most successful American potteries of the time, Homer Loughland of Pittsburgh. To staff it he stole all the key personnel from Medalta. From the sidelines Yuill had observed carefully and learned from the failures of Medalta.

"Medalta was never planned; it just grew," MacArthur observes. "I don't think they ever made money. There's a facet about this industry; sometimes you can get in but you can't get out."

It wasn't long before Cumming found out for sure—Armstrong had gone over to Yuill. In fact, a source who worked closely with Armstrong at the new plant claims Armstrong was suspected of having deliberately engineered Medalta's failures when he was general manager, hoping to buy out the company at a bargain and run it himself. Gordon Armstrong offers this version:

"About 1937 my father convinced the Alberta Clay Products Co. Ltd. that a pottery would be a good business proposition and they built an entirely new building, streamlined manufacturing plant (something the Medalta was not because it had been built up like "Topsy" which also added to costs) and in 1938 they commenced manufacturing. All the key personnel moved from the Medalta to the new Medicine Hat Potteries and it was then in 1938 or 1939 that the Medalta was finished."

JUG
¼, ½, 1, 2 & 5 Gal.

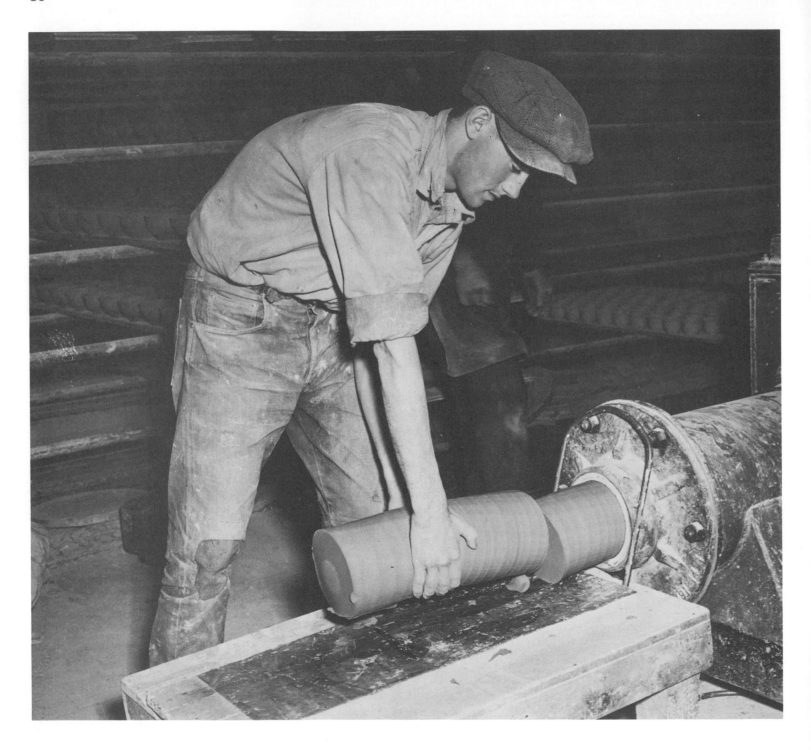

Chapter 5

Ed Phillipson joins Medalta.
"Ceramics is colloidal chemistry."
Fireproof ware, teapots, ashtrays,
and sand jars.
Rivalry and co-existence.
The great circular tunnel kiln.
Tilly Schlenker and her girls.
Apprentices.
"Made in Canada" is popular.

"What's the matter? Don't you have the guts to tackle the job?"

"Mr. Cumming, there's no job in the world that I don't have the guts to tackle. But, this is a dead horse and I don't play with corpses."

It was 1937. Ed Philipson had just taken his first look at the Medalta Potteries of Medicine Hat. Cumming wanted him to take over Karl Baumler's position as plant superintendent.

"It was a huge place . . . terrific waste of space. It was a badly run down place. They had three very old pug mills. And, I mean old. One of the very first ever put on the market. They're really brick pug mills, not pottery pug mills. They had jigger wheels and big drums for making crocks and that's all they ever had.

"For flower pots, they used local clay from the backyard. The clay wasn't too good and it was prepared very crudely. It was prepared exactly the same as for making brick. It was prepared in a wet pan . . . put through a double pug mill, actually half a pug mill. The pug mill wasn't there . . . just the mixing part of it."

Philipson was a ceramic engineer. He'd studied under Professor Worcester at the University of Saskatchewan and had spent a year working with the Department of Mines Geological Survey in Ottawa. In 1937, Philipson was heading "south" to study colloidal chemistry at Alfred University in New York State. He got as far as Regina, where he was told there was a job for him in Medicine Hat.

Clay extruded from pug mill.

"Medicine Hat? I'd been through there during the Depression and I don't think there was a more impoverished town than the city of Medicine Hat. I could recall the wooden sidewalks, the dirty dirt roads. There were no hard surfaces. I think there were two streets that were hard surfaces; the rest was all dust and dirt. And, the little kids running around with torn pants, patches on their knees."

He decided to have a look for himself. Medalta was running only four or five months out of the year with about 15 or 20 employees.

"I took one look at it and I turned around. I said, 'I am a ceramic engineer. My profession is designing construction of potteries, chemical plants—I don't care what they are.'"

But, not dead horses.

"We're going to put in a quarter of a million dollars," Cumming offered.

"Well, that was a different story. I could visualize what I could do with a quarter of a million dollars."

First, something had to be done about the kilns. Philipson wanted to go into earthenware. Beehives were suitable enough for stoneware, which didn't require a high degree of accuracy in temperature control, but for good earthenware, better control was needed.

"Beehive kilns were alright in the 18th Century when labor was very cheap or in China where there was an abundance of labor. But, I couldn't see it here."

According to Philipson, the two indoor kilns which had been built in 1913 had collapsed.

"I rebuilt #1 and #2 kilns. I changed them, put in a little of my own design. The reason I changed them was that the only ones they knew of when they were built were for salt, for sewer pipes, clay products. They had open pockets; I couldn't see any reason for open pockets. The crowns were crumbling; I was afraid the stack was crumbling."

Next, Medalta needed new lines to re-establish a steady market. Philipson designed a line of fireproof ovenware—casseroles, pie plates, mixing bowls—with a special finish he developed to give the ware a porcelain appearance. The process was called "white lining." An "englobe," or clay slip with oxide coloring, was applied to the raw inside surface of the ware to give it a white finish in lieu of a real porcelain clay body, which wasn't

available in Canada and which was too expensive to import. Philipson had done considerable research on englobes which he had published in the *Ceramic Journal.*

Medalta's new plant superintendent didn't see himself as a potter. He was a chemist, a draftsman, and an engineer. In fact, when he left Medalta some 20 years later, Philipson moved over into the petrochemical industry.

"Unfortunately, ceramics has been so badly misinterpreted nowadays. You talk about ceramics, you talk about making pots," he says. "It isn't. Ceramics is colloidal chemistry. It's a big, big field."

Before they left to go over to "the opposition," Baumler and Armstrong had a hand in selecting their successor. Philipson was something Medalta hadn't had before on the premises: a university graduate, a student of one of Charlie Pratt's "so-called professors of ceramic engineering."

"Attention: Mr. A. D. Cumming. Referring to Mr. E. G. Philipson's application, it would seem worthy of further investigation," Armstrong wrote in November 1937.

"Karl met him and says he is a clean cut vigorous young man with a good opinion of his own capabilities, who's ceramic experience is limited to his university training; that is not necessarily a drawback as he would have to get accustomed to these clays in any case.

"Would suggest, for your approval, he come up here and be checked over, if his salary expectations are not too large."

Of his first few months with Medalta, Philipson recalls:

"The people there, even Mr. Cumming, thought I was kind of a . . . the things that I was doing he always doubted. He said, 'There's a young fellow out of college with a belly full of books and he doesn't know what he's doing.'

"But, I had solid research behind me and I knew what I was doing. And, it turned out to be a bonanza. It was terrific. For two years we were manufacturing white-lined mixing bowls, casseroles. . . . and, we sold them; we shipped carloads of them. And, it kind of gave us a lift."

Those were the days before pyrex and plastics. Medalta's white lined ware found a ready market with a big demand. Originally, the fireproof line was made with an earthenware clay, because stoneware couldn't

provide the finer, attractive look required for kitchenware. Whatever its shape, a piece of stoneware still looked like a crock. But, the earthenware didn't do the job.

"Your body is extremely porous and the least chip would render it unfit for use," Cassidy's, Ltd., of Montreal responded to the first samples. Cassidy's was interested in the new line, however, and promised good distribution if the fireproof ware improved. In fact, they wanted exclusive control of distribution in the East.

So, Philipson went back to stoneware, finished it with englobes and decorated it with flowers. The result was a product that was attractive and that stood up well under continuous use. Some of Medalta's fireproof ware made in 1938 could still be found in Canadian kitchens 35 years later.

Shortly after Philipson took over, Cumming asked him to take a look at a clay deposit owned by Medalta and long forgotten in Willow, Saskatchewan. The Company had been paying taxes on the land for years but had never found a use for the clay.

"Go and have a look and if it's no use to you, sell it for pasture."

Philipson tested samples from the deposit in the laboratory he had built at the plant.

"I said to Cumming, 'How much do you want for that mine?'"

"I don't know. Five hundred dollars."

"I'll give you five thousand."

"What's the catch?"

"That's a little gold mine there. It's a pure porcelain clay that you can't find in Canada."

What Medalta had in Willow was a high-grade ball clay resembling a kaolin, or porcelain clay, in its properties. Up to then, Canadian potteries making vitrified ware had to import their clays from the United States.

"Well, what can you do with it?" Cumming asked.

"I can make hotel china out of it."

"We were sitting in the Cecil Hotel," Philipson recalls. "Cumming pointed to the teapot in front of him. He said, 'You mean to tell me you can make a teapot like this?'

"I said, 'Sure.'

"Ed, if I was only sure you knew what you're talking about, I wouldn't mind to put in more money.'"

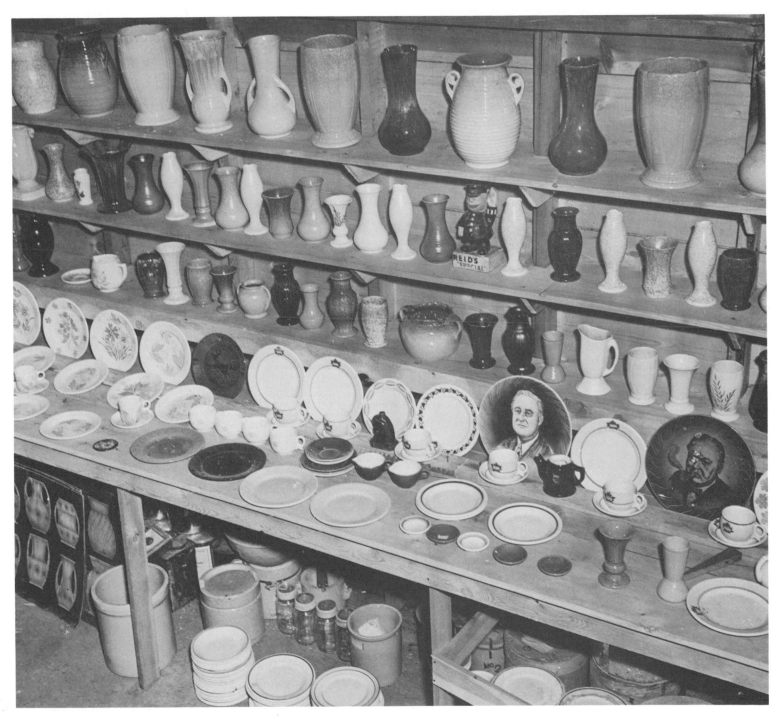

Some of the Medalta product lines.

Philipson went back to his laboratory and made up some sample tea-pots, green with a white inside surface. Cumming went back to Calgary with the samples. Within three weeks, Philipson received an order for two carloads of dishes for the new Hotel Vancouver. Ben Cunliffe, Medalta's British Columbia agent, had taken the order without further consultation with the plant.

Philipson was surprised and exasperated.

"What do you mean? I haven't anything to make it with. I haven't got the blungers. I haven't got the pug mills. I haven't got the chemical treatment that porcelain has to get. And, you're selling dishes!"

Cumming urged him to try to get out at least part of the order. Philipson spent the next few days drafting the specifications for the machinery he would need, working until two or three in the morning on the drawings, and rushed them to a local welder's shop. Medalta met the deadline on its first order of hotel china.

Medalta's agents and travellers had been urging the Company to get into the hotel china market and immediately went after orders for the new line based on the early samples.

"I have several accounts waiting to see these items and get an idea of the cost, that if we can line them up, will give us some very nice business. I have in mind getting sufficient orders for you to keep a staff steadily employed on these lines alone, as there is an enormous market for hotel ware in Canada," wrote Tom O'Connor of Johnson & Barbour, Ltd., Wholesaler and Importers, London, Ontario.

"If we can get it going we can make more money out of it than we can selling crocks," Cumming wrote to Philipson in November of 1938, regarding samples of green-banded hotel ware Philipson had sent him. "Montreal is all hopped up over it, and so is Vancouver, and we believe that we can go places with this."

Philipson believed they could too, but, the way they turned out their first order wasn't the way Philipson wanted to work.

"Look," he told Cumming. "Enough is enough. I'm not going to do this job this way, because sooner or later it will backfire. If you want me to go into hotel china I want a tunnel kiln. I've got to control my work within five degrees. It's alright for stoneware, earthenware, flower pots. You can

underburn, overburn them. But, hotel china has to pass specifications. It must be on the nose or it won't work."

Philipson, with his "belly full of books" and his laboratory background, was a perfectionist. He had no tolerance for the makeshift, intuitive procedures that had sustained the plant up to his arrival.

"When I came in, one thing I checked right away: that the crocks held the measure they said. The two-gallon crock did not hold two gallons. We threw away a lot of moulds. The same with bean pots.

"I can't work by guess. I was trained scientifically. And, it had to be that way. . . . If I can't produce it in a way that I know it's done right, then I won't produce it at all . . . I'm talking about *professional* ceramics. In professional ceramics, it's got to be perfect.

"You take a beehive kiln piled sky high with crocks, mouth to mouth. The bottom ones are bound to go out of shape. Now, that's a poor way of firing stoneware. But, we had no choice. Our stoneware wasn't made right. But, I wasn't concentrating on stoneware. To me, it was just a sideline."

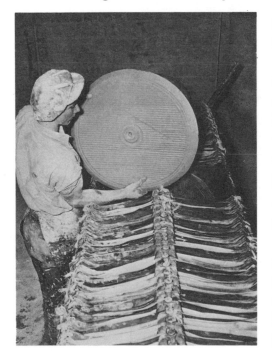

Filter cake being removed from filter press.

Philipson wanted to concentrate on hotel china, but he had to wait four years for his tunnel kiln. World War II had started and along with it a materials shortage.

Medalta managed with its beehive kilns, rebuilt according to Philipson's specifications, to supply a wide range of hotel china, made with its newly discovered white-firing clay, to Canadian National and Canadian Pacific hotels across Canada. Medalta's individual green teapots appeared on the tables of the Hotel Saskatchewan at Regina and the Hotel Palliser at Calgary in mid-1938. The Company invested in an oval jigger machine imported from England to produce a number of the oval pieces—casseroles, egg dishes—required by the railroads. Philipson also designed partition plates and baby plates to be manufactured from the white clay.

Meanwhile, the Company kept up production of its standard lines and specialty items. They finally produced a white matt and glossy white finish to please the lamp manufacturers and procured a magnetic separator to remove the iron particles which had previously rendered Medalta lamp bases inferior. Brooks, who had ridiculed Medalta's first attempts in 1935, was placing regular orders. In fact, in 1938, he attended a lamp

manufacturers exhibition in New York City and brought back several new shapes for Medalta to copy for him.

Medalta was filling large orders for ashtrays, specially stamped for the breweries, among other customers. Calgary outlets ordered the Company's hat ashtrays to sell as souvenir items during Stampede days. Medalta bowls and bean pots were a favorite premium offer as well as popular giveaways at the Isis Theatre in Calgary and the Roxy in Regina.

Of course, there were still the flower pots. Most people raised plants in them, except for a Mrs. Bray, who sent in a special request for a quantity of them without holes.

"This lady requires this flower pot for feeding mink, so it will be quite in order for you to fill in the holes the best way you can without going to any expense or trouble in doing so," Philipson was instructed.

Medalta did go to some expense and trouble, as long as it did not require the making of special moulds, to fill extraordinary requests from its bigger customers. One of these was for a photographer's developing tank 44 inches high and 13 inches in diameter ordered by the Hudson's Bay Company. The plant had received the odd individual request for a developing tank over the years from its beginning, but never in sufficient quantity to warrant a mould.

"This tank has been made up by joining sections of three crocks together, the lower crock having had the flange on the top removed, the center portion being made from a crock with both the bottom and the flange removed, and the top section being a crock with the bottom only removed," Philipson was advised by the Calgary office upon receiving the Hudson's Bay order. "Actually this article is just one tall crock with straight sides, and a flange at the top."

Medalta got a lot of mileage out of its crock moulds and was versatile in devising new uses for them when the occasion demanded.

"Please refer to an order given by the Corona Hotel, Medicine Hat for a special sink, which was made up by us and delivered July 8th 1938," Philipson directed the Calgary office. "This sink was made up of 1 - 5 and 1 - 3 gal. crock.

"Mr. Cantilini of the Assiniboia Hotel, also manager of the Corona Hotel, was in the plant to-day. Mr. Cantilini stated that the Government

Beer parlour inspector, inspected this sink and was that satisfied with same, that he intends to make every bar in Alberta put in a similar one. Which would mean approximately 300 such sinks. We have told Mr. Cantilini that we would be able to supply any quantity, of most any size of these. We also mentioned that the price would be approximately $5.00."

When Ben Cunliffe got word that the City of Victoria had passed a municipal bylaw forbidding the use of sheet metal thimbles in chimney construction and stipulating that chimney thimbles had to be made of fire-resisting clay ware, he immediately thought of the crock moulds.

"The thimble, as you probably know, is merely a tube without ends, just like a piece cut off a sewer pipe....I was offered an order for 500 of these and it occurred to me that we might have some moulds at the plant of the proper diameter; a two-gallon crock is seven inches in diameter inside, and it is possible that we may have other moulds that would be the correct diameters."

If the large sand jars in Canadian hotels suddenly were reminiscent of churns, it was economy, not style, behind the change. Just as an order came in from the King Edward Hotel of Edmonton for large sand jars, the plant found its sand jar mould broken. To fill the order, Medalta made up a "new style" jar from a six-gallon churn mould. Printed with the hotel's initials and decorated with the maple leaf, the jars were sent off to the customer on schedule.

E. A. Toshach's Dry Goods store in Drumheller, Alberta, gave away to their customers golden-brown glazed bowls and square pitchers which became a favorite among Medalta collectors years later. Toshach, who sold men's wear, ladies' wear, and shoes, ordered the bowls with a shoe stenciled on the inside and outside along with the slogan: "You Ought to be in Toshach's Shoes."

Medalta's new era of prosperity, coming as fast as it did, was not without its problems. The introduction of so many new lines in such a short space of time couldn't be accomplished with strict adherence to quality, despite the new superintendent's perfectionism. Complaints came in and Philipson had to answer them.

"We would like to mention at this time, that the chief difficulty is, that we have put out so many new items, and have never had a chance to perform tests to insure perfection," he wrote to the Calgary office in mid-1938.

"Quite often new samples turn out to be perfect and yet, when we make them in larger quantities some adjustments are necessary, which we do not get a chance to make, as orders for same are already waiting. It is not easy to turn out a white lined bowl when clay, room, saggers, dust storms, etc. are all against you."

Four of Medalta's kilns were outside the buildings. This wasn't necessarily a problem except in extreme weather. (All of the Alberta Clay Products kilns were outdoors.) In 1938, one of Southern Alberta's not uncommon spring blizzards struck, causing loss of wares and shipment delays.

"Due to the terrible snow storm we were delayed in our daily work being held back in unloading kilns as the storm drifted the snow as fast as it could be removed in the yard. The plant looks more like a slough and we lost considerably in glazed ware due to the heavy snow drifting inside through the roofs," Philipson wrote Calgary on March 29. "The Sudbury car is partially loaded and the balance is all crated. However if this weather keeps up it will make it very miserable though we intend to ship same tomorrow."

The next day, he informed head office: "We have loaded and have ready the Sudbury car for shipment. However, it may not be picked up tonight as the C.P.R. informed us that they may not be able to come down with their engine as the whole track is blocked with snow. There have been no cars or trucks moving in town—anywhere near the plant at least, and the heavy snowfall slows up our speed. We had to unload two kilns today and at least 8 men had to shovel snow to keep passages open for the kiln gang."

For local shipments in Alberta and Saskatchewan Medalta relied on a not always reliable, capricious Medicine Hat trucker named Kinnaird. Oftentimes Kinnaird didn't show up on the agreed upon day to pick up a load of goods. And, when he did, he was prone to drive them straight to his warehouse until it was convenient for him to deliver them. Also, there

seemed to be an inordinate amount of breakage when goods were moving in one of Kinnaird's trucks.

"Kinnaird called at the office yesterday, wishing to get the Regina load settled up," Philipson complained to Calgary. "When this breakage occurred we asked Kinnaird for a list required to make replacement or pass credits. He informed us that he would look after the replacement, and he would not give us the names of the party that the replacement was to go to. Instead he gave a list of what goods he required, to cover all. This list was made up by a truck driver that never saw a crock in his life before and was really mixed up."

"When we phoned Kinnaird re Ashdowns Regina shortage, he refused to give us any information, and hung up the phone but of course, any one knowing Kinnaird would expect such an action."

It soon became obvious to the Medalta people that when Kinnaird didn't show up, he was in fact just down the road loading goods for "the opposition." Medalta filed a complaint with the Highway Traffic Board of Saskatchewan and turned its business over to another trucker.

Medalta kept a worried eye on "the opposition" that year, 1938. Although the two companies were a stone's throw from each other, communication between them was indirect those first few months following the mutiny of Medalta's key personnel. Medalta could only surmise what effect Yuill's streamlined new pottery was going to have on its business. Medalta had no idea what Yuill had in mind and in the absence of direct communication, the older company had to wait and watch and sometimes resort to cloak and dagger tactics to find out.

"The one thing that is a mystery to the writer," wrote E. A. Stone, Medalta's business manager, May 26, 1938, "is that even with such a modern plant as I understand the new factory is, why Baumler is getting all his help from our plant, because I happen to know that outside of Albert Entzminger, Carl had a very poor opinion of anyone working in the factory. The only reason I can give for his taking these men, apart from Entzminger, is that he does not wish any skilled help working for him, as quite likely they would know too much to serve his purposes.

"You might keep us informed as to the progress of our opposition, especially as to whether they are actually shipping goods and if not when they expect to be able to ship.

Crocks are stacked in the storage yard at Medicine Hat Potteries in August, 1938.

"You might also be able to ascertain what orders they are working on, if any. Mr. Armstrong is in the east and may still be there. We happen to know that business in that territory is lousy."

Among the first goods shipped by the opposition and stamped with the Medicine Hat Potteries' Little Chief symbol were crocks made by Medalta employees and burned in Medalta's kilns. Of course, the customers didn't know that, and neither did Medalta at first. Medalta thought the crocks were going to their old customer Mr. Volway of the Service Hardware in Medicine Hat. Once they caught on, Medalta's management were more amused than threatened and eventually entered into a direct arrangement with Yuill. Apparently, the new company's excursion into the crock trade made no difference to Medalta's business. One customer was as good as another even if it was the opposition.

"We are enclosing two copies of a complete price list for your use at the plant, and also one copy of a shorter price list, which you may supply to the Service Hardware, as we understand that Mr. Volway is a very personal friend of Mr. Bill Yuills, and no doubt this price list will find its

way into the hands of the Alberta Clay Products for their reference," the Calgary office wrote on June 10.

On July 7: "We notice the yellow copy of the packing slip for a large quantity of goods for the Service Hardware, to be picked up on Friday. You make no mention of this in your letter so we assume same was forwarded to us for our approval, in view of the fact that this shipment, and also the last one, is destined for the Alberta Clay Products. However, we brought the matter up with Mr. Cumming, who arrived here yesterday, and he has given his authority to ship same. It should be an item of local interest to know that the new plant is operating, and purchasing our goods to supply to their customers."

And, on July 9: Re the Service Hardware order:

"It should have occurred to us when writing you about this truck to suggest that someone trail this truck after it leaves the factory, and in this way you could probably find out the exact destination of these goods, although there is no doubt that they are going to the opposition."

The two companies maintained an uneasy coexistence the first year,

cooperating when convenient, but never letting their guard down. Medalta's policy toward the other plant was often contradictory and changed from one week to the next. Caught short on churn dashers one week in July, Medalta went to Yuill's plant to purchase them in order to meet a shipment date.

"You will note that we have purchased 100 dashers from the Med Hat Pottery," Philipson explained to Calgary. "It rather hurt to do this, but was certainly better than shipping the Walter Woods Ltd. trucks short."

Later he wrote:

"Re churn dashers from the Med Hat Pottery, these were purchased, and will be charged out. If we start the loan system, they may come back on the same thing with crocks. This would never do."

The Medicine Hat Potteries dispensed with their middle man Volway and started ordering bowls, jugs, and crocks directly from the Medalta plant.

"We received a letter yesterday, signed by Mr. Armstrong, advising us that they would be willing to buy certain articles from us that they are not making, with the request that we give them prices. . . . Mr. Cumming replied to the effect that as soon as we were advised what items they require, we would forward prices immediately," Stone advised Philipson on September 1.

The next day, Philipson received a contradictory policy statement from Cumming: "With further reference to the goods sold to the Alberta Clay Products, please be advised that from now on if they come in and want to purchase goods, it will be necessary for you to tell them that you haven't got them to spare, until you hear from us further."

Two weeks later, Cumming informed Yuill: "Referring to your letter of September 13, we will make these fifty gallon crocks for you, putting your lable on them. . . . Your discount from these prices will be 50% and 10%."

By October, Yuill was ordering a variety of teapots also from Medalta, 1,800 of them in a single order. For information about each other, the two companies relied on less direct channels.

"Understand Clay products have their goods in Woolworth's. Would suggest either purchasing a piece or checking up on same as to quality, finish, etc."

"As regards the *Medicine Hat News* wanting some information on the premium deal" (Medalta was working out a large premium order with a Winnipeg company at the time), Stone warned Philipson, "we are not sure whether you know that this paper is either owned, or practically controlled by the Yuills."

The "opposition" turned out to be not a direct competitor in the Canadian pottery market, even though both Medicine Hat potteries were producing stoneware. Yuill chose to specialize in semi-porcelain dinnerware for the home which, while similar in composition to the hotel china Medalta produced, was not manufactured to meet the rigid sanitary specifications imposed on china for institutional use. Ironically, though, Yuill's new plant was better equipped for either article right from the start. For burning his dinnerware, Yuill had Allied Engineering build him a huge circular open-fire tunnel kiln, the largest of its kind in Canada. A small beehive kiln erected outdoors was used for firing saggers.

The tunnel kiln, which was fueled by natural gas from the four wells owned by Alberta Clay Products, was controlled automatically by a potentiometer pyrometer which provided the high degree of accuracy necessary for uniformity of wares. Seventy feet in diameter and 235 feet long, the kiln formed a three-quarter circle arc. Kiln cars loaded with wares moved continuously but imperceptibly on tracks from entrance to exit in 30 to 40-hour cycles. During that time the pottery passed through pre-heating, burning, and cooling phases, under temperatures that gradually changed from room temperature to an intensity of 2250°F. and back to room temperature again. The whole installation was so finely tuned that a quarter horse power motor was all that was required to keep the cars in continuous motion.

Yuill also had the technology already developed at his sewer pipe and tile operation, Alberta Clay Products, at his disposal. Much of the equipment for the new pottery was made next door at the parent plant. To run it, he had Medalta's best employees. Regardless of Baumler's opinion of their worth, Medalta's hands were the most experienced pottery workers within reach, most of them having been with Medalta for years. In fact, whenever the older pottery changed hands, the new management had always relied on the continuity of its staff for information on procedure.

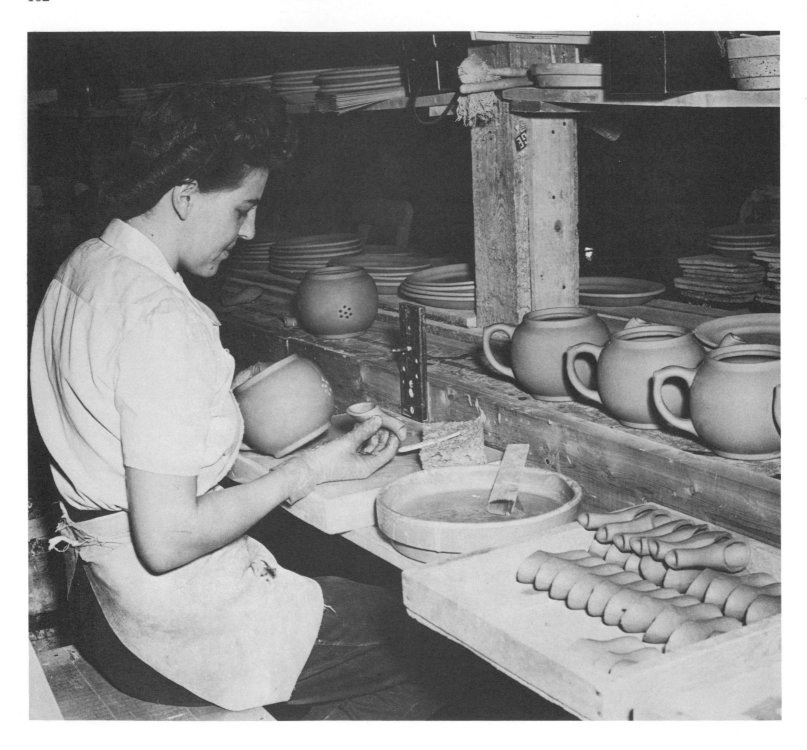

By the end of 1938, Yuill had purloined more from Medalta than its staff and some crocks. The Medicine Hat Potteries also had Medalta's major eastern agents for the lines in which the two potteries were in competition. James McQuillans & Company of Quebec switched their business from Medalta to Yuill almost as soon as the great circular tunnel kiln was turned on. And, Albert Pratt, Medalta's long-time critic and conspirator, sold out his business entirely to Yuill, only months after Philipson began to try his hand at pleasing the Toronto agent.

"Concerning the goods to be shipped, we have given them the proper attention, but the information that Pratt will refuse anything that is not absolutely perfect has been told to the men at different times, but we are not sure that Mr. Pratt, who is a very particular person, will not find flaws. At least we hope not," Philipson had written Calgary in March 1938.

Two months later, Stone in Calgary wrote Philipson:

"We have heard nothing from Mr. Cumming other than the telephone call from Toronto before crossing, and a post card from Glasgow. No doubt some of the conditions in the East will have come to a head by the time he returns and he can then find out more fully as to what actually is happening in Toronto and Montreal. At the present time we are advised that the Clay Products have purchased the business of the Medicine Hat Pottery Company (Pratt's firm) and will continue to run under that name. We have never had this confirmed by Mr. Pratt but we wired him a few days ago to the effect that we had been definitely advised of this, and asked him if we were expected to deliver goods to our opposition for them to sell..."

Yuill's local travellers, however, had a less easy time of it breaking into the market against Medalta. The older company's name was a household word, especially in Alberta. For one traveller, it wasn't Medalta's good reputation that got in his way, but quite the opposite. Jack Barrie, who later became curator of the Medicine Hat Historical Museum, travelled the same sales area for Yuill's pottery that Martin Perry covered for Medalta. Perry, the smooth-talking, shifty former business partner of Jesse Wyatt, was not too popular in the territory. Customers who mistook a B for a P when Barrie introduced himself would turn off immediately muttering, "Oh, you're that character from Medalta."

Attaching spouts.

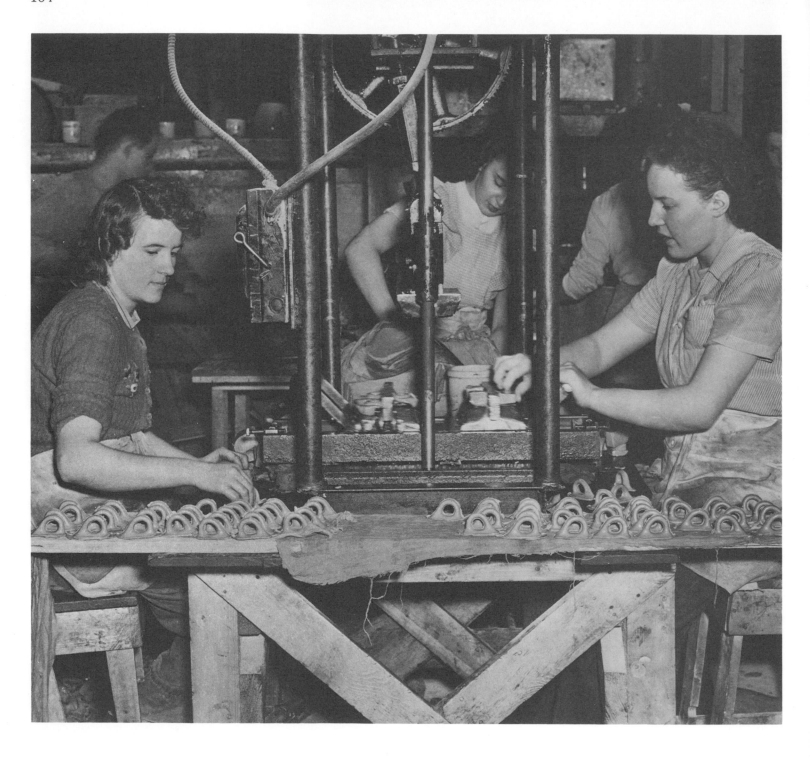

The advent of the opposition proved advantageous, if not to Medalta, at least to its employees. It gave them an alternative if they didn't like the working conditions or the pay. John Herter, a jiggerman, left Medalta shortly after Yuill got his plant going. Herter had started training with Medalta in the glazing department before joining the jigger line as O. Hehr's helper. Of his earlier days with Medalta, Herter recalls: "I got sick from lead poisoning. I was always sick and taking time off work."

Tillie Schlenker chose to stay, even though in the 15 years she had worked for Medalta she had often suffered illnesses from the atmosphere in the pottery. One bout of illness had kept her home from work for five years, but Medalta wanted to hang on to its experienced help. Miss Schlenker was asked to fill a job vacated by a man named Spitzer, who had gone over to Yuill. With her promotion, she became Medalta's first forewoman.

"It would be advisable to give T. Schlenker a raise of say $1.00 per week. She is now doing all the work formerly done by Spitzer. We would like at least to hang on to some of the old hands particularly the girls."

Miss Schlenker was in charge of the female employees, many of them schoolgirls who worked part-time after school hours trimming and sponging the ware and putting handles and spouts on teapots. She would go home for a few hours at noon and then return to supervise the schoolgirls. Although she was the only regular employee who had to work nights at the plant, Miss Schlenker received no extra pay for her split-shift work. However, she was "grateful" to have a job with an employer who accommodated her illnesses by taking her back after long absences.

"I didn't ask for the job; they just said 'You do this,' probably because I was the oldest woman there and had been there the longest. It was a big responsibility. When you had girls who wanted to work, it was nice. But, with some who were in there casually, it wasn't so nice. But, I tried to be easy on them."

To the teenagers under her supervision, women's work at Medalta held little appeal except as a means of picking up spending money. Sticking five thousand handles onto five thousand teapots moving steadily and swiftly along conveyor belts was hardly engrossing. The job left lots of time to daydream and chatter, often about the pottery dances. These

Machine pressed handles for mugs.

were organized by an energetic Medalta employee, Emil Schlenker (no relation to Tillie), remembered by some of the girls as quite a lady charmer. Every few weeks the younger girls could forget trying to get away with as little work as possible and dance to live music in a hall in town rented for the Medalta dances.

Miss Schlenker, who was caring for her ailing mother and whose unique position tended to set her apart socially from the other employees, never went to the dances.

Medalta supplemented its regular staff with apprentices from the Redcliff Youth Training School in an arrangement that made it possible to cut production costs during the difficult transition period of early 1938.

"We had an interview with a representative of the Redcliff Youth Training School and he stated that the school is willing to supply us with girl apprentices or boys, without pay for the first half year. Furthermore, the Government is willing to pay $2.00 per week per person to our Company for training purposes," Philipson advised the Calgary office.

". . . . if you can get any work out of these people, and the government is willing to pay it, it is a way to cut our labor cost," Cumming replied. "Please investigate it further and see if these people go in to work, or just to stand around. Of course, we cannot guarantee them jobs at the end of the six months."

Minimum wage, which was about all Medalta's regular employees could expect, had just been set by the Board of Industrial Relations for female employees at $12.50 per six-day week or 30 cents an hour. Men made little more, and O. Hehr's demand for 50¢ was pushing it. Some jiggermen still worked piecework—70¢ for 100 fern pans. There is some evidence from inter-office correspondence that management had secretly negotiated higher rates of pay with some older employees to dissuade them from joining Yuill's team.

"We would suggest that you take care to see that all the employees who are receiving rates of pay in excess of the ordinary employee, that the cheques be delivered to them personally," Stone cautioned Philipson. "In other words, you will readily see that it would not be well to have these cheques tendered to anyone else in the plant."

Despite the serious problems Medalta experienced during the early and middle Thirties, the Medalta name was firmly established in the minds of Canadians. Schools and individuals all over the country wrote to Medalta seeking to purchase small quantities of clay or requesting information on firing and glazing technique or the ceramic process in general. Some were writing term papers; others wanted the information for use in their own work. Philipson fielded the requests, supplying detailed answers to the questions as a public service. Customers could purchase Medalta's pugged or dry clay in 50 pound lots or more for two cents a pound and they often received information on firing it along with their purchases.

When Mr. W. F. Irwin, a teacher at the Western Canada High School in Calgary, queried in 1938 whether Medalta would consider burning small pieces made by his students, the Company found itself also in the business of finishing at ten cents apiece articles sent in by schools, individuals, and crafts organizations. One student of the Banff School sent work in to be finished.

"Regarding Mrs. Brown, who wishes to have some information and samples for her niece, Mr. Philipson will write up a short article, (on Clay Manufacturing) and forward this along with some few samples. Upon receipt of this article, it would be a good idea to make a few copies of same, you could then mail a copy out in answer to the many inquiries that come in for such."

One very strong factor in Medalta's favor in a market where it was competing with Japanese, British, and American products was the Made in Canada movement. Canadians were being urged to buy Canadian; they wanted to buy Canadian; and, when it came to pottery products, Medalta was the name Canadians recognized as their own. In the case of articles which went out by special order without the Medalta stamp, often with the stamp of the retailer instead, the Company was urged by its agents to mark them "Made in Canada" to increase their chances of sale.

"It is essential that the items not marked 'Made in Canada' such as the plain bowls, the harlequin bowl set and the white lined bowls be labelled. ...We are advised by the departmental stores here as well that it would be much better should all your items be marked 'Made in Canada' as not only do people not believe that the product you are now making is Cana-

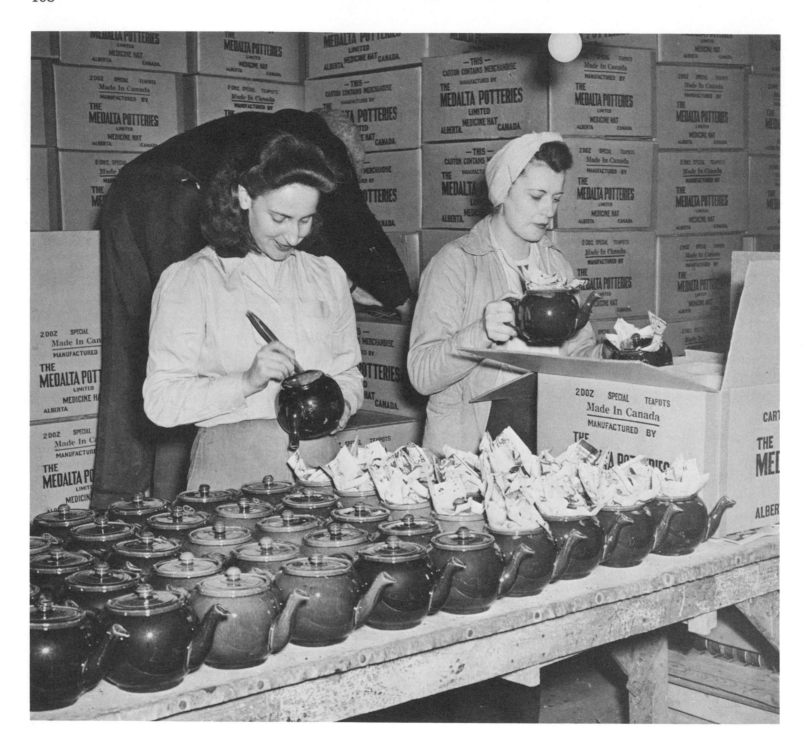

dian but on the cheaper items they are firmly convinced that because the article is not marked it is made in Japan," Ben Cunliffe advised from Toronto in June of 1938.

By the end of that year, the dead horse was back up on its feet and still very much in the race. The "opposition" had proved not to be such a threat after all and was being mentioned by name, if mentioned at all, in Medalta's inter-office correspondence. The Company had new agents in the East, Brown & Hargrave Limited in Toronto, managed by Ben Cunliffe Jr., and Johnson & Barbour.

Medalta was shipping large quantities of goods to points from coast to coast and in the U.S. Some Medalta wares were ordered from as far away as Australia and New Zealand. The plant was working full-time keeping 350 hands steadily employed.

Meanwhile a war was coming which promised enough government orders to keep all of Canada's potteries working full-time while creating an entirely new set of problems for the industry.

Brown Betty Globe

Checking and packing teapots. Note "Made in Canada" underlined on the packing boxes.

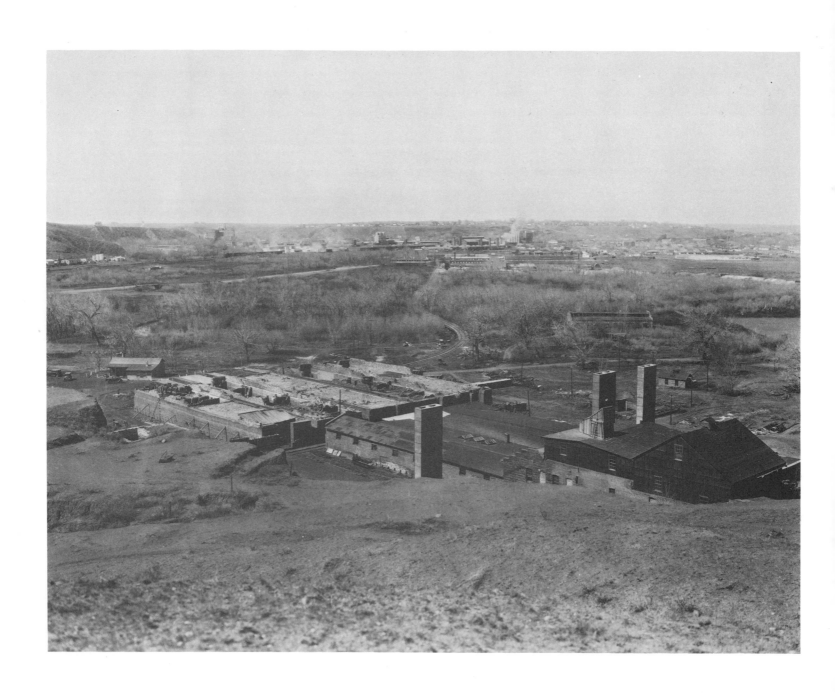

Chapter 6

Another war.
The Government as customer.
Prisoners of war.
Clays and glazes and the public
service program.
Safety regulations.
Export opportunities.
Delivery dates.
Peace brings its problems.

"We sneaked in a little civilian work. But, once they caught me. I had 25 crates ready to go to Eaton's. A colonel came in from Ottawa.

" 'Where are those crates going?'

" 'Well, we have private customers; we have to please them, too.'

" 'Oh, no, you don't.'

"And, he changed the addresses to 'Department of Munitions and Supplies.' Right there, he ordered a truck and they took it away."

During the early years of World War II, Philipson had only one customer to please—the Canadian Government. That went for Yuill, also. Medalta was commissioned to make green dishes for the Armed Services. The Medicine Hat Potteries provided the Government with a line of six plain white items. Both potteries worked through the war at full capacity with a guaranteed market and a guaranteed profit...no more than five per cent.

England was being bombed. Canadian potteries had to cover the market ordinarily supplied by the English potteries. Cups, saucers, dishes were needed by the railroads, and for the war effort, ships, army camps, and prisoner camps had to be supplied.

Working for the Government had its advantages. Philipson got his tunnel kiln in 1942, despite the materials shortage. Because Medalta was in wartime production, the Government gave the Company a priority on steel needed for construction of the kiln.

Medicine Hat Brick & Tile—foreground, Medalta Potteries—centre, Alberta Clay Products—background.

Yuill learned a valuable lesson in the economics of pottery manufacturing. When he first got into the business, Hop Yuill, not unlike Medalta, scattered his efforts trying to cater to a broad market, creating on demand of his agents a wide range of lines with limited sales potential. At the time, a plain white cup made by the Japanese could be purchased in Canadian stores for only five cents. With a diffuse production approach like Yuill's, the Medicine Hat Potteries couldn't even make the cup for five cents, no matter how low their wages were set.

Once the Government limited his lines to six plain white items, Yuill found his plant's production volume increasing dramatically.

"At the start we were making plain white cups for five cents each; when we got going we were making them for three cents," Jack Barrie, who was a traveller for Yuill at the time, explained.

There were disadvantages. Yuill wasn't allowed by the Government's five per cent profit restriction to pocket the difference. If he managed to pare two cents off the production costs of a white cup, Yuill had to reduce the selling price accordingly. The Government sent auditors around to make certain that no one was profiting from the war.

"Hop would get mad and leave when the auditors were coming; he'd never face the auditors," Barrie recalled.

With a war on and the labor force reduced, there were jobs to spare for those who remained in Medicine Hat. In factories working on war production, no one was allowed to quit and salaries were frozen for the duration of the war. For Barrie and the other salesmen at Medicine Hat Potteries it was a dismal time.

"Because domestic production was minimal, the sales staff had nothing to do. We never left the plant. I hated it. . . . I couldn't wait to quit. I spent my time learning to make moulds."

Meanwhile the rest of the plant was on 24-hour production. Hands working near the kiln-loading area labored under temperatures over 100°F. and had to take salt tablets.

Filling in for the experienced hands Medalta lost to the war effort, were a doctor, an architect, and a chemist—all working for fifty cents a day. They were German prisoners of war from the Medicine Hat internment camp.

In 1945, Medalta had fifty prisoners of war working in the plant, many of them 14 and 15-year-old Czechoslovakian and Hungarian boys who couldn't even speak German.

'When I first took them in, I asked the commandant what they would do about escaping prisoners," Philipson recalls.

" 'Oh, we'll have men around.'

" 'Armed?'

" 'Of course.'

" 'No, Sir. You take them right back. No armed guards. You can't tell what might happen around here; they might shoot one of our own men.' "

Philipson's concern about escapees proved unfounded. The whole plant was policed by two unarmed World War I veterans, who managed to catch up on their sleep during working hours.

"We didn't have one escapee. They were good. We tried to fit them in . . . we had a doctor; we had an architect who had about 20 articles in journals; I had chemists.

"When they came in that room there and they saw that machine that Karl Baumler bought from Germany, they were so proud of it. They polished it and painted it. When I came in there, I didn't even recognize the machine. In fact, something broke on one of the pugmills and there was an argument between two prisoners. Each thought the other had done something wrong. I was afraid at first that they would sabotage, but they didn't."

Medalta built a kitchen and provided ingredients for meals for the POW's.

"We kind of figured they needed at least one good meal a day. They did their own cooking. We even gave them oranges, but we were stopped. I suppose the Government figured we needed them for our own men."

Philipson couldn't give them orders.

"For them, rank was still the center. I had men who were better than corporal. And, I would tell *them* to tell the Corporal to do this or that. We had what we called 'the Fuhrer,' a leader who was usually a sergeant major or a commissioned officer, and he didn't work. He just walked around. It worked very good. As a matter of fact, it was a lot better. Because, if I'd say to him: 'Send four or five men over to. . . . ,' he'd get them. 'Line up! Right turn! Left turn! March!' "

Philipson himself was a military man during the war. Still intent on pursuing his studies at Alfred, he had resigned from Medalta in 1939, but once again he was sidetracked. He was drafted. Throughout the war, he served as a technical officer at a nearby military base while continuing to manage the plant.

"I had trouble with one of the Fuhrers. One day, all of a sudden, nobody could speak English.

"'What's the matter? Yesterday, you could speak English; today it's Nix verstehen.'

"'Well, we have orders not to speak.'

"I think the man was a spy there to see how the other men were working, because he was actually working with the men even though he was high up. He must have been a captain or something.

"I called him in.

"'You know, you've been giving me a lot of trouble.'

"He was standing there at attention.

"'You don't have to stand like that. You can sit down; you're not in the army here. You know what I'm going to do? The Colonel wanted to send me two armed guards. And, if you don't behave yourself, I'm going to chase you out into the yard and I'll tell them to shoot you.'

"And, you know, he started to tremble. If someone had told me that I'd have laughed in his face. Eventually they really liked it here. The problem was they were afraid of being sent back. All those who had come from the Russian zone, they didn't want to go back. Every day, they'd come to me and ask: 'Can you make out papers so I can stay?' But, they had to go back."

After the war, many of Medicine Hat's POW's returned to the area to settle. One of Philipson's "Fuhrers" had lived in Medicine Hat before the war. Having spent most of his life in Canada, he'd gone back to Germany to accompany his mother in 1937 and had been drafted into Hitler's army. He later confided that he'd been waiting for a chance to be taken prisoner so that he could come back.

Even with the prisoners of war, Medalta was suffering from a labor shortage. About eighty of its employees had joined the armed forces, including some of its best jiggermen. In February of 1945, Cumming

drafted a strong plea to the Government. In answer to an order for goods from the Department of Munitions & Supplies, Cumming responded:

"We note in your wire that these are extremely urgent and will bear the highest priority. We are wondering if this will bear enough priority to get some of our best jiggermen back, who are now in Italy. We understand two of them have been wounded and are now in hospital.

"Labor is our big problem. At the present time we are working fifty Prisoners-of-War and the Trades and Labour Council are trying, through the Selective Service man in Medicine Hat, to do something about it. However, if we lose these POW's, we could not supply you with any of this merchandise. You must also realize this is going to cut into our civilian trade to a great extent, as we are agreeing to furnish you with about 60,000 pieces a month. This will mean there will be 60,000 pieces less for civilian trade, and we do not want to get in trouble with the Wartime Prices and Trade Board by not making delivery of our commitments.

"Rest assured we are willing to do anything to help the war effort."

Later the same month, Cumming appealed directly to the Deputy Minister of National Defence:

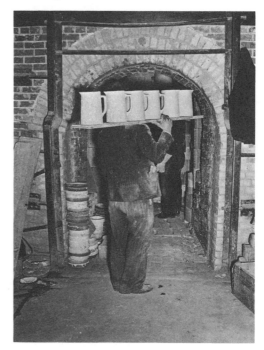

Loading the round downdraft kiln.

"We are nearly driven to distraction for labor which is trained for our type of work at the plant.

"We had two boys who went into the army early, and, we are given to understand by their brothers, who are still working at the plant, that one of these boys has been wounded three times and the other once if not twice.

"We are wondering if it would be possible for you to have these boys sent home to return to their former employment. We are enclosing their numbers and other information which it is necessary for you to have in order to locate these boys."

The two workers were members of the Adel family, whose association with Medalta dated back to the Twenties.

Even though plants in war production had priority on raw materials, some materials that Medalta required were cut off. Almost from its beginning the Company had purchased its stains for glazes and slips from the Blythe Colour Works in England. In 1941, Philipson had to turn to B. F. Drakenfeld and Company of New York because of interrupted service from Blythe.

For obtaining other materials, Philipson relied on his ingenuity.

"During the war, zinc was absolutely off the line for private industry. I said to myself, 'They're not going to beat me.' So, I wrote to Cominco in Trail, B.C. They used to throw away what they call 'chimney zinc.' They'd clean their chimneys and they had tons and tons and tons of zinc to throw away. They had one kind that was pretty much the same all the time and they had no use for it. We bought it for next to nothing.

"I tested it and found it had seven per cent lead which was fine because I was cutting down the lead. There was one undesirable element and I found something right away to counteract it. I was putting it in the glazes. We used to buy it and buy it and buy it, and then the guys found out what we were doing with it and, Bingo! The price went up."

Philipson did the same thing with cobalt. Before the war he'd ordered the cobalt he required from Belgium.

"So, I bought it from Eldorado Mines, Ontario. Theirs had contamination. But, in no time—maybe it was luck—I found a precipitate. I got by."

Eventually, Medalta had to curtail its public service program. The Company sold prepared clay and glazes to educational institutions from coast to coast, including the Art School at Banff, The Edmonton Museum of Arts, the Vancouver Art School, and the Junior School of Art in Calgary. In addition, they provided a question and answer service to elementary schools, high schools, and technical schools.

"We have built a small kiln at school and would like your advice on the matter of temperatures," W. F. Irwin wrote in 1941 from the Western Canada High School, Calgary. "Prof. Worcester of Saskatoon suggested I fire to cone 05 to 02 re from 1922°F. to 2030°F. Is that correct for your clay? Which one is specifically correct? This is for biscuit, I suppose, then what temperature for glazes such as you commonly use? I have a lot to learn but if I can learn a simple routine for this winter I'll get by.

"I wish I could make another visit to your plant."

Philipson tutored him thus:

"Prof. Worcester is right in suggesting the use of temperatures of 05 to 02 cones. This is a customary temperature used in small kilns and is commonly used in all schools where small kilns are in use.

"The reason for this is the following: the kiln is very small and the temperature quite uniform, and there is no need in going any higher as it would be in the case of large kilns. In large size kilns the temperature would be higher due to the fact that the temperature varies in the different places in the kiln, and to insure a fairly even burn the temperature would be higher.

"Also, it is harder to bring small kilns to higher temperatures, and is hard on the kiln itself. Also, most people using small kilns would like to economize on the fuel consumption.

"Actually our clay should be fired to cone 2 to insure durability and resistance to rough handling. In your case these conditions don't exist and therefore cone 02 will be most satisfactory.

"Our glazes are set to mature at cone 2, but you could get some soft glazes which will mature at almost any temperature. We are using only one glaze of this type, but unfortunately this glaze is rationed by the government and we would not be able to sell any of it. However, should you want some low burn glazes you may purchase them from the States. Our ordinary transparent glaze will be quite satisfactory at cone 02 and we could supply you with this one."

And, to Mrs. Peter Haworth of the Central Technical School, Toronto:

"Our modelling clay which we supply to most of the Western Canadian Public Schools, High Schools, and Technical Schools, is a ready prepared clay and is to be used for modelling without any additional treatment or alteration. This clay will take a lot of punishment and even amateurs who do not know how to handle clay carefully will find this clay very satisfactory.

"This clay could be fired successfully from 950° to 1170° centigrades (cones 010-2). Such a heat range would correspond with the temperature stated in your letter.

"This burns to a buff color at cone 010 and darkens to a cane color at cone 2. It is mined in our Saskatchewan mines.

"As far as Alberta clays are concerned while they are quite good for heavy clay products, they are not fit for the manufacture of pottery because of their high contents of iron. However this should not discolor your transparent glazes if the iron particles are in the clay body. Unless this

clay is to be used in a transparent glaze. This could be overcome by introducing certain chemical treatments, but why bother about these clays when we have much better ones at the same cost.

"Should you wish to procure a clay to be used in glazing we would highly recommend our ball clay. This is a pure white clay and when cured, is free from all contamination.

"We also have a pure white modelling clay but requires more skill in handling. As far as supply is concerned you may purchase our modelling clays or glaze clay in any quantity (not less than 100 lbs.) for an indefinite period.

"Concerning glazes we may say that we have glazes in almost any color including clear glazes. Our white opaque glaze has a high covering capacity that when applied on a buff body it will still retain its whiteness. These glazes are prepared in a liquid form and are usually at a specific gravity of 1.5 which you either could lighten by adding water or make it heavier by removing excess water. These then mature at cone 2."

The public service program, once it became known and used by schools and private individuals all over Canada, started to encroach upon the Company's business time. Ed Philipson and Tom Hulme were both too perfectionist not to take pains in providing the service.

"We encouraged art. We had a program to supply clay to schools and fire it for them. They would send in raw stuff and we would touch it up, glaze it and fire it. We were sending it all over. Later on we had to quit it. Tom Hulme was such an artist. He couldn't stand their rough art so he used to do it over to make it look decent."

Philipson did what he could to bring the plant up to date physically, mechanizing a number of procedures that had been done in the same fashion since the plant's beginning more than 25 years earlier. Where traditionally cups and teapots had been arranged on large heavy wooden bats to be carried by hand to the tables where the women added spouts and handles, conveyor belts were installed.

When his best jiggermen went to war, Philipson designed the first automatic jigger. The idea, Philipson claims, was later stolen by Miller, an American company, because Philipson had only the Canadian patent on it. The company made its own steel dies for a variety of items, such as

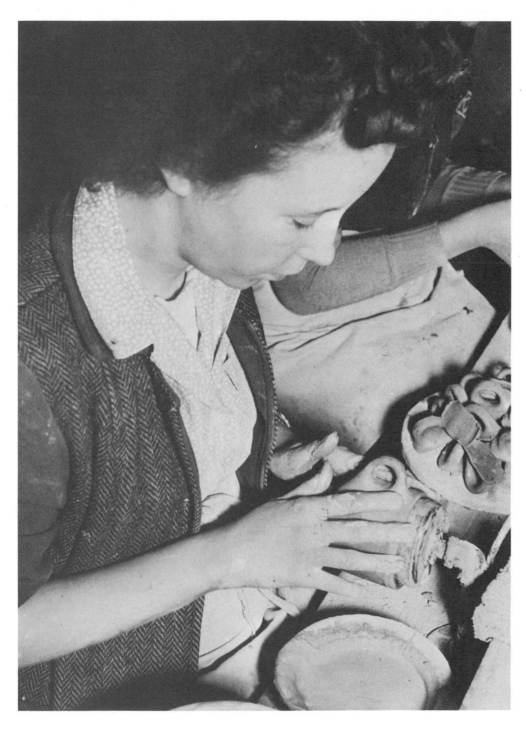

Attaching handles to mugs.

saucers and cups, which speeded up production a hundredfold. Another invention of Philipson's, the patent for which was to become a valuable part of the Company's assets, was a steel die for a cup with a handle already attached. This was designed to counter the Government's objection that bacteria could work into the slightest pocket that might form between cup and handle when the two were moulded separately.

Before he finally got his tunnel kiln, Philipson added one more round kiln, 14 feet in diameter, for artware alone. Previously, artware had been fired in the larger kilns, but the older kilns didn't afford the proper temperature control Philipson required.

Safety standards for the employees were slow in coming. According to one employee, Medalta's "first aid kit" consisted mainly of band-aids, which were dispensed to the women to soothe fingers rubbed down by sponging. In January of 1941, the Workman's Compensation Board, after a routine check, ordered Medalta to:

Replenish first aid kit

Provide a record book of all accidents

Secure respirators for workmen handling lead, and

Place a guard on belts, pulleys and other moving machinery.

It took a bizarre accident a few months later to get the Company to tighten up on safety precautions. Miss Alma Main caught her hair in a vertical shaft and, according to one eye witness, had her scalp torn off in the accident. The WCB accused Medalta of a violation of safety regulations. In his reply, Philipson defended the company's safety program:

"We must say we have always carried out the Inspector's instructions to perfection plus additional protection, which we always added on 'just in case.' In conclusion we would like to state that we have always protected machines far more than it was required and as far as this accident was concerned, there was no negligence on our part."

On July 21, 1941, Medalta's safety committee—C. Stickle, Adela Weiss, Tom Hulme, and E. Sailer—reported to the WCB: "At least 12 safety guards were put in to care of shafts and other moveable parts." By October, they reported the installation of two new lavatories to accommodate a doubling of Medalta's employees from 50 in 1939 to 106 in 1941. Women from that point on were required to wear hair nets.

As the War interrupted the flow of goods across the Atlantic, it left a large gap in the domestic pottery market and an opportunity for Canadian potteries to take over the business temporarily abandoned by the British, Germans, and Belgians.

"The way the War is going at present means that European goods will be more difficult to get into Canada," Tom O'Connor of Johnson & Barbour wrote Philipson around 1940. "Sovereign Potteries at Hamilton are extending their Plant and are unable to keep up with demand. If you had more equipment at your command, the time is ripe for expansion into light dinnerware and a number of items not now procurable.

"I expect to get a lot of business in vitrified ware in the next month as the large accounts will be getting low on Belgian and Bavarian goods. A large German importing house had huge quantities of the green vitrified hotel ware on hand and I'm told these stocks are getting low.

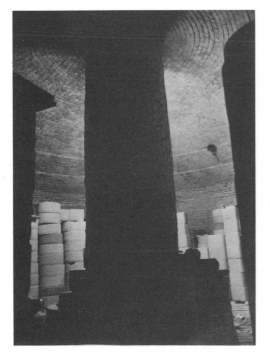

Interior of round downdraft kiln at Medalta Potteries (1966) Ltd., at Redcliff, Alberta.

"Can you make the Salada Special Teapot in Green? If you can I can get a lot of business away from Japanese importers on this line as our white lined green is not competitive with Japanese and unfortunately our people won't be patriotic when it costs them money.

"Sovereign Potteries are getting most of the white vitrified hotel ware. If I had money I would most certainly invest it in a pottery.

"I believe we will have a large expansion of population in Canada in the next 10 years and as a consequence a better and larger home market. A good large tunnel kiln for special jobs would be worth a lot of money later.

"Two or three small companies have started producing pottery since the war and are turning out large varieties of goods and selling at prices we cannot compete against. One company is installing a large tunnel kiln for dinner ware production. Mr. Cumming should look into this.

"Of course, Eddie, I am only telling you this as a friend and if it is useless information, just throw it in the waste paper basket."

From Vancouver, Ben Cunliffe wrote in March 1940:

"I think that orders for the hotel ware will be forthcoming soon. The fact of the matter is that all the jobbers here had ordered heavily of the English vitrified ware in expectation of shipping delays and as a consequence it has been hard to break in. Now they are beginning to really experience

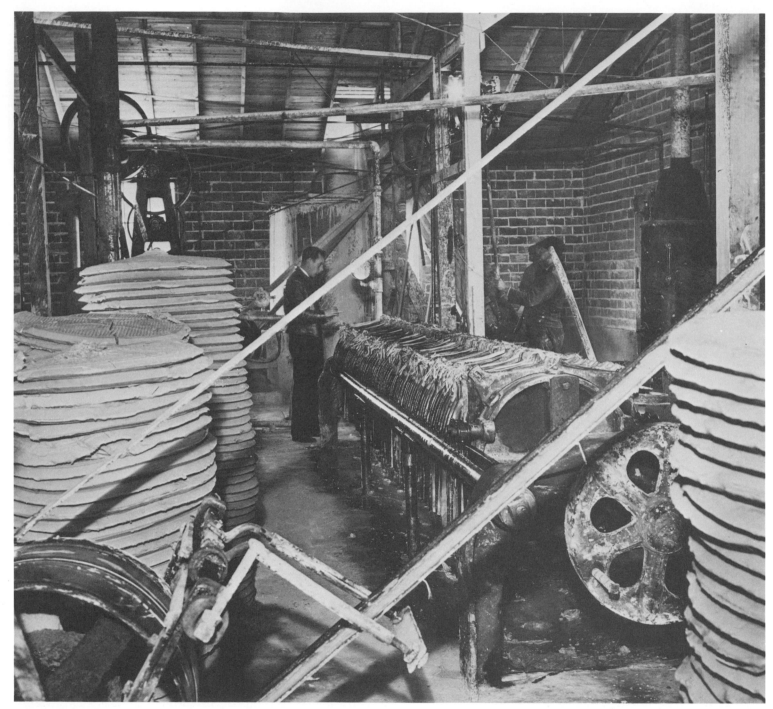

Filter press with filter cakes stacked and
ready to be pugged.

the delays and I think we will be able to break in if your product stands up."

Medalta's product wasn't standing up, yet. Philipson was still experimenting with his new white clay body. By mid-1940, Medalta was making its wares exclusively out of the white clay, but firing and glazing problems still had to be worked out.

"At present our hotel ware is fired to cone 10 high. This temperature produces quite a vitrified body, but by no means as good as the English vitrified ware," Philipson explained in May. "We have a white cheap body ready and have had it tested thoroughly. It is good, pure white, works nicely, etc. There is only one thing: it has to be burned to a very high temperature, about cone 12 before it is hard, safe for glazing. We are going to do this."

By May, Philipson could promise:

"As for your inquiry about being able to get the ware a little thinner using the new white body, I would like to say that we can get the ware just as thin as any made English ware. The reasons are as follows: First, we are making setters and by using them we will get the plates perfectly straight whether they are thin or not. We have also changed the saggers to eliminate any kind of sand roughness. Any ware will be made very light except the one-burn ones. These have to be made slightly heavier or else they fall apart on dipping. We have also started to use pins instead of stilts. This eliminates all wiping and rough bottoms. In general I may say that when we get going on all this we should be able to get real nice ware. The reason we couldn't do it before was because we were kept so busy on making new glazes and changing them around that we have neglected in perfecting the kiln part."

Even as the Canadian domestic market was cut off from its European suppliers, there were still the more experienced and better equipped Americans to contend with.

Cunliffe sent Philipson an American-made sugar and cream set as a sample to be emulated, commenting:

"This is the sugar & cream that I had in mind to match the plate sample which you sent to me. . . . Just note how these sugar & cream samples are finished, this is the kind of selection we have to compete against. I know you will say that the plate you sent me is just as good, I acknowledge

that it is, but if I get an order for five hundred, one hundred & fifty of them will be out of shape or encrusted with sand or something. I just ran through about 200 pieces of Homer Loughlins Fiesta ware in the 5¢ store this morning and I didn't find a piece which I could condemn & this undersells us although it has paid duty, sales tax, excise tax and freight from the Eastern United States so get those people of yours up on their toes."

But, the home market had to take a back seat to the Government. Medalta fell far behind in meeting its commitments to its agents, who were trying their best to maintain business as usual.

"It is no good saying that it is the war that intervenes," Cunliffe complained to Philipson in July 1940, "for the Government is drilling it into the ears of all the manufacturers that their production must go on as usual, so that wages can be paid and taxes can be paid, in order to pay for the war."

What exasperated Cunliffe more than anything was Medalta's unwillingness to admit that it couldn't meet a delivery date. Orders were accepted as usual; they were delivered when the company got around to it.

It was three weeks before Christmas 1940:

"Honestly Ed, you have me worried stiff, you see a date does not seem to mean a thing to you, on the other hand in the relation between seller and buyer, that is between me (Cunliffe) and the customer, a delivery date is something almost sacred for the success or failure of a transaction particularly when a dept store depends almost entirely on the goods being available at a certain date when all preparations have been made oftentimes weeks beforehand, to sell them. For instance take this babyware for Spencers, it is in their Christmas catalogue, they have spent good dollars to have a color page advertising our ware and for the last two weeks they have been having to turn down the orders which would have paid for it because we have not made delivery during the estimated time. Cant you see just how disgusted people get dealing with us?

"Can't you see also what this kind of thing does to me personally? I work on a commission and when delivery is not made to any firm I cannot sell them more goods until they get goods already on order. Also I get no commissions and eventually I starve to death. This may seem a small

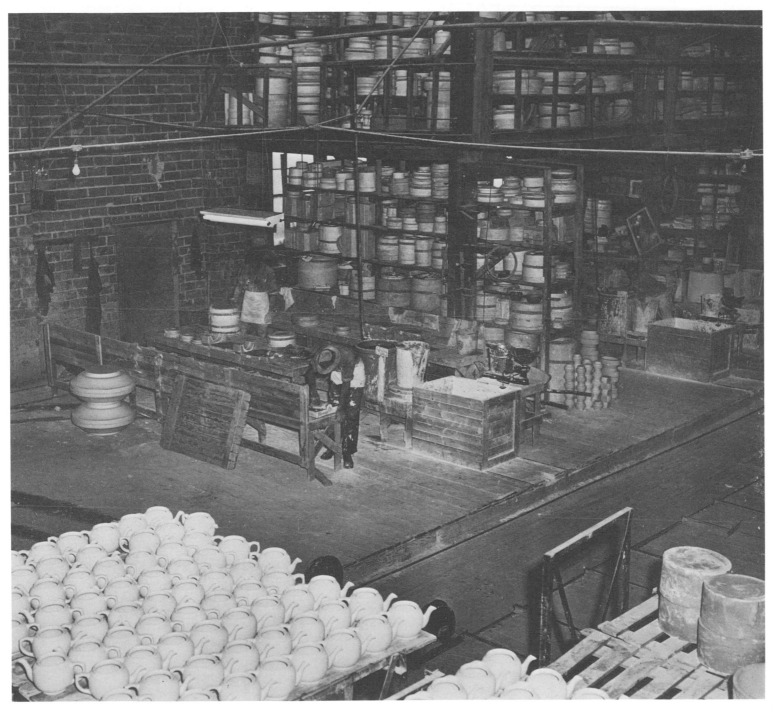

Interior view of the Medalta plant, mould storage, and manufacturing area.

matter to you & perhaps it is in the cosmic scheme but to me its a damn painful thing to look forward to. So-o you'd better mend your ways or in desperation I'm likely to come down there and exterminate the whole lot of you.

"In your letter you said to go ahead and take the order it could always be cancelled if you couldn't fill it on time, that however can't be done if one wishes to stay in business and keep the confidence of the customer."

By December 17, Cunliffe had lost all hope but not his sense of humor:

"Thanks for your letter of December 12th but it does not give me much satisfaction. I spent $4.25 phoning about Spencers nursery ware and you write and tell me about Marshall Wells nursery ware, what a headache.

"What I can't understand is how you all get into such a hell of a muddle. I have just been checking off on my copy of the list, which I sent to you in the middle of November, the deliveries in this car and there are still orders sent in March/April still undelivered.

"If you look at that list you will see my footnote asking you to let me know if any of the orders thereon could not be shipped in the November car, that way I could have notified my customers and given them a chance to get goods elsewhere, but did you let me know? No, you let me go blundering on expecting, since you did not so advise me, that everything was going on swell and the orders would be here at the end of November, even when you did let me know that the car would not leave until Dec 7th never a word to tell me that half the goods on order would not be on the car.

"Can't I get you to understand that it is much better to tell a customer that he can't get the goods when he wants them than to take his order for a date and then let him down.

"That is what this bloody war is about—making promises and not keeping them. Honestly, Ed, sometimes you make me feel like coming down and murdering you.

"Speaking of coming to Vancouver for Xmas, Ed, don't forget that I told you we had a spare bedroom. Tell the old man (Cumming) you are going to have a nervous breakdown if you don't get away for a few days."

And, in response to yet another missed delivery date:

"If Mr. Hitler had charge of you all your heads would be chopped off if you could not synchronise any better than that."

After writing to Philipson, Cunliffe had steam to spare for Stone and Perry, too.

Stone heard from him in January 1941:

"It always seems that if an error is made the factory follows it up with another two or three just to show their contempt for the customer. Can't something be done about it? The way we treat customers it is a wonder we have any."

And, Perry in March:

"Don't let down on your efforts to improve the fireproof qualities of the Green and Brown fireproof ware. I had a session with the C.P.R. here last week and they were very skeptical about our ware as the steward of the Vancouver Hotel after his experience with the shipments they received had advised the purchasing dept that he wanted no more of it."

Perry tried to placate him:

"No doubt, Mr. Cunliffe, you are aware of why most of our goods are not right. A great many of our moulds are not in shape. Our whole plant has been run on as cheap a scale as you could possibly imagine and everybody is rushed from one place to another and our goods haven't been properly checked, let alone properly made, however I am doing the best I can to have all those loose ends picked up."

There were some bright spots in Cunliffe's dealings with Medalta during the War years.

"Now I've got that off my chest and I hope it makes some impression on you, let me tell you something good. You've made a hell of a good job of the bisque jug. If the decorated ones. . . . are as good, I think we've got something."

Cunliffe had sent Philipson a plaster block for a jug sculpted in a bust of Winston Churchill. The Vancouver agent had a timely idea and he had copyrighted it. Medalta's Churchill jug was a big seller.

While Cunliffe was pleased with what Medalta did with his Churchill jug, another jug the Company turned out at the time provided considerable reason for complaint—it stank.

"Enclosed is a hot water jug returned by a customer of the David Spencer Co. Ltd. You will notice that it is badly crazed inside & that the crazing apparently exudes some kind of salts. The worst feature however

is that if you take off the lid it stinks & was returned for this reason. The pot has been boiled to try and eliminate the smell but it still stinks. The pot has never had in it anything but hot water; why should it stink?"

Medalta's smelly jug may have been the only one of its kind, but, that same year there seemed to be an epidemic of Medalta teapots dropping their spouts—all in one neighborhood in Edmonton.

"Last Thursday, my husband bought from the Hardware Store on Norwood Boulevard a brown teapot made by your company. I was examining it and happened to pick it up by its spout which came right off in cutting my fingers very severely. My husband took it back, the storekeeper made an exchange. I made tea twice, then my husband happened to do the same with the second as I done with the first, pick it up by the spout & that one came off in his hand but did not cut his fingers, so then I thought there must be a flaw, or maybe someone working against the company, anyway I felt you ought to know how the teapots are, so I am writing you & hoping you will understand I have wrote this with the best intentions."

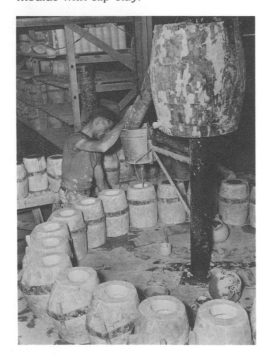

Slip-casting operation, filling plaster moulds with slip clay.

Philipson sent the Edmonton lady "a fancier teapot, much superior in quality" and promised to conduct a general check-up in the plant to remedy the flaw.

A few days later a thank you note arrived from Edmonton with more bad news:

"I think there must be something wrong somewhere, for my friend Mrs. Jordan came to visit me & of course the subject came up, she told me she bought one & hers done exactly the same, the spout came right off in her hand, but she never bothered about making a complaint, she just passed it up saying wouldn't buy anymore of that make. However, we both agreed it was a generous gesture on your part to send me a much better teapot."

Despite the war, Medalta managed to introduce in the time and space left over from filling Government orders a number of new lines for the home market. In 1940 and 1941 the Company made perfume bottles, barrel-shaped marmalade containers, candlestick holders, flower blocks, and a line of maple leaf bowls as a cooperative advertising item for its long-time customer, Ogilvies Flour Company. With his new white clay, Philipson started a line of decorated crocks.

Mould showing the slip-cast lamp base ready to be removed.

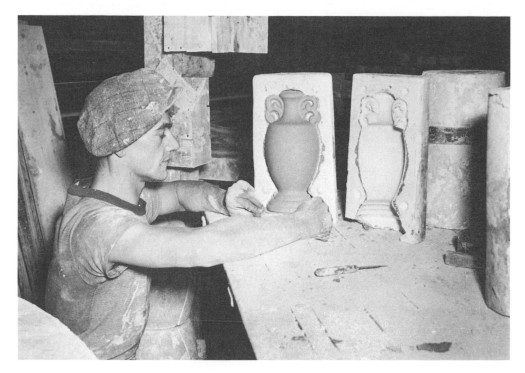

Stone ginger beer bottles came in briefly for a revival in 1940. About that same time, Medalta pulled its lamp bases out of the Eastern market and sold them exclusively through its Vancouver agents. Toronto lamp manufacturers, however, continued to procure their bases from their familiar source, the Medicine Hat Pottery Company, which was now owned and supplied by the Yuill family and managed by a man named Clark.

Clark was convinced that there was a huge market for mixing bowls and managed to convince Yuill to take advantage of it. However, the Medicine Hat Potteries wasn't equipped to make them. But, there were two idle kilns out at Redcliff that no one had given much thought to since Martin Perry and Shorty Matuska wound up the Alberta Potteries a few years back. Yuill, who shared ownership of the Medicine Hat Potteries and Alberta Clay Products with other members of the Yuill family, reopened the Alberta Potteries as a private venture in partnership with Clark.

To run the small new pottery, Yuill hired a young self-starter named Luke Lindoe fresh out of art school with no pottery experience beyond six months at trimming tea pot lids and emptying moulds at Medicine Hat Potteries. Lindoe made up for his lack of experience with an eclectic background and an unbeatable philosophy: "I've always believed I can do anything as well or better than anyone else."

Lindoe had spent the first 16 years of his life, which started in Bashaw, Alberta, traveling with his mother and attending 28 different schools in the Western provinces and parts of the United States. He never finished grade 10 and instead weathered the first two years of the Depression "bumming around in the back country of B.C., not because there was any work there but because my mother was a romantic. We lived there for two years, just surviving, only rabbits around and turnips. . . . but better there than in the city without work."

When he decided to go to art school, Lindoe looked up his father, who was general manager for two mines in Coleman, Alberta. "I decided who I wanted to be and deliberately formed my adult person. I needed to make money and my father—a realist, a pragmatic—knew how."

Lindoe acquired the $250 per year he needed for art school by mining coal underground. He studied painting and later sculpture at Alberta College of Art in Calgary for four years without taking a diploma. "I didn't finish the required 800 hours because I was always away working. I kept being cited for scholarships, but they always went to someone else. 'Oh, Lindoe will make the money,' they reasoned."

He then went East to attend the Ontario College of Art, studying sculpture until he ran out of money.

"There I was introduced to ceramics. I had to pass through the ceramics shop to get to sculpture. But, you needed a pass to get into the shop at night and they were hard to get. One evening I found one of the staff sculpting a model of a horse and having a lot of trouble with it. I helped him out.

" 'How can I thank you?'

" 'Let me in here evenings.'

"He was so pleased. He gave me a pass, but very reluctantly. . . . they were that tight with them."

When his money ran out, Lindoe left without picking up a diploma and went back west to Medicine Hat. While in Toronto, he had met Clark and had worked out some designs for the Medicine Hat Potteries. Clark sent Lindoe to Yuill, who put him to work in the Medicine Hat Potteries.

"I came here because I wanted to learn what was going on. I saw the possibility of a career in design. They had some people on staff they called 'designers' but they were actually decorators."

After six months working at the pottery in Medicine Hat in all capacities, Lindoe was sent out to Redcliff to get the mixing bowl venture started.

"When we got in there, the place looked like it had never got going. It was my first experience in firing kilns. Actually, they were quite easy to fire. The first thing I did was to lift out the floor and clean out the flue. Which turned out to be just the right thing. That meant my thinking was on the right track."

The newly revived Alberta Potteries was a makeshift business throughout. Lindoe worked with a staff of about six, including an experienced jiggerman O. Hehr, an experienced burner, and an experienced clayman. The kilns were outdoors, so their first job was to build a shelter for them. Lindoe rigged up a timer out of copper wire for the old trimming machine abandoned by the Wyatts years ago. For the first six months, the plant turned out only one line of single-burn jiggered bowls finished with a raw red lead glaze.

"Everything was pink all over the plant. We had a female cat and her kitten hanging around the place. The kitten finally went into a fit, ran around and around, convulsed and died. Then the cat. They'd been licking lead off their fur," Lindoe recalled.

"I decided we had to change and asked Yuill to spend money on it, but they wouldn't. That was a factor in my leaving. I went there on the promise that this would be an expansion of the original idea, but I soon discovered that they had no intention of doing this. . . . just bowls."

Lindoe broke with Yuill after six months at Redcliff. Karl Baumler, who was dissatisfied working at the Yuill plant, suggested that Lindoe go into partnership with him in their own business, but Lindoe wanted to move on.

"It was winter of 1941. I quit, packed right away and drove as far as I

could that same day. I got as far as Brooks when my old Dodge coupe sputtered and stopped. I found sand in the tank. I knew right away who had done it. Ollie Hehr was the most experienced and the most difficult man in town to work with...."

Hehr took over as foreman after Lindoe left. Whether or not the mixing bowl business proved as successful as Clark's predictions is hard to determine. The Alberta Potteries was Yuill's own separate company, in no way connected on paper with his family's Medicine Hat Potteries. However, those close to the bookkeeping office of the bigger pottery noticed a considerable amount of raw materials quietly shuttling over to the small plant in Redcliff.

When the war ended, the Medicine Hat area had three potteries looking forward to expansion of a domestic market starved from having had to sacrifice its needs to the war effort. They also had labor problems in store.

For a trade journal, Medalta issued a "Preview of the Pottery Business for 1946":

"In endeavouring to look over the horizon at what is in store for the Potteries for 1946 many problems confront us. The two major problems, however, are getting retooled for peace time, and labour.

"In July 1945 we began retooling our plant for peace time production, and we are still working feverishly at this job. Many new designs have to be developed, and this means starting from scratch to retool. We had most of the drawings ready, but that is just a minor item, and it will be well into 1946 before this work is completed.

"In the meantime, there is so much agitation amongst labour for higher wages and shorter hours, and we doubt very much if we will ever be able to produce merchandise with the same number of hands as we did in 1938 and 1939.

"We do know that wages are going to be at least 50% higher, which, of course, must reflect on the selling price of merchandise. However, this company is not averse to paying higher wages provided the general public is willing to pay the prices necessary to offset increased wages.

"We do know that we will be able to sell all the merchandise we can manufacture, and we are now laying plans to expand our production. The machinery at our plant has been working overtime throughout the war

Pickle Jar

period, and many pieces must be replaced. For this, we have to depend on machine manufacturers throughout the world, and deliveries on some of the machines we require will take from 12 to 14 months.

"As a whole, the picture for 1946 is bright on one side and rather gloomy on the other."

March 28, 1946. MEDICNE HAT *CITY*

Alberta Clay Products Co. Plan Expansion Program

Mr. J. H. Yuill was elected president and general manager of the Alberta Clay Products Co., Ltd., at the annual meeting held this week. Other officers elected included: W. C. Yuill, vice-president; E. T. Eck, secretary treasurer; Dr. H. C. Dixon and Dr. C. A. Campbell, directors.

An extensive expansion program calling for the expenditure of many thousands of dollars was placed before the meeting and endorsed. Proposed plans call for the immediate construction of a $65,000 kiln for the manufacturing of brick; the electrification of the Alberta Clay Products, and a $100,000 addition to the Medicine Hat Potteries as soon as materials and labor are available.

The Alberta Clay has for years been one of Medicine Hat's largest industrial concerns, with an annual payroll of more than $260,000.

Both the A.C.P. and the Medicine Hat Potteries have large backlogs of

J. HARLAN YUILL

orders including orders for more than one million cups and over 800,000 saucers.

To cope with the demand and also to increase production an automatic jig is to be installed, which when ready for operation, will be the most modern of its kind on the American continent.

In addition to being president of the Alberta Clay Products, Mr. Yuill is also president of the Medicine Hat Potteries Ltd.; Alberta Potteries Ltd.; China, Glass Distributors Ltd., Toronto; Ceramic Sales Ltd., Montreal; Alberta Linseed Oil Co., Ltd.; Monarch Broadcasting Co., Ltd., Station CHAT; Monarch Investments Ltd., and the Medicine Hat News.

Canadian Club Meets April 5

Dr. Osman James Walker will be the speaker of the evening at the next meeting of the Canadian Club, which will be held in the Cosmopolitan hotel on Friday, April 5. Dr. Walker, who is head of the chemistry department of the University of Alberta, will speak on "The Development of Synthetics," a subject upon which he is fully qualified to speak. Dr. Walker's special interest in research has been in connection with water supplies and

134

MEDICINE HAT INDUSTRIES...BUILDING WESTERN CANADA

The Little Chief... maker
of Canadian Potteries —
famous across the Dominion

MEDICINE HAT POTTERIES, bearing the "Little Chief" trade-mark, start their journey to the dining tables of the Dominion through the largest pottery tunnel kiln in Canada. This is the final stage of a highly technical ceramic production line which transforms prosaic clay into a sparkling white semi-porcelain ware that's known and used from Halifax to Vancouver Island.

This plant, one of Medicine Hat's many busy industries, gives employment to over a hundred men and women and has played an important part in the industrial development of Western Canada. Established in 1938 to manufacture the highly popular colored dinnerware, Medicine Hat Potteries limited its production during the war to white ware only.

Now, with resumption of peace-time production, the "Little Chief" is scheduled to make his appearance on a much more varied line of potteries, increasing both volume and distribution of the products of Medicine Hat Industries.

MEDICINE HAT POTTERIES
A Division of Alberta Clay Products Co. Ltd.
MEDICINE HAT • ALBERTA

Reprinted from WESTERN BUSINESS & INDUSTRY, *February 1946.*

Chapter 7

Beating out the English with canary
yellow.
Insulators.
The Medalta strike.
"Alberta plate."
Pulkingham and his movie
giveaways.
An industry begins to die.

When the British Ceramic Society met in Stoke-on-Trent sometime in 1946, one problem that had them scratching their heads was: how did an upstart Western Canadian pottery manage to snatch a major account from one of their own? It all had to do with canary yellow, according to Ed Philipson.

Prior to 1946, the Canadian National Railroad had been importing their distinctive yellow-bordered plates from England, but the Railroad wasn't satisfied with the British product. The glaze scratched easily under the pressure of steak knives, leaving marks that trapped unsightly grease stains. The CNR approached Medalta with their problem.

"The English didn't know how to make hotel china; it was not their line. They'd been using a borosilicate glaze. But, for a hard glaze I'd want to use a lead silicate glaze, and it would have to be fired at cones 6 and 7. The trouble was you can't fire canary yellow over cone 2; it starts to fade and at cone 6 there's nothing left of it."

The solution? Philipson went back to his englobes. The English had used an underglaze. Medalta applied a yellow stained clay slip which melted into the raw body under firing. Then, a clear glaze was applied over all.

"CNR was completely in our hands. The English couldn't do it. They tried to figure out how it was done. But, that was our secret. We took over all of CNR, half of CPR and we just about controlled every restaurant in Alberta and most of the hospitals."

The War over and a steady, essentially non-competitive business in hotel china assured, Medalta expanded. For payment of one dollar to the City of Medicine Hat, the Company increased its size by the area of one air force hangar, left over from the War. A second, larger tunnel kiln was installed in 1947. Philipson sent for blueprints from Harrop Engineering and supervised construction of the kiln on the site. He used the shorter kiln, which fired at cone 12, for bisquing and the longer one for glazing at cone 6.

"It was such a perfect design—Harrop are well-known for their design—that the dishes that came out of that kiln were sold right away. They just came out perfect at the other end and they were just loaded into cars for shipment. That's how well it worked. And, I controlled everything within 5 degrees and that's the way I like it."

Around that time, Medalta was being pressured by market demands to go once again into production of insulators. Philipson experimented with some insulators, firing them side-by-side in the same kiln with white ware, but the dishes were coming out of the kiln discolored.

"On insulators you use iron glazes, what they call 'traveling glaze,' and it was going right over onto the dishes. I said, 'I'm not going to bother my dishes. Build a porcelain plant. See that lot over there? Build a porcelain plant on it.'"

Cumming sent Philipson on a scouting trip to Harrop Engineering in Columbus, Ohio, and to Westinghouse in Garry, Pennsylvania, to absorb information on insulator manufacture. On his return, Philipson designed and supervised construction of a porcelain plant just across the tracks from Medalta's front door. The plant was equipped with machinery Philipson purchased in the United States and with a stationary kiln designed by Philipson on the basis of the fire zone of a tunnel kiln. National Porcelain was a private venture, separate from Medalta, for Cumming, Philipson, and two other partners. Philipson trained the staff and ran the new plant for six months until it was operating smoothly.

The plant was eventually sold to Motor Coach Industries of Winnipeg when Cumming became too ill to manage it. When Greyhound took over Motor Coach Industries, the bus line had no use for a porcelain plant. Greyhound sold National Porcelain to I-XL Industries of Medicine Hat, a

rapidly expanding clay products industry which had its beginnings with the Redcliff Pressed Brick Company in 1912.

Medalta seemed finally to be heading for a clear stretch. It had a profit-making line and the modern equipment needed to produce it. The bright side of the Company's business outlook for 1946 had materialized. The gloomy side was looming on the horizon. Medalta's workers, who had been unionized in 1936 struck for higher wages. They were organized by William Longridge, international representative of the International Union of Mine, Mill and Smelter Workers. The strike ran for 72 days and before it was settled seven Medalta workers landed in jail, City Council had an election issue, and Medalta lost a lot of money.

The seven men were sentenced to a month in the Lethbridge Jail for participation in picket line fracases. Longridge appealed to City Council to petition the Attorney General's office for their release. In a scathing address to Council, Mayor W. M. Rae branded Longridge an "agent of Moscow," "an individual with a deformed brain, a misfit who admits receiving the gold of Moscow, to either make a tool of me or place myself in an undefendable position." After a heated exchange on the issue, Council voted against interceding in the labor dispute.

The strike was dirty and violent, and according to Philipson, totally unnecessary.

"That was not the fault of labor. Their wages were poor. I always worked hand in hand with the unions. They helped me. But, Cumming's attitude was that unions were to be fought with."

In Philipson's opinion, Longridge was a "trouble-maker from Calgary" who had no business representing pottery workers. The workers themselves became pawns in a power struggle that got out of hand. Philipson blamed the hostilities on Neil German, Cumming's son-in-law and Medalta's lawyer.

"He's a lawyer and a Rhodes scholar—one of the smartest men to ever practise law . . . too smart for his own good. He got so stubborn. He said 'We won't give in. We won't give in.' And there was no necessity. Seven men went to jail for nothing. That was one of the dirtiest strikes ever."

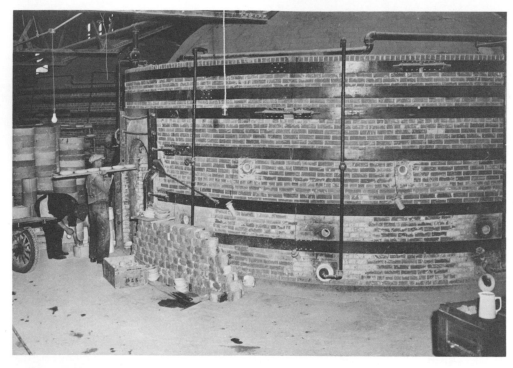

Loading the round downdraft kiln. Pitchers will be placed in saggers which stack.

Throughout the strike Philipson provided his picketing workers with hot coffee. Cumming and German won their point when the court declared the strike illegal. The striking employees were all fired and had to negotiate from scratch when the strike ended, but the Company later gave them back their seniority.

Meanwhile, up the road Hop Yuill's 100 employees, if not better paid than Medalta's, were working under better conditions. Modern safety devices were built into the design of the plant, as were windows and sky-lights sufficient to create a bright, naturally lighted atmosphere. Employ-ees worked to music and radio programs piped out over a loud speaker system controlled from the office.

Even though old Grampa Yuill had scotched Hop's time and motion study, the management had the most precise gauge of each employee's productivity in the person of superintendent Karl Baumler. Baumler, in the memory of those who worked under him, personified the Germanic stereotype—strict, brilliant of mind, rigid in his passion for order, and intolerant of any sign of untidiness or lack of discipline.

Wally Fode, who worked under Baumler, recalled:

"Every morning he'd tour the plant. You could set your clock by him. He'd walk down the aisle, not looking left or right, and go straight to the foremen—first the kiln foreman, then the jigger foreman, then the clay foreman—and then he'd go into his office and shut the door. A minute or two later, you'd hear his voice over the loud speaker system: 'So-and-so report to the office.'"

Any worker who had been sloughing off during Baumler's rounds would be summoned for a reprimand. Baumler knew his staff all by name and kept close scrutiny over their daily production sheets. Those who worked with him claim Baumler could look at a finished piece of ware and identify precisely what had gone wrong, with one exception.

"Our white ware was coming out with little black specks and we couldn't figure out what they were or where they were coming from," Fode recalled. "One day I was up on the roof opening a window. It was too hot in the plant and I was letting some air in. As I was coming down, these little coal ash specks rained down on me and got in my eyes. Baumler was standing there watching: 'That's where our specks are coming from.'"

The jiggermen were a class by themselves: the only employees who flagrantly resisted controls and got away with it. Ollie Hehr, John Herter, Entzminger the jigger foreman, Metz, and Kidair were the pottery's most skilled employees with years of training and experience that was irreplaceable. For over two decades, the only jiggermen in town were Medalta's and Yuill had lured away the best of Medalta's lot. Working on a piece-work basis at a furious pace at their wheels, each turning out thousands of pieces a day, they couldn't resist competing with each other. Each had developed his own distinctive pattern of movement, either standing or sitting. Metz, the fastest of the group and the jiggerman who could claim the least loss of ware, set the pace and frustrated the rest by going home early after completing his self-imposed quota that none of them could match.

The jiggermen worked with one eye to the wheel and the other to the next man, spurring their young mould runners on to ever faster feats. Mould runner and jigger were a team and the boys would be paid from the jiggermen's earnings. So, the men even competed for the fastest mould

runners. The jiggers were a hot-headed bunch and it was common to see two jigger wheels standing empty while their occupants stepped out back to indulge in a fist fight. Their steam uncorked, the men would return to their wheels and resume the pace.

Yuill didn't always end up with Medalta's best workers. One of his mould runners, a dull-witted fellow with less than a grade four education, had been let go by Medalta. This young man had the unique ability to fit 13 moulds on a rack which was designed to carry 12.

"Hey, we only want 12," his jiggerman would yell.

"That's what you got," he'd reply.

Burning the kilns for Yuill out at Alberta Potteries had to be one of the most enigmatic characters ever to come out of Medalta. Shorty Matuska, after a stretch as Philipson's burner, had made his way back out to Redcliff. Having started at Medalta in the 20's as a handyman, Shorty was an experienced burner by the 40's, and was keeping his trade secret to himself.

Yuill was still running Alberta Potteries on the side, relying on the expertise he had employed at the Medicine Hat Potteries to help his small staff in Redcliff. Shorty was totally in charge of burning the kilns at the Redcliff plant. Shorty knew his business and could turn out a fine kiln of ware. But, every once in a while the kiln at Redcliff produced a bad lot of ware, some of it underfired and unsalable. These occasional bad kilns were a mystery to all who were called in to examine them. Shorty blamed it on the glazes. Whatever the problem, every bad kiln cost the company thousands of dollars in lost wares.

"One night I was visiting a friend in Redcliff and decided to stop in over at the plant," recalls the man who was glaze foreman at Yuill's larger plant at the time. "It was two or three a.m. Shorty was there alone. He didn't see me come in. His back was to me and he was standing there by the kiln manipulating a big, long iron rod through the opening. I didn't make any move to let him know I was there after I realized what he was doing. He was laying the cones over so he could close up and go home!"

Shorty wouldn't teach anyone else how to fire a kiln, but hated to stay late into the night waiting for a firing to finish.

"I used to tell him you can light it in the evening and regulate it so it

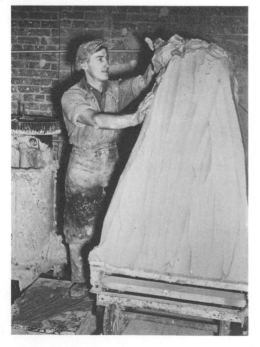

Soft clay for jiggering operation.

would fire during the day. But, no. Shorty wouldn't listen. He was stubborn. One day it was a very bad kiln—thousands of dollars involved. It sort of put me on the spot. So, I took Shorty aside and told him what I saw. After that there were no more bad kilns."

Employees at the Medicine Hat Potteries were paid on an incentive system, the invention of Malcolm MacArthur, Yuill's cost accountant. The workers received their base pay plus a certain percentage for productivity. But, according to one employee at the plant, no one could ever figure out how the system worked.

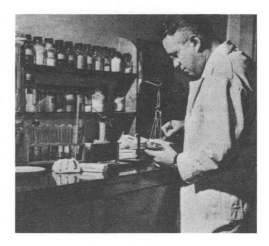

Karl Baumler

"Finally, one day I went in to Mac and asked him how come one pay day it was two per cent, another it was seven per cent, and another it was five per cent."

"Well, if you make too much money, I just take the figures out of my head."

MacArthur took over as general manager in the late Forties when Baumler left Medicine Hat, some say in disgust, to pursue a more rewarding career in related industries in the United States. The German ceramic technologist, who passed away long before this history was attempted, became something of a legendary figure in Medicine Hat's ceramics industry.

According to one man who worked under Baumler for ten years: "Karl just got sick and tired of working for peanuts. When he left here, he went to Lincoln, Illinois, to run a pottery and ended up running eight places from a private plane."

Another former co-worker of Baumler's claims to have run into him at a ceramic engineering convention in the United States not long after he took leave of the Medicine Hat Pottery Company.

"Karl was excited, talking plastics. He'd heard that plastics would be the next big thing and he was planning to get in on it."

Others say Baumler eventually took a position with Corning Glass Works in New York State, but Corning claims to have no record of his employ.

The German once told MacArthur that he had made by hand the dinnerware that had been used on board the dirigible Hindenburg. Another man who had worked with Baumler says that he had heard this story and

once asked Baumler about it. Baumler neither confirmed nor denied it.

Whatever the truth to the Hindenburg story, Baumler was highly respected by nearly all who worked with him as the most knowledgeable man in Medicine Hat's ceramics industry at the time. According to one source, Baumler should be credited with some of the glaze and clay developments which paved the way for Medalta's upsurge after he left the plant to Philipson in the late Thirties.

When MacArthur took over from Baumler shortly after the end of World War II, the Medicine Hat Potteries resumed production of colored dinnerware, which Baumler had introduced during the plant's first year of operation with little success. According to MacArthur, Yuill was reluctant to get back into the line.

"It damned near killed us before," Yuill objected.

But, the plant's years of experience with streamlined wartime production techniques were not to be discounted. MacArthur convinced Yuill to give the dinnerware line another try.

"You see, I had inherited Karl's knowledge. Where Karl was only

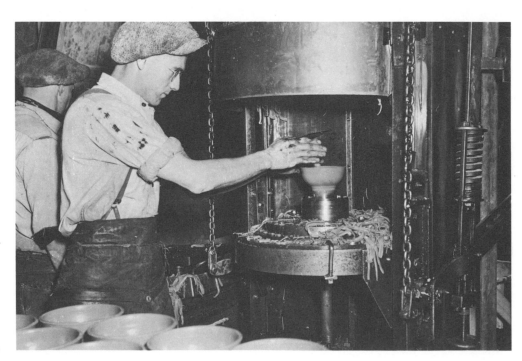

Bowl machine.

turning out 65,000 pieces a month that first year, I got out 350,000 the first month we tried it after the war."

When the War ended, Yuill's plant went back to making colored dinnerware as a staple. Even with its streamlined plant and Medalta's trained help, however, the Medicine Hat Potteries was nowhere near as successful with its dinnerware as Medalta was with hotel china. Yuill was competing in a market where he was up against experienced European and Japanese companies which had the advantage of cheap labor. When plastics came in after the war, the pottery still wasn't paying for itself after nearly 10 years in production. Alberta Clay Products, which commanded Western Canada's building brick and tile market and which was the major supplier of drainage and sewer pipe as far east as Sarnia, Ontario, still carried the pottery with its excess profits.

The Medicine Hat Potteries had continued to make stoneware throughout the war years, firing its crocks, water coolers, churns, and beanpots in the small beehive kiln outside the plant. Later, to get around foreign competition, the Company decided to create a line that would appeal directly to North American taste. The result was the "Alberta Plate," which was decorated with scenes depicting Canadiana. By going into specialty ware, Yuill hoped to cut out for himself a non-competitive market. The plant shipped carloads of specially designed cups without handles.

The Yuill plant tried to capitalize on souvenir items, grasping at any new line that might possibly sell. A former plant foreman recalls a figure of a fawn designed by Baumler—the Bambi. Canadians were probably never aware that Bambi was made in Medicine Hat. Stamped on its hoof was the word "Indian," which didn't necessarily have to mean "Made in India," or "Made by Indians."

While at the plant level Medicine Hat's two potteries were busy retooling after the War to make their comeback on the domestic market, dealings were afoot behind the scenes at the top management level which were to lead to another major change in Alberta's pottery industry in the mid-Fifties.

On January 22, 1945, Medalta's shareholders received a form letter offering to purchase all shares and bonds. Two weeks earlier, Cumming

had written the shareholders the following words of persuasion:

"Your directors have received an offer for the complete outstanding issue of Bonds and Shares of Medalta Potteries Limited.... The company has benefited from the War, but now, increased taxes and wages with ceiling prices, make business more difficult. After the war there will be renewed competition. Your Directors, therefore, feel that you will probably wish to accept this offer." ($100.00 for each bond; six shares for $100.00)

In June of 1946, the Director of Companies in Edmonton received a complaint from W. L. Geldard of Vancouver, a Medalta shareholder.

Geldard complained that he had not received any dividends in the past year and, in fact, he had been urged to sell out by Mr. Cumming, who had paid him a personal visit. Geldard sought an investigation, citing "high pressure letters" and personal visits by directors to Medalta shareholders.

By the end of 1947, Medalta had a new board of directors, Messrs. March, Hall, Janes, Melville, and MacKay, all of Montreal and Neil German of Calgary. Philipson was later named a Director, but the Company was essentially owned by March of Montreal. Philipson still had control at the plant level, but, in 1952, the Eastern management changed hands and a group from Hamilton, Ontario, headed by a Mr. Pulkingham took over. Pulkingham was one of the founders of the Sovereign Potteries in Hamilton, which also turned out hotel china in the 1940's and which was, overall, a larger plant than Medalta.

"We were making a terrific profit at the time," Philipson recalls. "That was the first time we were in the black. We always used to be in the red. And, this Pulkingham came to me and said, 'We're going to quit making hotel ware,' and it about knocked me over. We had a terrific line in hotel china, no competition. We didn't have to be afraid of the English or the Japanese or the Germans. They didn't make that kind of stuff. We also had a terrific business in artware.

"You know how it is when sometimes you meet a person and after ten minutes you feel you've known him all your life and you like him. And, then you meet someone and right off you say, 'Uh, uh.' When Mr. Pulkingham was introduced to me, I took one look at him. I said to myself, 'This is it. I'm finished.'"

MEDICINE HAT INDUSTRIES . . BUILDING WESTERN CANADA

50 MILES

of
FLUE LINING

to keep Canadian Chimneys *Safe, Clean and Efficient*

MANY a freight car, bearing a part of the more than 50 miles of flue lining and 60 miles of 4-inch sewer pipe now on order at Alberta Clay Products Company, Limited, will rumble east—or west —from "The Hat" this year. This is today's important contribution to Canada's post-war building by a clay products industry started in Medicine Hat forty years ago— where abundant natural gas for firing and plenty of clay for material quickly made it one of Western Canada's most important industries.

The glass-like, salt glazed sur-face of Alberta vitrified clay flue lining provides a clean, sootless chimney with full draft and con-sequent efficient fuel consumption. Its tightly jointed lengths eliminate leaks to cause draft and heat leaks with accompanying fire hazard. Chimneys constructed with this flue lining require approximately 200 less bricks for every three feet of chimney . . . economical to build! Equally efficient and equally desirable for building is vitrified clay pipe for sewers and house drains.

In supplying this superior clay product to help build the buildings of Canada, this pioneer industry is helping to build Western Canada.

ALBERTA CLAY PRODUCTS CO. Limited
Medicine Hat, Alberta

Pulkingham, according to Philipson, was strictly an earthenware man. The new owner from Hamilton had his eye on the movie giveaway market.

"In those days, the colored dishes came in—bang, bang. And, he had it all worked out. He claimed he had three million dollars worth of orders for the movies alone. One night they'd give you a cup; the next night they give you a saucer. You keep coming back and you could collect the whole set."

Pulkingham called a meeting of the Board of Directors and presented his scheme. He had calculated that it would take two weeks and $20,000 to convert the plant to earthenware. Philipson's estimate was six months, during which there would be no production, and $150,000.

"He didn't like my remarks. He comes up to me the next day and says, 'Mr. Philipson, we don't seem to see eye-to-eye. I think you should resign from the board of directors.'

"Next day I went in to him and said, 'Here is my resignation as director; here is my resignation as manager; here is my resignation, period. How long do you want me to stay?'"

Philipson was a professional engineer and abided by the ethical code of his profession, which said that six months notice must be given for resignation. Pulkingham held Philipson to his obligation for the full six months.

By the time Philipson left, Pulkingham still hadn't completed conversion of the plant, and nearly $175,000 had been spent in the process. Meanwhile, Canadians were just becoming captivated by television and ventured out less to the movies. According to Philipson, most of Medalta's movie giveaway orders were cancelled.

A letter dated January 31, 1955, arrived at the Companies Branch in Edmonton signed by Medalta's office manager:

"The situation at Medalta Potteries has been in a state of flux for the past number of months and with the directors all in the East. . . ."

On November 15, a mimeographed statement went out to all of Medalta's creditors to the effect that the plant had closed down in the summer of 1954 and the Company had been insolvent for a "considerable time."

"Medalta Potteries is absolutely without funds and cannot even pay its auditor so as to obtain an audited financial statement for an Annual Meeting."

Glazing operation.

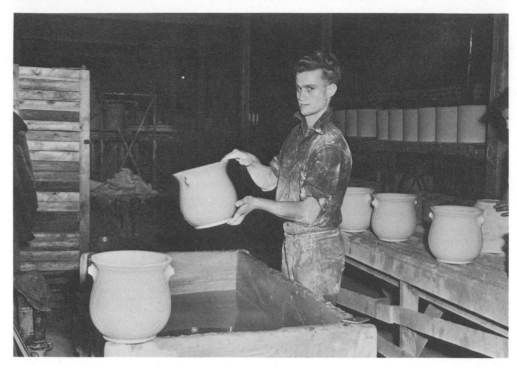

The Company was $585,085 in debt. Medalta filed an assignment in bankruptcy in 1958 and was finally struck off as a registered company in 1965. Listed among its assets, in addition to land and buildings, was Philipson's patented method and apparatus for forming pottery handles, for which the exclusive right and license was granted to the Buffalo Pottery, Inc. (N.Y.) for $110,000.

Meanwhile, the situation at the Medicine Hat Pottery Company and its parent plant the Alberta Clay Products was also in a state of flux. President and general manager Hop Yuill wasn't aware of it. The pottery still wasn't paying for itself. For years, other members of the Yuill family who were shareholders in the Company had been urging Yuill to get rid of the plant. They had never actually wanted to go into the pottery business in the first place. Hop Yuill was the power in the organization, but he did not own 51 per cent of the shares.

Philipson, who went to work for Yuill after leaving Medalta, recalls the day Hop lost his pottery.

"I was sitting around with Hop and Malc MacArthur and Hop got up

and said, 'Well, I have to get to a meeting of the shareholders.' Every year he was re-elected president automatically. A little while later, Hop phoned. He was shaken up. The family had sold the whole shooting match without his knowledge to Marwell Construction of Vancouver."

The Yuill family was no longer in the clay products business. Hop had other financial interests, including a radio station, to involve himself in. Philipson left Medicine Hat to return to university. Malcolm MacArthur, who had observed that it's easy enough to get into the business but hard to get out, stayed on.

Marwell turned the Alberta Clay Products over to an affiliated firm, Evans, Coleman and Evans, and renamed the pottery, upon MacArthur's suggestion, "Hycroft China" after Hycroft Towers, one of its projects in Vancouver. But, the pottery industry in Alberta had passed its peak and was essentially dead as a major industry.

"Marwell didn't know beans about pottery or the ceramic business," MacArthur observed. "They were fairly big, impressive people and they poured a lot of money in there. But, they finally decided the game wasn't for them and after about 18 months they put it up for sale."

"If the balance of the Yuill family had gotten off Hop's back and given him a free hand, this would be Stoke-on-Trent today."

Yellow Pitcher

Out at the Dunmore claypits, Bill Hrehorchuk noted the passing of the management he had worked under for over 35 years:

"The new manager come in here. He talk to me and says, 'I hear you stay here quite a few Fridays. You can tell where the good clay and bad clay is. We didn't make a good stock.'

"I says, 'There's something wrong with the management there in your place too.' I say, 'ACP take the same clay like you did today.' I say, 'Why you not make a good stock like ACP?' I say, 'Too many heads run that outfit. Same clay. But, they can't make the same stuff. What you think about that?'

"Lots of times I go there to the plant. They say, 'You have got nothing to say. We pay you for your work.'

"You take it this way. You take one sack of flour. You put two womans to bake a bread. That bread not be the same."

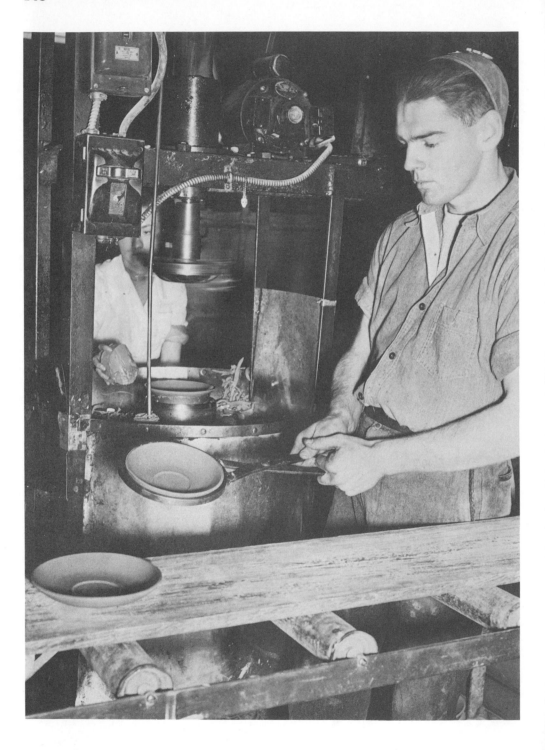

Chapter 8

Luke Lindoe returns to Medicine Hat.
Expansion of I-XL.
The Mayor of Medicine Hat turns potter.
Medalta reopens.
Fire!

"I knew there was a wealth back in those hills for whoever was smart enough to put it together."

Luke Lindoe made his way back to Medicine Hat in 1957 armed with the knowledge he needed to put it together. In the 15 years between the time he drove away from the Alberta Potteries in his doomed Dodge Coupe and his return, Lindoe had tackled several careers and mastered all of them.

His first move had been to talk his way into a job as a geological surveyor for Imperial Oil.

"They signed me on as instrument man based on my background. So, I shut my mouth and learned the job in a week, concentrating as hard as I could concentrate, in order to get onto a crew to Saskatchewan."

Lindoe spent three years in the field in the Cypress Hills mapping the Whitemud formation. He emerged an expert in the ceramic clays of the area and later published articles on the subject for professional journals.

Lindoe, the artist, spent his winters during this period engrossed in his painting. In 1945, he resigned from Imperial Oil and moved to Salmon Arm, B.C., "to have a shot at the painting thing" full-time. He "gave it a good blow" and two years later was contacted to apply for a position as department head at the Alberta College of Art in Calgary. He wasn't selected for the position, but was invited to join the staff in an unspecific capacity, stipulating the courses he wanted to teach. Although primarily a painter at the time, Lindoe demanded as one of his terms for accepting

Spin pressing saucers.

the teaching position, that a ceramics and sculpture department be created. He cites Alberta artist Marion Nicholl as his most useful ally in the School for realizing the beginning of a ceramic department.

"I progressively became disillusioned with the purpose of teaching. I found myself handling more and more uncommitted people of mediocrity. And, I could not find time for people of promise," Lindoe recalled.

"The school was more and more devoted to teaching the techniques of success, and less and less interested in teaching art. People were being told that if you do it this way, put this kind of a matt on it, this kind of a price on it, people will buy it. And, if people have bought it, well then, you are a success—a sort of formula approach to personal success which has very little to do with artistic success."

Lindoe was also disillusioned with the path he was taking as a painter at the time. In 1952, he was considered one of the best water colorists in Canada and was regularly exhibiting with the Canadian Watercolor Society, of which he was second vice president.

"At the same time, exhibitions were taking what I considered a rather nasty turn. I explored just about all the avenues everybody else explored relating to the post-impressionists. And, I did a lot of paintings that were off course philosophically for me, but quite good paintings. But, they were not genuine just because they came out of me.

"Every once in a while, when I exhibited, one of these things would be new enough and intriguing enough so that I would submit it. And, so, when I would send in my five, they would always pick the ones that were experimental no matter how good some other ones were. In those years I was getting pretty good in watercolor and I submitted some really good watercolors which they would pass up in favor of second-rate watercolors which looked more like they belonged on the museum walls of 1951."

Lindoe resigned from all exhibiting societies in 1952. About the same time, a proposition for a new venture gave him an avenue of escape from the art school.

He says he had his first "clinking" about a ceramics shop back in Salmon Arm, but he didn't have the money to pursue the idea at the time. In 1952 the money came along in the person of J. Sproule, whom Lindoe had known at Imperial Oil and who now approached him with the idea of

a small pottery studio. Lindoe Studios, later to be known as Ceramic Arts, in Calgary was conceived in a 50-50 partnership, Sproule providing the money and Lindoe, the know-how.

It was not an ideal relationship, and Lindoe recalls the experience with some cynicism.

"Sproule wanted to have a manufacturing company and he knew I could do it. I wasn't aware of his purpose then. And, he realized that a 50-50 partnership wouldn't serve his purpose. Legally, it wouldn't give him the tax dispersal mechanism he needed. So, he had to get out of it, but he didn't have what it takes to tell me the background of this whole thing. As it was, I assumed there was something funny going on.

"He had delayed for a year and a half the agreement. He knew what he was doing. I didn't. I was being very gullible. It took me a while before I realized that somebody could take Lindoe for a ride."

Lindoe directed the building of Ceramic Arts singlehandedly, from selecting the location to determining the most profitable market. He dug out the foundation by hand and built a 40-cubic foot updraft kiln which was the largest in the province outside of big industry. Lindoe Studios became operational in 1954, using primarily casting and drape moulding techniques and a small amount of wheel work. Square ashtrays were the studio's bread-and-butter line.

Lindoe felt constrained by Sproule's unwillingness to allow him to increase the output with mass production techniques.

"He had some philosophy there somewhere but no one could tell what it was. The business wasn't good; it wasn't going to go anywhere unless someone could convert Sproule."

Lindoe and Sproule parted ways after two years of association.

"I had nothing to sell out to him under the circumstances. All I had invested in it was my knowhow and I took that with me. I ruined my back on it trying to save money. . . . gullible as hell. It took two years out of my life and left me walking around a year and a half with a corset."

Lindoe returned to Medicine Hat in 1957, to apply the knowledge he had absorbed in geological survey to the area's brick and tile industry. Just as the pottery business was experiencing a major upheaval, important, but less dramatic shifts had been taking place in the brick, tile,

and sewerpipe industry. Three brothers, Gordon, Jack, and Tom Sissons, sons of Herbert Sissons who had co-founded the Redcliff Pressed Brick Company in 1912, were gradually taking over the entire industry in Medicine Hat under the umbrella of their I-XL trademark. The corporation had expanded slowly over the years, acquiring the Medicine Hat Brick and Tile Company in 1929 and the Redcliff Premier Brick Company in 1944. But, it was Alberta Clay Products which had dominated the market.

In the mid-Fifties, after Alberta Clay Products changed hands, the balance shifted. In a matter of a few years, I-XL took over Alexander Brick and Tile of Edmonton (which they renamed Northwest Brick and Tile), the National Porcelain Company built by Medalta, and Alberta Clay Products. When Lindoe arrived, I-XL was exploring their Saskatchewan holdings for clay and were running into serious mining problems. Lindoe was signed on, under his own terms, as Director of Research and Mining.

"I took one look at their mining and I was horrified. They didn't have a clue in what they were doing. They had started to explore for clay following an Alberta Research Council study and they couldn't even find it.

"I did their exploration for them, put them on the track right away. I did their lab work to show to them that some of the materials they thought were garbage were good materials and some of the stuff they thought was the very best of clay was garbage and they didn't dare use it."

At one quarry, just outside of Medicine Hat, Lindoe managed to cut I-XL's mining costs in half.

"I turned their quarries all around. I didn't ask them any questions. I gave them no decisions to make. They never did understand the bases on which I made my decisions, but they came to think they were all right. Gordon Sissons to this day thinks there's some kind of a witchcraft to what I was doing. But, if you spend enough hours thinking about something, you'll figure it out."

One of Lindoe's conditions for going to work for the Sissons was that they provide him with his own personal studio at the plant. It was there that Lindoe started seriously to develop as a potter. In lieu of a raise, he requested that the Company provide him with a gas kiln of his own design. Lindoe recalls that his association with I-XL was the best working relation-

OVER 20% GREATER CAPACITY
For a few cents per foot

The greatest carrying capacity of glazed Vitrified Clay Sewer Pipe is demonstrable. For example: the difference between a 12" Vitrified Clay Pipe and any other substitute material laid at a slope of 0.2 feet per hundred is 120 gallons per minute. 12" Vitrified Pipe carries 700 gallons per minute. The other material carries 580 gallons per minute.

This 22% greater capacity at no extra cost of construction, and only a few cents per foot in the cost of the pipe, makes Vitrified Clay Pipe the only choice. The unimpeded efficiency is only one of the many advantages of Vitrified Clay Pipe. It is also proof against the corrosive effects of modern sanitation.

Build for continued efficiency and permanence with Vitrified Clay Pipe.

The first cost is the last. The 20% extra capacity is everlasting.

BUY VICTORY BONDS and WAR SAVINGS CERTIFICATES REGULARLY

Associated for Publicity Purposes

NATIONAL SEWER PIPE CO. LTD. STANDARD CLAY PRODUCTS LTD.

CLAYBURN COMPANY LTD. ALBERTA CLAY PRODUCTS CO. LTD

VITRIFIED CLAY PIPE
PERMANENT AS THE PYRAMIDS

ship he'd had in his many careers and that the ten years spent working in his studio at I-XL were the most prolific of his pottery experience.

About the same time Lindoe started turning I-XL's mining operation inside out, the operation at Hycroft China was thoroughly shuffled and redealt by a man who had never seen the inside of a pottery before. In fact, he never saw the inside of Hycroft until after he'd bought it. Harry Veiner, Mayor of Medicine Hat and head of a multi-million dollar empire of ranches and greenhouses, relieved Marwell of their flagging pottery business in 1957 and set himself to make a go of it just for the sake of the challenge.

"Being the mayor, I wondered why they couldn't make it go. So, I told them I'd take a gamble on it. I was looking at the buildings and the gas wells they had there. So, I made them a cash offer. Money doesn't mean anything to me; success is important. I'll take over something nobody else can make a go of and I'll make a go of it.

"After I bought the place I started coming inside to see what I'd bought. I didn't figure on the dishes or anything. I didn't know anything about dishes."

Veiner, who may have inherited from Grampa Yuill the reputation for wearing the biggest cowboy hat in town, cut a colorful figure as mayor of Medicine Hat for 15 years. As promoter of the City, he was virtually a one-man show, known all over the country for his publicity stunts in the name of Medicine Hat, Alberta. Anyone who challenged Veiner to perform almost any feat from a bathtub race to a walking race had a bet on. And, when a challenge wasn't forthcoming, Veiner would create one.

An independent, self-made millionaire, he prefers trusting his own management instincts to delegating responsibilities and keeps a tight rein on all his business enterprises. True to this do-it-yourself attitude, Veiner's first act upon taking over Hycroft was to fire the sales department and the American management Marwell had installed. He also pared down the secretarial staff.

"I didn't pick the best-looking girls, because I knew the others would work harder and do a better job. I called in the five or six superintendents they had. They asked me how I was going to do business. Well, Marwell lost about $180,000 that last year. I said, 'I can get anyone to lose money. I want someone to make it.' I raised their wages and told those fellows,

'You make the stuff and I'll sell it.' By managing the place and selling the stuff myself, I cut out about $150,000 in salaries alone."

Veiner's authoritarian way of doing business didn't set too well with some of the employees who had seen the Company through its first twenty years under the Yuill/Baumler/MacArthur reign. The abrupt, seemingly arbitrary manner of the new boss who had never before seen the inside of a pottery was hard to swallow and Veiner soon had a mutiny on his hands. MacArthur, who had to turn down a chance to purchase the Company himself from Marwell, chafed under Veiner's rule, and left after six months as general manager.

"He came in; I went out. I just couldn't follow his thinking. It was just commercial all the way. He knew nothing of the field and I didn't get along with his decisions."

As a case in point, MacArthur cites a decorated china deal he had managed to set up with Woodward's, a totally new account for the Company. He developed six patterns which Woodward's agreed to carry providing they could have them exclusively.

"I sent them some sample patterns and they were displaying them in Vancouver. A few days later their head boy phoned me. He really reamed me out but good. It turned out the same pattern was across the street in the war surplus store in which our friend (Veiner) had some money invested. He was aware of the deal I'd made. I could site you twenty cases like that."

Depending on the source, MacArthur either resigned or was fired by Veiner—a clear case of incompatibility. MacArthur had already made one abortive attempt at his own private venture in the pottery business. Shortly after Marwell had taken over, he took six or seven employees with him to run Hop's Alberta Potteries in Redcliff. When that venture failed after six months, the small crew reopened Medalta on a cooperative basis, working without salaries and sharing the profits, should there be any. There weren't. A year after they left Hycroft, MacArthur's group returned. When MacArthur and Veiner terminated their relationship with a bitterness that still rankled twenty years later, Medalta once again reopened.

This time MacArthur was convinced he had success just within reach. He had Medalta's plant and equipment on a low rental plan; he had Tom Hulme who had headed up Medalta's art department for nearly 30 years; and he had stolen some of Veiner's men, among them the most experienced in the business. MacArthur is still convinced the concept he had in mind would have taken off if it hadn't been for the unfortunate twist of fate that finally depleted his resources.

"The market started to come; the labor came with me; we were doing excellently; our stone line was just starting to sell. Then, the day before Christmas 1958, the phone rang. 'Your factory's on fire.' Up she went in smoke.

"I had pushed for what was going to be a barbecue deal. We created a birch bark set—all patterned in birch bark with a cup like a chopped log and a twig of a branch for a handle. I had a chance to put that with Dairy Queens all across the United States. The fire smashed it all. It was a heartbreaker."

The fire is still a source of speculation and insinuation among parties whose business interests were either helped or hindered by what happened at Medalta on Christmas Eve day of 1958.

Wiped out financially, MacArthur nevertheless felt he still had one more card to play. The assets of the defunct Medalta Potteries, Limited, were tied up in bankruptcy proceedings, the City of Medicine Hat being one of the major creditors. All MacArthur needed was to find someone with the capital to purchase the pottery outright and he might still have the chance to realize his dream. He found the kind of money he needed in Lethbridge in the hands of the Thrall family, whose millions were invested in two wealthy companies—Mountain Minerals, Limited, and MacIntyre Ranches.

For the Thralls, Ralph Senior and Ralph Junior, the pottery business was entirely alien to their experience, but Medalta seemed worth trying, even if it were only to be absorbed as a loss. MacArthur would run the place if they would put up the $110,000 to buy it.

Meanwhile, Mayor Harry Veiner had other plans for Medalta. He proposed that the City foreclose on the property for the $75,000 owed in back taxes and unpaid utilities and use the buildings for space. MacArthur

hired a lawyer by the name of Shannon to present his case before City Council. Veiner is known least of all for his tact and subtlety, and there ensued in Council chambers a free-for-all of insinuations, counter-insinuations, and name-calling which overstepped what the courts considered the legal limits of debate.

According to one party present, Veiner referred to MacArthur and associates as a "bunch of jackasses" and promised to "mow them all down." Veiner claims that Shannon was trying to insinuate that he wanted the City to purchase Medalta to suit his own ends. Veiner responded to the purported insinuation in a manner more suitable outside of City Hall. Shannon sued.

"The Judge said, 'You can't say that.' So, I paid $10,000 for calling him a 'G.D. Liar.'

"I was thinking the best for the City. On paper it looked like something I was trying to work for me. I always say 'oil will come out on top.' I got all I want; what do I want with it?

"I was in the City for 21 years and never charged the City for any of my traveling, never put in for expenses, paid for my own stamps. When I wrote a letter, I paid the girl for my stamps, never took a dollar out of it. I will dare anyone to say I took a dollar."

Within a year of the episode in City Hall, Medicine Hat once again had two potteries—Harry Veiner's and Sunburst Ceramics, Limited, owned by the Thralls and managed by MacArthur. The new company started business producing crocks and beanpots, which they burned in Medalta's old beehive kilns after restoring the sections of the plant which had been damaged in the Christmas Eve day fire.

Right from its inauspicious beginnings, Sunburst had its problems. So did MacArthur. He had a share in the ownership of the Company, an arrangement which, according to his version, went counter to the way the Thralls liked to do business. Within a few months, MacArthur claimed, the senior Thrall approached him:

"Well, Malc, we've always had our business, just the two of us—it's always been a family thing. You're the first outsider that's ever been in on it. I'll give you a chance to buy us out or we'll buy you out."

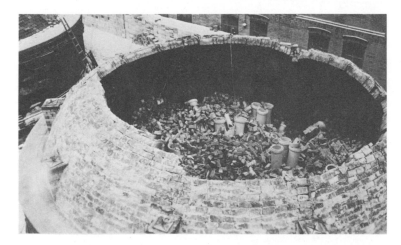
Interior of the circular tunnel kiln.

"Well, if I'd had that kind of money, I wouldn't have come to you in the first place."

MacArthur took a lump sum for his share and left the pottery business for good.

That same year, 1961, Bill Hrehorchuk had to leave the clay business, too. When I-XL took over Alberta Clay Products, they had closed down Bill's pits. Bill put down his shovel, unharnessed his team, and went to work in the plant. Pushing 70, with nearly 50 years of clay hauling behind him, Bill hadn't given a thought to retirement. That is, not until he switched on his radio early one January morning—the routine start of a routine day out at the little house by the pits. The Alberta Clay Products Company was burning.

The fire came as a surprise to no one who had been close to the industry. Constructed in the early days of the Century, when building and fire codes were unheard of, and expanded after a haphazard fashion, plants like Medalta and Alberta Clay Products were known fire traps. Everyone had his own theory as to how the fire started, but the fire itself was taken as a matter of course.

"Of course, you see how they worked," Bill explained. "Well, I know that's what's gonna be happen. But, I didn't say nothing to nobody. They say somebody smoke a big cigar in engine room and throw it on roof."

When it burned, Alberta Clay Products had been owned for a year by I-XL Industries, which was operating the old plant as one of several

The Alberta Clay Products plant as it was burning. It was never rebuilt.

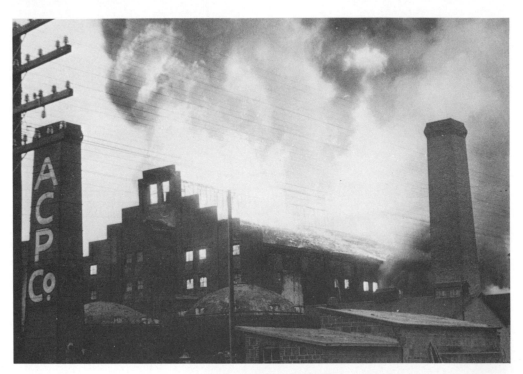

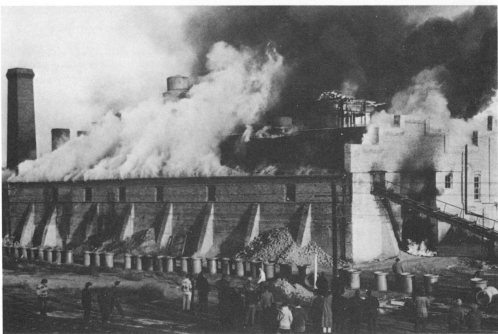

operating divisions. I-XL chose not to rebuild on the site. Eighteen beehive kilns surrounded the plant when it burned. In 1976, a handful of them remained—their insides studded with the glassy amber residue of salt glaze—relics, like Bill, of Alberta's early ceramic industry. The fire marked the end of an era that had slowly been drawing to a close over the past decade.

"I hear it on the radio. It was eight o'clock. I says, 'For Cripe's sake, there's nothing left to do.'"

I-XL, outfitted with a professional research department established by Lindoe, fueled by its own gas wells, and supplied with clay from its own pits in Alberta and Saskatchewan, continued to expand. The Company acquired the Western Clay Products Company of Regina in 1965 and built Red River Brick and Tile in Lockport, Manitoba, in 1970. These, combined with its four Alberta Divisions, put I-XL in the forefront as a major supplier of brick, tile, and sewer pipe between Victoria and Montreal. By 1976, I-XL was the only clay products company in Alberta which, over the booms and busts of the decades, had not only managed to survive but also to extract a wealth out of those hills.

CROCK COVER

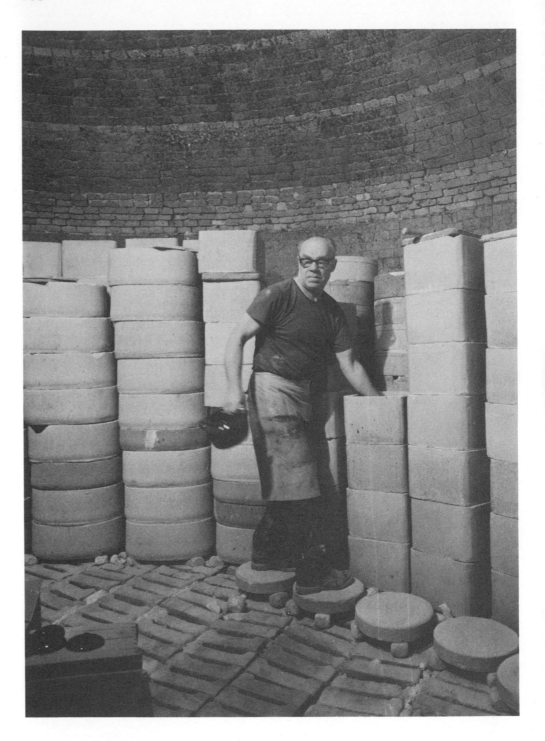

Chapter 9

"We saw we weren't going to make anything on dishes. It was tough with the imports—Japanese, Chinese, and from the Old Country. In Montreal they can buy from England cheaper than I can ship it by freight." Veiner.

"This country was very British oriented in consuming pottery. By 1967 Canadians were ready to buy well-designed, domestically produced pottery. But, we didn't have the design input from the start." Thrall.

What remained of Alberta's pottery industry in the mid-Sixties was in trouble. Europe and Japan had rebounded from the Second World War and plastics had replaced colored dinnerware for household use. For inexpensive, everyday dinnerware and hotel china, the foreign competition, with cheap labor, easily undersold the Canadian potteries. So, Alberta's potteries had to completely change their market orientation or go under.

Moreover, in the new affluence of the post-war years, Canadian taste was beginning to appreciate products with strong design elements. No Canadian pottery could begin to compete on the basis of design. In Europe and Japan, the artist/designer/craftsman was traditionally regarded as a central figure in the industrial process and industry maintained close liaison with the schools that trained designers and craftsmen. In Canadian potteries, the 'artists' or 'designers' were simply the people who decorated the wares. Design, in the total sense, had never been formalized. So, although there was a domestic market for well-designed pottery, it went to the foreign companies by default.

Emil Janke unloading bean crocks from saggers. Crocks are stacked floor to roof in centre area of kiln on round clay bats—Medalta Potteries (1966) Ltd., Redcliff, Alberta.

For Veiner and Thrall, mere neophytes in the industry, the prospect of competing against centuries of design tradition was formidable.

"You take me or Thrall—what the hell do we know about starting a thing we don't know about? My satisfaction is something I sell and I can make it go. It's not that I can have an idea for something different. I don't know anything about that. If I knew I could sell it, yes. . . . but, to speculate, no. If I were a ceramic man, maybe. But, we are not. Even the U.S. don't have that kind of class."

Veiner's solution?

"So, I got an idea: we'd make sanitary ware. We'd ride the dishes on the bottom and ride the sanitary stuff on top, which would give them a free ride. And, we'd have production in the dishes and production in the sanitary ware."

Hycroft China may well be the only plant in the world which runs toilet and tank sets and dishes through the same kiln. It is certainly the only plant in the world which produces "The Albertan."

"I went over to Israel. There was an engineer there—he'd invented something in flushing. Nobody'd know what it is; it's just a little thing. There's no flusher in the world that flushes like this toilet does. I could sell the idea for more money than this plant's worth. Just one man in the world knows about it.

"People liked them. There isn't one in Canada like this. I'm not saying they're finished as fine, but when it comes to flushing, then you have no trouble. When people got to know about this special toilet, we called it "The Albertan."

The addition of sanitary ware saved Hycroft. By Veiner's own admission, neither the toilets nor the pottery alone could keep the Company in business. After a year in sanitary ware production, Veiner managed to buy out Briggs, an American toilet and tank manufacturer.

Hycroft's lines are dictated by Veiner's hard-nosed, practical business philosophy: "I specialize in things that I know I can sell . . . things that there's a demand for and that they can't get anywhere else. Take the fourteen-inch bowls. We're the only ones who make them. They come up from the States for them."

For Veiner, it's a matter of simple production economics. In 1975, he could sell his twelve-inch bowl for $4.95, saucers for a dollar a dozen. He had to handle 20 dozen saucers to net the same profit he could make on a single bowl. A finished toilet was a $25.00 item, yet it required no more handling than a dozen saucers.

Essential also to Hycroft's business success was the fact that Veiner threw nothing away. A large part of Hycroft's profit came from seconds and thirds, pieces with slight chips or crawling glaze. A toilet that Crane, the quality sanitary ware manufacturer, would discard for a slight imperfection, Veiner would sell as a third, something the customer might install in a basement.

Hycroft does a fair amount of trade in personalized pottery items—plates, mugs, cups and saucers—hand decorated to order. In terms of profit, however, these lines account for a small proportion of the business. Likewise, the Company produces a small amount of white ware.

"If we didn't make it, we'd lose our business. If they want a saucer, we've got it. But, we don't want to push it, because we don't make any money on it."

Hycroft is making money, according to Veiner. Part of the reason for this is that the Company still includes among its assets the gas field which fueled its parent company, Alberta Clay Products, from the earliest days of this Century.

"We don't owe five cents. Hycroft is a wealthy little company. It's not the richest, but there's no sounder company in Canada."

By contrast, in the summer of 1975, Ralph Thrall, Jr., President of Sunburst Ceramics, Limited, of Lethbridge, had a white elephant on his hands. Over the 15 years since he had gotten into the pottery business by buying Medalta, Thrall had been plagued with technical and management problems. Within the first three years the Thralls realized that the production facilities and techniques used in the Medalta plant were outmoded.

Thrall preferred to stay clear of the day-to-day business of the pottery and relied heavily on hired managers and outside consultants to determine what direction Sunburst should take. In 1963, upon the recommendation of a consulting engineer from Los Angeles, Sunburst installed

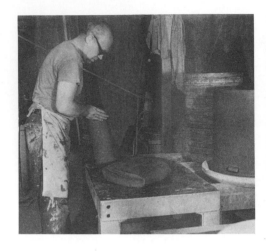
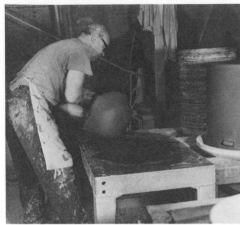
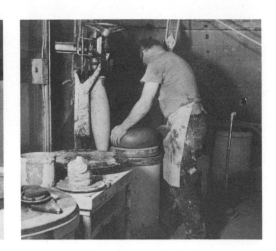

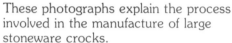
These photographs explain the process involved in the manufacture of large stoneware crocks.

several new pieces of equipment, most important among them a ram press and a moving envelope-type shuttle kiln. These were the first of many purchases over the next 10 years which would qualify Sunburst in 1975 as one of the most sophisticated ceramics plants in North America. Some of Sunburst's equipment was available nowhere else in Canada.

But, modern equipment wasn't enough to make a success of the Thralls' pottery. Sunburst didn't have the technical management expertise to run such an operation. After MacArthur departed, Sunburst hired in succession Walt Dexter and John Porter, the two ceramic artists who had succeeded Lindoe at Ceramic Arts. Porter recognized that the massive technical, financial, managerial, and marketing problems facing the fledgling company required sound research input. He also knew that there was no such thing in Canada at the time. Porter approached the Alberta Research Council, a Government agency, for assistance. With this move, Sunburst initiated a relationship with the Provincial Government which was unprecedented in the Alberta ceramics industry.

By 1966, the Lethbridge-based Thralls claim they finally "came to the realization that the ceramic industry was a very complicated business and that good, close communication between all the management people was essential." Up to that time, Ralph Thrall, Jr., had been an absentee owner/manager commuting from Lethbridge to Medicine Hat, and maintaining his office in Lethbridge, the seat of his family's mining and ranching interests.

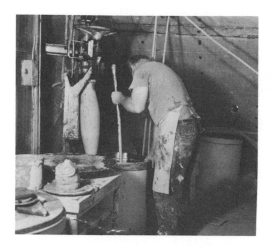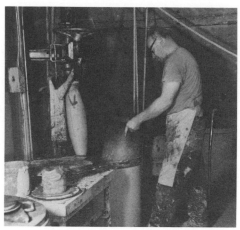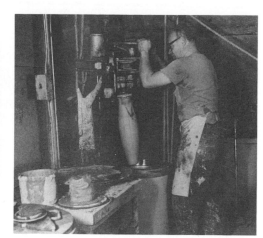

Sunburst moved out of the plant that had "grown like topsy" and into a smaller, more compact building in Lethbridge which had been laid out by the Research Council. The new premises didn't solve the Company's problems. A year later Thrall realized "that a small Canadian pottery could not compete in the field of mass produced items and success could most likely be found in the field where design was of considerable importance."

"The question facing us was: do we get into the ceramics business in a big way or get out?"

Thrall invested heavily in more equipment to go into the business in a big way. In 1973, he brought in four expensive new pieces of machinery intended for dinnerware production. They included the only automatic cup-making machine and the only commercial plate-making machine in Canada.

It was one thing to purchase the equipment. It was yet another to put it to work. Thrall had gone through three or four more managers and several consultants since Porter left in 1966 to return to Ceramic Arts. Also, he'd had the services at two different times, in 1963 and 1972-73, of a respected artist/designer/craftsman, Neils Gravsen. Gravsen resigned out of frustration at the Sunburst management's seeming lack of design and marketing awareness.

Thrall appealed to the Alberta Government for more help. The Alberta Opportunities Company, a government agency, came through with a

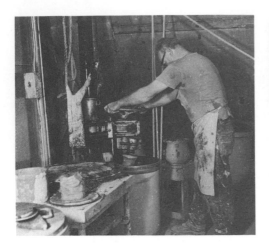
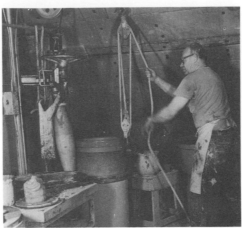
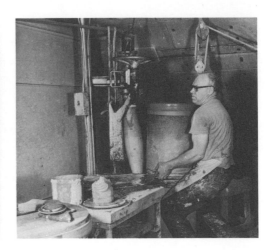

large loan and then another within a year of the first. The Research Council stepped up its involvement in Sunburst by installing four of its own people in the plant on a full-time basis, one of them as acting director. By early 1975, Thrall had a plant representing two million dollars worth of investments, a quarter of it coming from the Alberta Government in loans. He was still in trouble.

The physical plant far outstripped Sunburst's technological expertise, its market wisdom, and its design capabilities. It would be a long time before Sunburst's expensive new equipment would start paying for itself. In fact, the cup maker and the plate machine were doing nothing more than taking up space. The former had a capacity of 7,000 mugs per day and the latter, 500 dozen plates, yet neither had yet been used in production because the rest of the plant wasn't tooled to handle such a production capacity.

In early 1975, Thrall and the Research Council decided to concentrate on the production of food-related lines, promoting specific cooking vessels for particular food products. Out of this concept came Sunburst's clay bread baker, the only commercial item of its kind in the world. The baker was test-marketed in Edmonton's Safeway Stores with a bread mix included. The bakers bombed. Thrall applied once again to the Government for another large loan. He was having some success in getting orders for crock pots. If the Government wouldn't support him, he said, he would have to close down his plant for good and sell out, most likely to a foreign company.

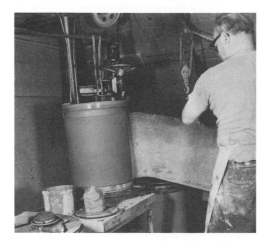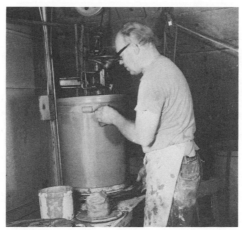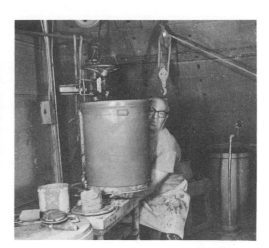

The Alberta Government was faced with an issue which went beyond the particular question as to whether to support Sunburst. Thrall argued that his foreign competition not only had years of expertise on him, but also the benefit of governmental support systems which enabled them to compete successfully on the world market. Alberta, he claimed, must be willing to support its own ceramics industry in the same manner or lose it entirely. Sunburst was the only large-scale pottery remaining in Alberta and one of only two plants of such size in Canada.

Alberta's Department of Business Development commissioned a report on Sunburst from a consulting firm and heard submissions from ceramics experts concerning the feasibility of a successful giftware or dinnerware industry in Alberta. In July 1975, the Department made its decision. The Department was careful to note that its decision was not meant to reflect on the future possibility of a government-aided pottery industry in Alberta. It simply was not willing to pour any more money into Sunburst based on the Company's record of the past 15 years.

Thrall put his plant up for sale within a week.

"Buy Sunburst?" Harry Veiner declined. "If I was a younger man, I would. But, you see, I carry all the load myself. Besides, if you start with two machines and you make stuff, you bring in a third and you go from there. But, with all that machinery sitting there, you try to use it and then you're in trouble."

Thrall sold his plant piecemeal. A group of 12 Sunburst employees,

including Thrall and a member of the Alberta Research Council, incorporated as equal partners to lease and operate part of the plant, carrying on with the crock pots. This enterprise hardly got off the ground before it folded in a few months time.

If Thrall was bitter about the Provincial Government's failure to support him, others in the industry would have been equally bitter had he received the aid. The Medalta Potteries (1966), Ltd., in Redcliff, had been turned down for a much smaller request. The Redcliff plant, often confused with the original Medalta, was a relative newcomer to the industry, although it was the repository of some of the longest working kilns, equipment, and craftsmen in the area.

Shorty Matuska, who had started out as a Medalta handyman under Wyatt in the Twenties, had leased the defunct Alberta Potteries plant from Yuill in 1966. Calling themselves Medalta Potteries (1966), Limited, he and his partner Bill Crockford set out to make crocks and flower pots. Within seven months, their building, which had been Canada's first automobile manufacturing plant, burned down. Matuska and Crockford had started with only $5,000 between them. After the fire, the pair received a $38,000 loan from the Alberta Government to erect a new building over the two beehive kilns which had survived the fire. These were the kilns which the Wyatt family had built in the early Thirties.

"They called it a 'Wonder Building,' and I wrote the company and said it's a wonder it stood up," recalled Jessie Reuber, the plant's bookkeeper. "And, Johnnie (Matuska) had hired a bunch of numbskulls to put it up—not a one of them a carpenter."

The new building, a prefabricated aluminum quonset structure, created more problems than it remedied. The builders had forgotten to allow for condensation, inevitable in a heated, enclosed space where a drying process is going on.

"It poured in there; it wasn't safe to walk in there. That clay—it's beautiful clay—has got fat in it. It was like walking on a pound of butter. We just had to keep trying to cover the ware with plastic," Mrs. Reuber recalls.

Even before the "Wonder Building" was completed, the partners depleted the funds they had obtained from the Alberta Government. Matuska appealed for help from local businessmen and residents, offering

a free share in the pottery for every thousand dollars put up and jobs which didn't exist to everyone who backed him financially. By the time the plant reopened, six more major shareholders had been enlisted: Roy Ogilvie, a farmer; George Hawrelak, a druggist; Robert Kost, a businessman; Herbert Wahl, owner of a greenhouse business; Earl Beach, a farmer; and Robert Pedersen, a laborer. None of them knew anything of the pottery business and none realized at the time how deeply they would become involved in it.

The small pottery's physical plant problems were compounded by management problems from the start. Matuska single-handedly ran the production end of the enterprise while Crockford kept the books. But, neither partner trusted the other, according to Mrs. Reuber, and the two fought constantly. Finally, Wahl bought Crockford out and took a personal interest in the pottery.

The business soaked up money faster than Matuska could solicit it and he kept going back to his shareholders for more. Ogilvie started neglecting his crops to assume responsibilities as general manager to protect his growing investment. In 1968, he asked Mrs. Reuber, a housewife who hadn't worked in an office in twenty years, to take over the bookkeeping.

Working under him in the plant, Matuska had 18 staff, including his wife, son, and daughter. His two jiggermen, Emil Janke and Frank Anhelcher had logged over twenty years experience each at the old Medalta plant. For his glazing formulas Matuska went to Tom Hulme. They were an "eccentric" crew to work with, Mrs. Reuber claims, and tempers flared often.

"The machinist was an alcoholic. One day I watched him take a sledge hammer to a forty-dollar bearing out of frustration."

All worked to the incessant patter of water dripping from the ceiling of the Wonder Building onto the huge plastic lean-tos which protected the wares from condensation. With the kilns firing and the doors closed, the plant was as humid as a rain forest.

Yet, people sought to work in the plant—in particular, the people who were promised jobs for their purchase of shares. When the jobs didn't materialize, some wanted their money back. One man even went to court to claim his job or his money. Apparently, the principal shareholders and

directors weren't aware of the promises Matuska had made. The summons to appear in court was served to one of the directors.

"He thought it was such a joke, he ignored it," Mrs. Reuber says. "So the judgement was awarded to the plaintiff because we never showed up."

As he watched the struggling pottery eat up his thousands in investments without showing any profits, Ogilvie decided to take firmer control. Together with his bookkeeper, he set about learning the production process from scratch. At age 65, Matuska still displayed the possessiveness toward the secrets of his craft that had so frustrated his co-workers in the Yuill plant 15 years earlier. According to Mrs. Reuber:

"Johnny was firing; Johnny was glazing; Johnny was doing everything. Roy knew nothing and Matuska would tell us nothing. So, I bought some books. I didn't know feldspar from kaolin when I went there. I had to learn the hard way."

Gradually, Ogilvie started to assert his authority as general manager.

"But, Johnny never paid any attention to Roy. He even changed the lock on us one day. He locked us both out—the secretary and the general manager. He was a queer little jigger. And, he never would cooperate. You know, he kept all his formulas under his armpit. He was a likeable little jigger, but he never trusted anybody. Everyone was afraid to cross him."

Those who worked with him claim that Matuska felt he was irreplaceable and that his family shared his attitude. The night Johnny went home and died of a heart attack, leaving a kiln of flower pots burning, a strange thing happened reminiscent of strange happenings at the Alberta Potteries years before.

"It must have taken a 10-foot rod to lay the wares over. It looked like someone was trying to knock the cones down. Roy had to use a pick and an axe to get the crocks out. There was only one other key to the plant besides Roy's and Johnny had it."

Matuska's son had worked at the plant for a while and is remembered more for the traits that got him fired than for any work he might have done.

"He always went around with a candy bar in one hand and a Coke in the other. The only time I saw him move was the day Emil poured oil in his Coke.

"We had bought some materials from Sunburst that they had left behind in the old Medalta plant when they moved to Lethbridge. The plant was being leased as warehouse space by some people at the time. Young Bill Matuska antagonized everyone so much over there they wouldn't let us in to get the bisque and moulds we had paid for. Someone up in High River got the bisque and the moulds were dumped into the creek," Mrs. Reuber claims.

Ogilvie retired from farming in 1971 to take over where Matuska had left off. By reading books on the subject and experimenting, he taught himself mould-making and kiln-burning and passed the information on to his two jiggermen. He still has a problem of indispensable staff.

Emil and Frank are the last working crockmakers in Alberta. Janke spins out the five- to fifty-gallon crocks, a staple of the pottery's business, on three antiquated jigger machines which he first encountered when he went to work for the old Medalta in 1949. But, his unique status is small source of satisfaction to the aging jiggerman. The work is gruelling and the struggling Company cannot afford to pay him a wage befitting a skilled craftsman. Nor can it produce more than a minimum wage to attract apprentices to take up the dying craft. As Janke complains that he is "getting too old" and has worked "too long" in the business, and as Frank's health suffers, Jesse Reuber and Roy Ogilvie worry: "We're going to be up the creek if something happens to Emil or Frank."

In 1975, Medalta Potteries Ltd., (1966) operated with a staff of nine, all working at little more than minimum wage to get the pottery back on its feet under the burden of debts left over from the Matuska era. Mrs. Reuber counts the company fortunate in that she and Ogilvie have been able to supplement the information they gleaned from books with expert technical advice freely given by men still living in Medicine Hat who have figured prominently in the area's ceramic industry—the Sissons brothers, Luke Lindoe, John Porter, Ed Philipson, and Wally Fode, a former Hycroft foreman and current supervisor at I-XL Industries.

The Company's primary business is in over-the-door sales of cookers, jugs, crocks, cannister sets, and casseroles to tourists who purchase the products wholesale. Some of the wares, including one-quarter to thirty-gallon crocks and three- to five-pound butter crocks go to retail outlets

and restaurants from Vancouver Island to as far east as Winnipeg. Red clay flower pots, "real flower pots," which Alberta had been supplying to Canadians on and off since the days of Charlie Pratt, have had to be discontinued, even though, according to Mrs. Reuber, the plant had to turn down $100,000 worth of orders for them in 1974.

"It takes five people and they're so hard to dry. In summer we can't even open the doors, they're such finickity things."

In the background, the rain still falls inside the Wonder Building.

Pudding Bowls

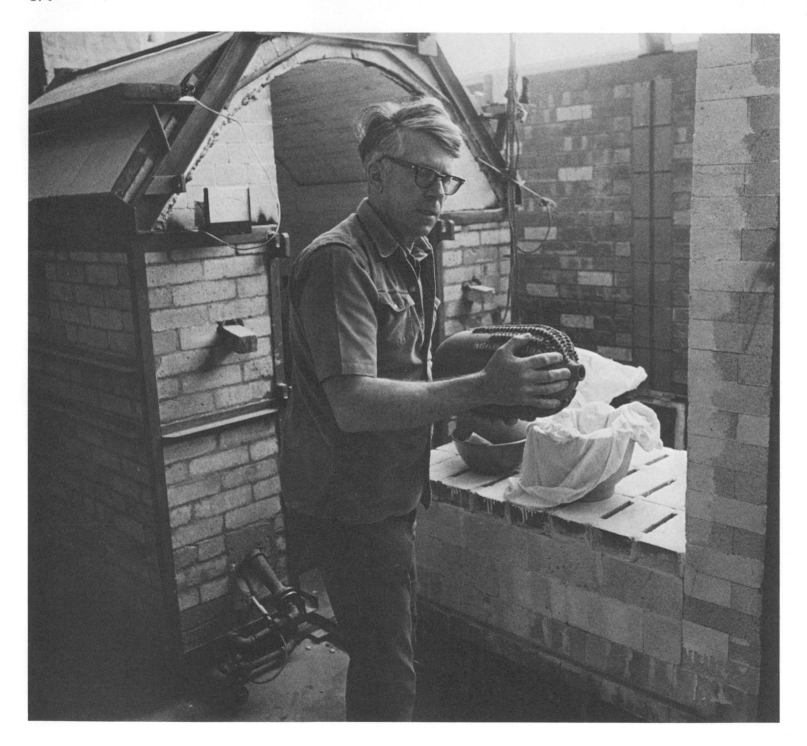

Chapter 10

Plainsman Clays.
The rise and fall of the Athabasca
Clay Products Company.
Ceramic Arts of Calgary.
The artist/production potter and
new horizons.

Luke Lindoe

"An individual takes what he has and either succeeds or does not fail," said Luke Lindoe.

In 1964, Luke Lindoe had $5,000 cash, a credit rating for $5,000 and "horsepower to burn." With these assets, he moved from his job as Director of Research and Mining for I-XL Industries to a job "where I was running clay back and forth in a wheelbarrow myself."

"Plainsman must surely have started 10 or 15 years back as a concept in the community mind," Lindoe reflected in 1975. By then he was president of a clay processing company with a near monopoly on institutional clays throughout British Columbia, Alberta, Saskatchewan, Montana, and Manitoba.

Lindoe had conceived of Plainsman Clays from observing what happened to requests to I-XL to supply clay to institutions. That was not I-XL's business, but the company did try to fill a vacuum by meeting such requests.

"Every sort of thoughtless error that could be made, even in grinding it and bagging it, was made. Bags were incorrectly labelled . . . It got so bad that I secretly recommended to people that they not buy clay from brickyards.

"I was really only qualified for the 'mining' part of my title. It was assumed I knew something about ceramics, but in fact I didn't. I knew about as much as a farm boy paddling a barn door down a river knows about seamanship. And, yet, I had distinct advantages. Just being a potter, I knew something about clay that others didn't."

So Lindoe set out to fill the vacuum properly. To check the soundness of his idea, he conducted a year and a half of market surveys before making his move.

"The first survey showed me that I didn't know how to make market surveys. It told me what people *had* been using. I needed to know what they *would* be using in the future. The second survey had nothing to do with clay."

This time Lindoe concentrated on educational trends and cultural shifts. The second survey produced a projective graph which gave him the green light for Plainsman.

While still maintaining his position half time with I-XL, Lindoe scrounged a pug mill from California and a hammer mill from a discontinued mining operation in Blairmore, Alberta, and started processing clay in the old Alberta Clay Products' machine shop. For the first two years, Plainsman was a one-man operation paying no salaries. When he needed extra hands, Lindoe paid his son and daughter minimum wages. Within a short time, he was processing and selling over two million pounds of clay a year and had outgrown his premises.

"All I had to do was have wet weather or snow to shut me down. I had the equipment for five million pounds but couldn't use it. I had no storage or staff. I was working 16-18 hours a day, 12 months a year."

Lindoe claims his projective curve has held up well over Plainsman's first 13 years, except for one factor he forgot to take into account.

"Whenever there's a pinch for money, clay sales go up. Institutions that already have workshops find that in times of need clay courses are a cheap way to produce education. The raw materials for clay are cheaper than for paint and paper. So, bad times are good times for Plainsman."

By 1971, Lindoe was able to build the larger plant he needed on the site of the old Alberta Clay Products Company which he bought from I-XL. He acquired as partner and general manager, John Porter, a British ceramic artist who had managed Sunburst Ceramics and Ceramic Arts before joining Plainsman.

The Company continued to grow through the early '70's, reaching and surpassing sales of five million pounds a year of processed clay to school systems, clubs, colleges, and studios throughout Western Canada, Montana, Eastern Ontario, Nova Scotia, New Brunswick, and Quebec.

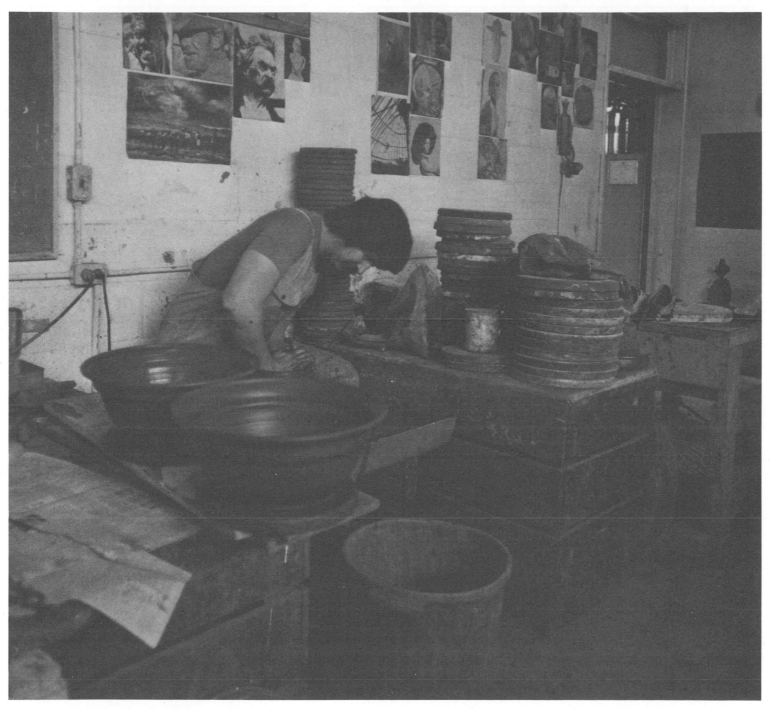

Tony Bergman at Ceramic Arts, Calgary
is shown production throwing.

Lindoe claims "Plainsman succeeds because it self-consciously sets out first to solve problems, second to sell clay. I knew from the start that the role of Plainsman had to be problem solving."

Unlike Philipson, who considered himself a scientist in relation to clay, Lindoe has a more intuitive approach to ceramics.

"Ceramics is not a science; there are too many variables. Anyone attempting to make a science out of ceramics is not going to live long enough to put it together. It's as empirical as can be. You have to be a craftsman even in the laboratory. You have to understand intuitively what this complex is leading to. You have to simplify it in your own mind.

"Some people can't deal with ceramics at the intimate level—what actually is going on inside the kiln. Some people can't do it because you can't measure it, you can't poke it with your finger . . . 2400°—it's clear out of your reach; it's unreal as Anderson's fairy tales. When it's cooled down to 300° it becomes real again. It's not reality. Look at a kiln . . . it's another sphere altogether. You have to know a whole lot of junk that is otherwise useless . . . but it only feeds your imagination to help you understand what's going on."

At about the same time Lindoe was hatching the Plainsman concept, a group of businessmen in Athabasca, Alberta, were sitting around a coffee shop one morning kicking around ideas about clay. The Athabasca area is rich in a medium fire earthenware clay. They should be doing something with this local resource, they agreed.

"Typical, gambling, reckless entrepreneur that I am, I ended up with a pottery I never intended," Ed Polanski recalls. Polanski's business was electronics.

The Athabasca Clay Products, Ltd., started in 1964 making weeping tile, flower pots, and hand-thrown pottery. Polanski enlisted the help of the Alberta Research Council to build his kilns. He experimented at first with gas firing, but found the sulphur content of the local gas was discoloring his ware. He settled on four small electric kilns which he rigged up with a switching system to rotate power on a 24-hour basis to take advantage of power demand rates.

Polanski tried to develop his designs around an Indian theme, using for the most part clear glazes on natural earth colors. The pottery's hand-

crafted, and later slip-cast, bean pots, teapots, vases, coffee mugs, and wall plaques were decorated with Indian paintings on earthenware colors.

"We were trying to develop the same kind of market as there is for Eskimo carvings. We encouraged Indian help, researched Indian legends and made designs based on Indian sketches and legends."

According to Polanski, there was a market for his product. In fact, he claimed he could not produce enough to satisfy it. The pottery had outlets in British Columbia and all over Alberta, including its own store in Edmonton.

Nevertheless, the Athabasca Clay Products Company never broke into the black and closed down only four years after opening.

"The biggest difficulty was finding craftsmen," Polanski explained. "Our schools don't turn out craftsmen. We don't recognize pottery as a legitimate trade. I had to import my craftsmen and that was a very expensive business."

Polanski started out with potters from Switzerland and Czechoslovakia. A woman was called in from Norway to paint designs. At its peak, the pottery employed 16 persons turning out 60,000 pieces a year.

From the start, the foreign staff had problems adjusting to life in Alberta. According to Polanski, the Swiss potter turned out to be schizophrenic and returned home after only a brief stint at the pottery. The Czech had arrived in Athabasca without his wife. When Russian tanks rolled into Czechoslovakia, his wife fled to join him in Alberta. The couple lived in a flat in the plant, but two weeks after they were reunited they started squabbling. One night, in a drunken rage, the potter wreaked $10,000 worth of damage on the plant with an iron rod. Shortly after, the pair left Athabasca.

Polanski had projected that it would take 15 years before the pottery would break even. He claims that he was willing to make that investment and even had plans for expansion into mechanized production in a bigger plant. However, a license came up in Edmonton for a cable television station, a business more in line with Polanski's earlier career. In 1968, the Athabasca pottery, after making about 150,000 pieces in all, closed down and was sold off piecemeal.

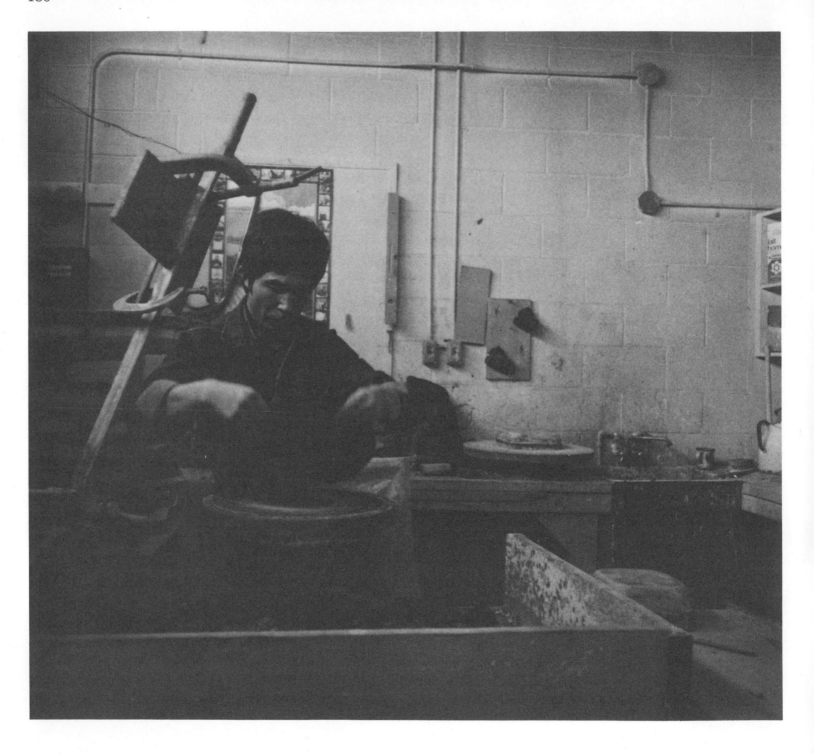

One Alberta pottery, a hybrid between ceramic art and industry, has survived in a quiet way on a small scale for nearly a quarter of a century. Ceramic Arts of Calgary, the brainchild of Luke Lindoe and J. Sproule, was perhaps timed just right to benefit from Alberta's increasing visibility as a centre for ceramics and from the experience of those who had gone before. In the early Sixties, partly attracted by the Alberta College of Art's ceramics department, partly by the Province's reputation for clay, natural gas, and ceramic industry, and partly by a general burgeoning of government and institutional activity in the ceramic arts, artist potters were choosing Alberta as their place to work. Many of them were associated with Ceramic Arts.

Lindoe was succeeded at Ceramic Arts by a long line of artist craftsmen with art school training and interest in production pottery. They included John Porter and Jane (Askey) VanAlderwegen from England, Walter Dexter, Walter and Pat Drohan, Les Manning, Vivian Lindoe, Luke DeVries, Neils Gravsen, and Tony Bergman. All have left their creative stamp on the products. They worked almost exclusively in stoneware, thrown, cast and hand-built, and of a high quality craftsmanship and design.

Over the years, Ceramic Arts has remained a small operation enjoying the backing of the Sproule family. Up until 1977, the company has relied on a clay dealership for half its profits. However, Bergman, who ran Ceramic Arts, often alone, from 1971 to 1976, found the economic necessity of dealing in materials and over-the-door sales interfered with production.

In 1976, he turned the management of Ceramic Arts over to Gordon Robertson, a potter from Ottawa who trained in an apprenticeship in New Zealand. Robertson and his assistant Jason L'Abbe, also from Ontario, have set out to make of Ceramic Arts "the best retail factory in the Province, where people can buy artistically designed domestic pottery straight from the muddy hands that made them."

Their first move toward that goal was to dump the clay dealership and to build a new 50-cubic foot kiln based on Lindoe's design for a car kiln. They added improvements which make it, according to Robertson, "the best kiln in the Province," able to run on full heat at less than 500-cubic feet of gas per hour.

A worker at Ceramic Arts in Calgary is preparing to jigger a plate.

Another goal Robertson has set for himself and Ceramic Arts is to become self-sufficient with clay, "to make it as cheap to pot as it is to live." Alberta potters had been dependent upon Plainsman for their clay, but many have found that the pre-packaged clay, while sufficient for institutional use, sacrificed workability for drying qualities. Robertson describes himself as "a cantankerous sot for whom getting it out of a plastic bag is not good enough." He purchased a vacuum pug mill to reclaim waste clay and to have control over his mixture. In league with other like-minded potters, he began a loosely structured clay research group to cut the "apron strings" from Plainsman and to develop a low-cost workable material from the Saskatchewan clays. From his preliminary tests, Robertson was confident in mid-1977 that they would succeed.

Professional potters and observers of the changing market for ceramics are convinced that Ceramic Arts represents the direction the industry in Alberta should be taking. Medalta, and Medicine Hat Potteries were able to thrive in a pre-World War II Canada by mass-producing domestic stoneware to be sold cheaply to a largely rural market more interested in utility than aesthetics. Plastics, rural electrification, and the rise of Taiwan and Japan as industrial giants with cheap labor supplies knocked the market for inexpensive household ceramics out from under the Canadian industry. As Harry Veiner knew, Taiwan can do it cheaper. Canada can no longer support a Medalta.

She is supporting increasing numbers of artist/production potters. Affluent Canadians, sons and daughters of the people who were satisfied with household crockery, now have the money and leisure to develop tastes for a finer product. The Canadian industry has been slow to react to this change. In the domestic vacuum, Canada has imported its finer ceramics from the Europeans—Dansk, Arabia—and the Japanese—Mikasa, Noritake—who have a tradition of incorporating the designer/craftsman into the industrial process and who have developed sophisticated marketing techniques to sell their products. Prior to the beginning of Ceramic Arts, there was no point of intersection between the art and the industry in Alberta. "Designers" for Medalta were the people who cut stencils for decorative touches on the wares. Meanwhile, art schools and individual artist potters shunned industry as a bastardization of art.

This situation has changed in Alberta over the past decade as more and more artists have become production potters. As one of them put it: "If I am going to put a lot of creative energy into designing one coffee mug or teapot, or ten, or twenty, why not 200,000?" And, as the potter with a design concept begins using the industrial process to mass-produce that concept and more sophisticated industrial marketing techniques to sell it, he is becoming a part of and giving new direction to an industry that has grown up with Alberta.

SLOP JAR

In July 1976, the Hon. Horst Schmid, Minister of Alberta Culture, desig-
nated the round downdraft kilns and the original buildings of the Medalta
Potteries in Medicine Hat a classified historic site.

Glossary

Ball clay

An extremely fine-grained, plastic, sedimentary clay. Although it contains much organic matter, it fires white or near white in color. It is usually added to porcelain and white-ware bodies to increase plasticity.

Batting machine

A process of batting (beating) out the clay before it is placed in the jolly.

Beehive kiln

From their characteristic shape, circular downdraft kilns were commonly known as "beehives."

Bisque (biscuit)

Unglazed ware, usually porous. Bisque firing semi-vitrifies the ware, conveniently rendering the ware less fragile and making glazing easier.

Blunger

A mixing machine equipped with revolving paddles or blades used to prepare large quantities of clay slip or glaze.

Burned

To fire or heat the kiln to a desired temperature.

Car kiln

A kiln in which the floor and part or all of the door are built on a car which sits on a track. The car is pulled out of the kiln for easy stacking and unstacking and pushed into the kiln for firing.

Clay elevator (bucket elevator)

A frame which carries a series of buckets on an endless belt and is used to move materials to a higher level.

Colloidal

A substance in the form of submicroscopic particles that when in solution or suspension do not settle out.

Cones

Pyrometric cones are made from a mixture of ceramic materials formed into triangular elongated pyramids and designed to melt and bend over at given temperatures. They measure the heat work, rather than just the temperature in the kiln.

Crazing

Hairline cracks in a glaze caused by differences in contraction or expansion between body and glaze.

Downdraft kiln

The flames and hot gases from the fires first rise to the top of the interior of the kiln and then descend through openings in the floor, where they exit through flues out the stack. In consequence of the gases travelling first upwards and then downwards they act more efficiently on the articles to be fired.

Drape mould

A form over which a soft clay slab is draped and pressed to the shape of the mould.

Englobe

A prepared slip that is halfway between a glaze and a clay; contains clay, feldspar, flint, a flux, plus colorants. May be used on bisque ware.

Feldspar

A crystalline rock composed of the aluminum silicate of potassium, sodium, and calcium. These silicates are never found in a pure state but in a mixture with one or the other predominating. Feldspars are a major ingredient of porcelain and white-ware bodies, and are often the only source of body flux (fusion).

Filter cakes

See filter press.

Filter press

Equipment for dewatering clay, consisting of an accordion-like set of canvas bags through which slip is pumped. When the pressure is released the clay is removed as filter cakes.

Firebrick

Brick made from fireclay used for lining furnaces and in other situations where high temperatures are to be resisted.

Fireclay

A sedimentary clay with an unusually high alumina content. Usually fires tan or grey and is used in the manufacture of refactory materials such as bricks, muffles, and so forth for industrial kilns and furnaces.

Flint

See silica.

Glaze

A thin layer of special glass used as a coating for biscuit. It may be clear, colored, or opaque, or contain crystals.

Hammer mill

A machine used to break down hard materials into small particles.

Hollow-ware

Extruded clay building blocks which are hollow.

Jiggering

An industrial method of producing pottery. A slab of soft clay is placed upon a revolving plaster mould. As the mould (attached to a wheel head) turns, a template on a moving arm trims off the excess clay and forms the reverse side of the piece.

Jolly

An upright spindle carrying a mould to form the outside of the article.

Kaolin

Pure clay, also known as china clay. It is used in glaze and porcelain bodies and fires pure white.

Kiln burner

The person whose job is to fire the kiln.

Magnetic separator

Running slip through a magnetic separator removes iron specks from the slip.

Mould

A form usually made from plaster containing a hollow negative shape. The positive form is made by pouring liquid (slip) clay in this hollow.

Mould runners

Persons employed to fetch and dispense moulds to the jiggermen.

Plaster of Paris

Hydrate of calcium sulphate, made by calcinating gypsum. It hardens after being mixed with water. Because it absorbs moisture and it can be cut and shaped easily, it is used for moulds and casting work.

Pressed brick

Brick pressed under high pressure. A dry clay—or clay containing very little moisture pressed in dies under high pressure. A dry pressed brick has very sharp square edges.

Pug Mill

A machine used for mixing and extruding plastic clay.

Pyrometer

An instrument for measuring heat at high temperatures.

Ram press (ram process)

A method of forming simple shapes by the use of moulds (dies) in hydraulic presses. Male and female moulds shape the form and under great pressure squeeze out the excess clay.

Saggar

A clay box-like container in which pottery is fired to protect the ware from flames.

Sanitary ware

A term used in the industry to describe toilets, sinks, urinals, and the like.

Scove kiln

A simple rectangular updraft kiln. Usually had openings at each end for loading and fire boxes along the sides. The true scove kiln had no permanent roof, but the bricks in it are covered with a layer of burned bricks and soil. Also called a scotch kiln.

Setters

See stilt.

Shale

As the water was squeezed out of clay in geological time by strata movements, pressure and heat, it hardened into shale.

Shuttle kiln

Generally has doors at either end and two cars, which can be shuttled in and out of the kiln; the advantage being one car can be stacked or unstacked while the other is firing.

Silica

Flint produced in the United States by grinding almost pure flint sand.

Slip

A clay in liquid suspension, used for slip casting. Sometimes clays applied as englobes are referred to as slip clays.

Slip casting

The making of pottery in plaster moulds using clay in liquid suspension. The mould is filled with slip. The plaster absorbs a thin wall of clay onto its surface and the surplus slip is poured off. The cast is left to dry and shrink away from the mould, then removed.

Soft mud mould machine

This is a machine which fills a wooden mould with clay, turns it over, and empties it automatically.

Stilt

A ceramic tripod upon which glazed ware is placed in the kiln.

Stock brick

Brick commonly used for ordinary brickwork.

Stoneware

A high fired ware generally in the 1200–1350°C range, with little or no absorbency. Usually grey in color.

Throwing

Hand forming pottery of plastic clay on a potter's wheel.

Tunnel kiln

A long kiln through which kiln cars loaded with dry ware enter, and as they slowly move along entertain a gradual temperature rise until they reach peak temperature. As the cars continue to move along, the temperature decreases till they exit at the end of the kiln, fired, cooled, and ready to be packed.

Updraft kiln

Perhaps the simplest form of kiln. Essentially a fire beneath the floor, or at floor level. The flame and hot gasses rise through the ware to a vent at the top.

Vitrification

Pertains to the hard and non absorbent quality of a body or glaze. It is the progressive fusion or glassification of a clay.

White ware

Pottery or china ware with a white or light cream-colored body.